Art in Context

Leonardo: The Last Supper

Art in Context

Edited by John Fleming and Hugh Honour

Each volume in this series discusses a famous painting or sculpture as both image and idea in its context – whether stylistic, technical, literary, psychological, religious, social or political. In what circumstances was it conceived and created? What did the artist hope to achieve? What means did he employ, subconscious or conscious? Did he succeed? Or how far did he succeed? His preparatory drawings and sketches often allow us some insight into the creative process and other artists' renderings of the same or similar themes help us to understand his problems and ambitions. Technique and his handling of the medium are fascinating to watch close up. And the work's impact on contemporaries and its later influence on other artists can illuminate its meaning for us today.

By focusing on these outstanding paintings and sculptures our understanding of the artist and the world in which he lived is sharpened. But since all great works of art are unique and every one presents individual problems of understanding and appreciation, the authors of these volumes emphasize whichever aspects seem most relevant. And many great masterpieces, too often and too easily accepted and dismissed because they have become familiar, are shown to contain further and deeper layers of meaning for us.

Art in Context

Leonardo da Vinci was born at Vinci, near Florence, on 15 April 1452 and died on 2 May 1519 at le Clos-Lucé (Cloux), Amboise, in France. He was brought up by his father who later became a respected notary in Florence. From about 1467 he was trained as a painter and sculptor under Verrocchio in whose house he lived until 1476. He became a master of his guild in 1472. He left Florence around 1482 when he was invited to Milan by Lodovico Sforza. He stayed there until 1499, returning to Florence in 1500 until 1506. He was again in Milan until 1513, then chiefly in Rome until he went to France in 1517. Painter, sculptor, architect, musician, mathematician, engineer, scientist and inventor, Leonardo was one of the great Universal Men produced by the Renaissance. Few paintings by him have survived but there are many authentic drawings.

The Last Supper in the Refectory of S. Maria delle Grazie, Milan, is painted in a kind of tempera on stone and measures 460 x 880 cm. It was probably commissioned in 1494 and was far advanced by 1497 though not completed until 1498. The surface had already begun to decay noticeably by 1517 and it is questionable how much of Leonardo's actual painting survives since it has been restored and repainted almost continuously over four and a half centuries.

The Viking Press New York

Leonardo: The Last Supper

Ludwig H. Heydenreich

Reference colour plate at end of book

Acknowledgements

I am sincerely grateful to Mrs Elisabeth Beatson at Princeton who most carefully, and with great understanding and intuition, revised the English translation of this book. To Dr Franco Russoli, director of the Galleria di Brera, and to Padre Angelo M. Caccin O.P. of S. Maria delle Grazie I am greatly indebted for photographs and for other help. I should also like to thank the editors of this series, John Fleming and Hugh Honour, for many helpful suggestions regarding the presentation of the material, especially in the preparation of the appendices.

Finally, I should like to remember here, with gratitude, the debt we all owe to the late Gino Chierici who was Superintendent of Monuments in Lombardy during the last war. The survival of *The Last Supper* is due to his care and foresight. Had it not been for the steel armature filled with sand-bags which he had erected to protect it, *The Last Supper* would certainly have been destroyed by the bombs which fell on 13 August 1943.

Historical Table

1490	Treaty between England and Lodovico Sforza of Milan.
1491	
1492	Lorenzo de' Medici dies.
	Pope Alexander VI (Borgia) elected.
	Columbus sails from Palos.
1494	Charles VIII invades Italy, expels Medici from Florence.
	Savanarola becomes chief figure in Florentine republic.
	Spain and Portugal divide the New World between them.
1496	
1497	Vasco da Gama rounds the Cape.
1498	Savanarola burnt in Florence;
	Machiavelli becomes Secretary of State.
1499	Lodovico Sforza expelled from Milan by French army under Louis XII.
1500	Alexander VI proclaims crusade against the Turks;
	Cesare Borgia's conquests in central Italy.
1501	
1502	Leonardo becomes Cesare Borgia's military engineer.
1503	Death of Alexander VI and collapse of Cesare Borgia's power.
1504	
1505	Luther enters Augustinian Friary at Erfurt.

		1490
Leonardo begins main phase of work on the Sforza monument.		1491
Bramante begins choir of S. Maria delle Grazie. Piero della Francesca dies.	Franchino Gafurio: *Theorica musice.*	1492
Leonardo commissioned to paint *The Last Supper.* Hans Memling dies.	Sebastian Brandt: *Narrenschiff* Pico della Mirandola, Poliziano and Boiardo die.	1494
Michelangelo in Rome. Perugino: *Crucifixion.*	Pico della Mirandola: *Disputationes* published posthumously.	1496
		1497
Leonardo: *The Last Supper.*	Luca Pacioli: *De divina proportione.*	1498
Dürer: *Apocalypse.*	Philippe de Commines finishes his memoirs.	
Leonardo leaves Milan. Signorelli begins frescoes in Orvieto.	F. Colonna: *Hypnerotomachia Poliphili.* Ficino dies.	1499
Leonardo returns to Florence; begins *The Virgin and St Anne.* Michelangelo: *Pietà.*	Erasmus: *Adagia.*	1500
Michelangelo returns to Florence, begins the *David.*		1501
Leonardo probably begins the *Mona Lisa.*		1502
	Ariosto begins *Orlando Furioso.*	1503
Leonardo begins the *Battle of Anghiari*; Michelangelo: *Battle of Cascina.*	P. Gauricus: *De sculptura.* F. M. Grupaldi: *De partibus sedium libri due.*	1504
Raphael: *Sposalizio.*	Sannazaro: *Arcadia.*	
Dürer returns to Italy.	Bembo: *Gli Asolani.*	1505

1. Introduction

Very few works of art, even among the greatest and most widely appreciated masterpieces, have entered into the general consciousness and become, in a certain sense, the spiritual possession of the whole world. Leonardo da Vinci's *Last Supper* is among these exalted few – indeed it stands supreme among them. [See colour plate at end of book.]

This great painting has always been famous. It began to acquire its unique reputation immediately after it was finished when Luca Pacioli eulogized it in the dedication of his *De divina proportione* to Lodovico il Moro, dated 8 February 1498. Its renown soon spread throughout Europe. Nor has its prestige ever diminished, despite all the subsequent fluctuations in taste and in artistic styles and despite the rapid physical deterioration of the painting itself, which began only too soon. In the great disputes over the basic principles and purpose of art which raged for three centuries, especially in Italy, France and England, this painting's status as a perfect creation was never questioned, let alone doubted.

The perfection of the work lies not only in the formal or purely artistic merits of the composition but also in Leonardo's expressive mastery, in his deeply human and profoundly felt exposition of the subject. He created an ideal pictorial representation of the most important event in the Christian doctrine of salvation – the institution of the Eucharist – and his representation has maintained its absolute validity over and above all later doctrinal and other divisions of the Church. Countless copies and reproductions of it have been diffused in schools and homes and places of worship of all denominations (both Catholic and Protestant) in all countries. It would be hard to name another representation of any part of the Christian story which

has achieved such a perennial and unanimous – completely oecu-
menical – acceptance and authority. Nor does any other painting of
a Christian subject dominate our imagination with the same power:
whenever our thoughts turn to the Last Supper we seem to see
Leonardo's composition before us.

Let us now turn to the work itself and the history of its genesis as
image and idea.

2. *Commission and Execution*

The Dominicans of S. Maria delle Grazie in Milan enjoyed from the start the special favour of the ducal court. In 1458 their mother house in Pavia had been requested to found an offshoot in Milan. Count Gaspare Vimercato gave the new arrivals the piece of land on which, from 1464 to 1482, the imposing friary and its church were erected.[1] The protection in high quarters continued: the church and friary had hardly been in existence for ten years when they once again found a great and ambitious patron. Lodovico Sforza [1], proudly conscious of his swiftly won political power and anxious to give visible expression to his position also in impressive buildings, had chosen S. Maria delle Grazie as court church and burial place for his family. He decreed that the building should receive a more splendid form in accordance with this lofty function. On 29 March 1492 Archbishop Guido d'Antonio solemnly laid the foundation stone of the new choir [2], which was designed by Bramante as a mighty cube crowned by a dome.[2]

Lodovico also devoted his special attention to the monastery itself and provided it with rich endowments. This munificence included the extension and appropriate decoration of the interior. He put to work on this great project the two best artists of his court: Donato Bramante was entrusted with the direction of the architectural work and Leonardo da Vinci was commissioned to execute a painting of the Last Supper in the refectory, which was likewise enlarged [3, 4]. It was under these circumstances that one of the most perfect creations of Western art came into being.

Contemporary sources are scanty, nevertheless they provide us with one or two reliable indications about the progress of the work. Probably commissioned in 1494,[3] it was far advanced in 1497 and

1. Lodovico il Moro, detailed from the *Pala Sforzesca*, *c.* 1495. Anonymous

2 (*opposite*). Choir of S. Maria delle Grazie, Milan, 1492. Bramante

completed in 1498.[4] We also possess a very lively description by an eye-witness who watched *The Last Supper* being painted. The famous novella writer Matteo Bandello, as a young monk and the guest of his uncle, the Abbot of S. Maria delle Grazie, saw Leonardo at work in 1497 and incorporated his memories of this experience in one of his stories.

'Many a time', he says, 'I have seen Leonardo go early in the morning to work on the platform before *The Last Supper*; and there he would stay from sunrise till darkness, never laying down the brush, but continuing to paint without eating or drinking. Then three or four days would pass without his touching the work, yet each day he would spend several hours examining it and criticising the figures to himself. I have also seen him, when the fancy took him, leave the Corte Vecchia when he was at work on the stupendous horse of clay, and go straight to the Grazie. There, climbing on the platform, he would take a brush and give a few touches to one of the figures: and then suddenly he would leave and go elsewhere.'[5]

However, the careful consideration which – as is clear from this evidence and from many other credible anecdotes handed down from later periods[6] – Leonardo devoted to his work also determined his choice of medium, a choice which, as time was to show, turned out to be an unfortunate one. His mode of working, marked as it was by intense intellectual concentration but a hesitant manner of execution, did not suit the commonly used fresco technique, which requires a swift, assured approach and precludes any change in the course of the work. In order to be able to continue his usual manner of working Leonardo devised his own technique for mural painting, a sort of tempera on stone. The wall must first have been coated with a strong ground of some material which would not only absorb the tempera emulsion but also protect it against moisture. This ground, which he compounded out of gesso, pitch and mastic, has not proved durable. The pigment soon began to break loose from the ground and a process of progressive decay set in which could be described as 'the tragedy of *The Last Supper*'. As early as 1517 Antonio de Beatis referred to it as an excellent picture, but one that was beginning to decay, 'though whether because of the dampness of the wall or some other mischance I cannot say'.[7] The painter Giovanni Battista Armenini, who saw the work towards the middle of the century, calls it 'half ruined'[8] (mezzo guasto) and Vasari, who

3. The refectory, S. Maria delle Grazie, section and plan

4. Interior, the refectory

visited the monastery in May 1556, speaks of it as 'so badly affected that nothing is visible but a mass of blots' (macchia abbagliata).[9]

The process of decay proceeded inexorably through the centuries. Frequent and careless restorations made the condition of the painting even more deplorable.[10] The year 1652 saw the construction of a doorway which ruthlessly eliminated the lower central area of the painting. But no tampering with the surface-layer could succeed in destroying the magic power of the original picture; it still continued to exert its overwhelming effect on the spectator. One of the finest testimonies we possess is the verdict of Rubens, which has come down to us through Roger de Piles:

'He [Leonardo] allowed nothing to escape him that could assist in the expression of the subject he had chosen. By the fire of his imagination and the strength of his judgement he exalted divine things through human things and was able to lend men every degree of worth up to the heroic.

'The finest example he has left us is the Last Supper which he painted in Milan. He has depicted each of the Apostles in the spot appropriate to him and the Lord in the place of honour in their midst, with no one constricting him or too near to him. His attitude is serious, and his arms lie free and at rest, to lend further emphasis to the impression of greatness. The Apostles, on the other hand, move this way and that in the violence of their unrest, which yet shows no trace of vulgarity or of offence against good order. In a word, as a result of deep thought he has attained such a degree of perfection that it seems to me impossible to speak in adequate terms of his work, let alone imitate it.'[11]

A century later the painting was still a main objective of all visitors to northern Italy. By then the repeated attempts at restoration had almost totally effaced the original – though the restorers appear to have gone on undaunted with their retouchings and repaintings. The Irish painter James Barry gives a vivid description of their recent handiwork in 1770. 'This glorious work of Leonardo is now no more', he declared in one of his Academy lectures.

'I saw the last of it at Milan; for in passing through that city, on my return home [in 1770] I saw a scaffold erected in the Refettorio, and one half of the picture painted over by one Pietro Mazzi; no one was at work, it being Sunday, but there were two men on the scaffold, one of whom was speaking to the other with much earnestness about that part of the picture which had been re-painted. I was much agitated, and having no idea of his being an artist, much less the identical person who was destroying so beautiful and venerable a ruin, I objected with some warmth to the shocking ignorant manner in which this was carried on, pointing out at the same time the immense difference between the part that was untouched and what had been re-painted. He answered, that the new work was but a dead colour, and that the painter meant to go over it all again. Worse and worse, said I: if he has thus lost his way when he was immediately going over the lines and features of Leonardo's figures, what will become of him when they are all thus blotted out, and when, without any guide in repassing over the work, he shall be utterly abandoned to his own ignorance. On my remonstrating afterwards with some of the friars, and entreating them to take down the scaffold and save the half of the picture which was yet remaining, they told me that the convent had no authority in this matter, and that it was by the order of the Count de Firmian, the Imperial Secretary of State. Thus perished one of the most justly celebrated monuments of modern art, particularly for that part of design which regards the skilful delineation of the various sentiments of the soul, in all the diversities of character, expression of countenance, and of action.'[12]

Barry's protests appear to have been more successful than he realized. For it may possibly have been his intervention that persuaded the new Prior of the monastery, Paolo Gallieri, to prevent Mazza from continuing his unfortunate work by the simple expedient of removing the scaffolding (see Appendix 3).

Towards the end of the eighteenth century, continuing admiration of the great work gave rise to the feeling that something should be done to save it. Historical interest in the great masters of the

Renaissance stimulated by classicism encouraged in the case of Leonardo various attempts to preserve his most important creation, *The Last Supper*, for posterity. In 1789, on behalf of Louis XVI of France, André Dutertre began to study *The Last Supper*. In 1794 he entered his 'reconstruction' in the form of a small-scale gouache, the fruit of many years' work for the 'Prix de Dessin' of the – by then Republican (!) – Louvre and was awarded the prize. This work [5], in my opinion the best existing copy of Leonardo's picture, only became known again in 1958, when it came into the possession of the Ashmolean Museum at Oxford.[13] The same impulse was responsible for the numerous other efforts made at that time to produce a faithful copy of *The Last Supper*, in particular Giuseppe Bossi's great undertaking, which prompted Goethe's essay, one of the finest of all literary tributes to Leonardo's painting (see Appendix 2). Other moves in the same direction were the studies by Andrea Appiani and Teodoro Matteini, and the anonymous Weimar series of Apostles' heads. These efforts culminated in the copper engravings by Raphael Morghen [6] and Giacomo Frey (1803).[14]

5. Copy of *The Last Supper*, 1789–94. André Dutertre

6. Engraving after *The Last Supper*, 1800. R. Morghen

Simultaneously with these historical studies and attempts at a faithful imaginary reconstruction of Leonardo's picture, new restoration campaigns were begun to preserve the work itself. It had passed through a dangerous period following the entry of French troops into Milan in 1796. According to the story of an eye-witness, Padre Giuseppe Antonio Porro, Napoleon himself intervened to protect it. After visiting the by then suppressed monastery and seeing *The Last Supper*, he scribbled an order on his knee before mounting his horse – 'che quel luogo fosse rispetato, né vi si desse alloggio militare o vi facesse altro danno'[15] (that this place be respected and that it neither be used as a barracks nor be misused in any other way). But his orders were not obeyed. The monastery became successively quarters for officers, troops and prisoners: the refectory was used as a magazine, a stable and a hay-store, and *The Last Supper* received rough treatment. Only after the establishment of the Italian Republic in 1802 were efforts made to take proper care of the room and paint-

ing. The painter Andrea Appiani, then Commissioner of Fine Arts
for Lombardy, was charged with the supervision of the work. But
at first repairs were limited to the structure of the refectory itself.
Later, in 1807-9, Giuseppe Bossi executed his full-scale copy of the
painting (destroyed in the Second World War). The restoration of
The Last Supper proceeded by fits and starts from 1819 to 1823 and
then again in 1854-5 under Stefano Barezzi. These restorations went
on through the century and form a chapter of their own in the history
of restoration techniques (see Appendix 3). Efforts made at the
beginning of the twentieth century to rescue the painting from
further decay also had little success. It was these attempts at con-
servation, undertaken as they were with little confidence, that in-
spired Gabriele d'Annunzio's ode 'On the Death of a Masterpiece'.[16]

In 1924 a new restoration was carried out, which once again con-
sisted mainly in anchoring the loosening layer of colour. Nothing
could be done about the basic trouble – the tendency to humidity in
the supporting wall. Because of the media used by Leonardo it was
not possible to detach the painting and a slow decay seemed inevi-
table.

When, one August day in 1943, a bomb fell almost completely
shattering the great cloister of the church of S. Maria delle Grazie
and the surrounding buildings, it was thought for a moment that
Leonardo's *Last Supper* had perished with the refectory [7]. But, as
though by a miracle, it had survived. The iron framework of the
protective shield set up before the painting had acted as a support
for the wall, preventing it from collapsing and had thus preserved
the picture unscathed. Exemplary care for the preservation of his-
torical monuments had thus saved the work of art itself and soon
also restored the refectory.[17] Following the reconstruction of the
room it became possible to apply the latest methods of conservation
both to the painting and to the wall. Careful cleaning of the surface
laid bare large sections of original paint, so that as compared with
the pre-war condition the character of the work as a whole has been

7. The bombed refectory, 1943.
The Last Supper is behind
the sand-bags on the right

tremendously improved. It might have been expected that this most recent restoration, carried out under the direction of Mauro Pellicioli, completed in 1954 and involving the minute work of anchoring individually thousands upon thousands of particles of paint by means of a solution of shellac, would put a halt to further decay.[18] However, these hopes have not been realized; on the contrary, serious anxiety continues to prevail. Variations in temperature in the refectory and the inherent porosity of the wall, which still continues to absorb moisture, subject the painting to stresses which in the long run it cannot tolerate. The need to eliminate this dangerous situation confronts modern scientific techniques of restoration, which have recently made such amazing progress, with one of their greatest challenges.

3. Content and Form

Although *The Last Supper*, after all the hazards to which it has been exposed, now retains only a shadow of its original perfection, it nevertheless casts an overwhelming spell on all who see it. Monumental in size – it measures twenty-eight and a half feet by fifteen – it occupies the whole north end of the refectory. The setting in the picture is a continuation in perspective of the real room, so that Christ's table seems to be in the refectory itself; thus the Lord appears to share, as their 'spiritual Prior', the monks' own repast [8].

8. *The Last Supper*, Leonardo

In adopting this arrangement Leonardo followed and perfected a tradition developed in the course of the fourteenth and fifteenth centuries in connection with the rise of the great representative monastic buildings. Until then the Last Supper had usually appeared in sacred wall paintings as part of the Passion cycle, but in this period it emerges as an isolated scene and acquires a par-

ticular significance as a subject for refectories.[19] When he began his task in Milan, Leonardo was doubtless perfectly familiar with the theme through its frequent use on painted panels and predellas

10. Fragment of *The Last Supper*, *c.* 1365. Orcagna

11 (above right). *The Last Supper Crucifixion, Entombment and Resurrection*, *c.* 1450. Castagno

and in carved altars, and he must have had in mind the several important examples of the monumental treatments of the subject then to be seen in Florence. The scene had been painted in the monastery of S. Croce by Taddeo Gaddi about 1350 [9], for S. Spirito by Orcagna about 1365 [10], by Andrea del Castagno about 1450 in S. Apollonia [11] and, in 1480, by Domenico Ghirlandaio in the

convent of Ognissanti [12]. The version in the convent of S. Marco was painted in the 1480s when Leonardo had already left Florence for Milan. But it is possible that Leonardo had also seen the beautiful early version of the subject [13] produced in the seventies by Domenico Ghirlandaio and his brother Davide for the refectory of the Badia (Abbey) of Passignano.[20] Yet if one compares Leonardo's preparatory studies and his finished painting with these works, only the very slightest traces of a possible relationship can be detected. Leonardo may have recalled some types of the Apostles; for example, the gesture of Simon with outstretched hands at the right end of the table is prefigured in Gaddi's painting; Philip's hands are similarly brought together in front of his chest in Ghirlandaio's

12 (*opposite*). *The Last Supper*, 1480. Domenico Ghirlandaio

13. *The Last Supper*, c. 1470–79. Domenico and Davide Ghirlandaio

fresco in Ognissanti; and Leonardo's Peter in the Albertina draw-
ing [14] (almost identical with the Windsor study no. 12542) re-
sembles the left-hand outer Apostle at Passignano [15]. Finally, the
gesture of Andrew, with raised hands as if to avert something, is
twice employed by Castagno's Apostles [16]. But these correspon-

dences – in so far as they have any relevance – only serve to show
all the more clearly what life and spirituality these various motifs
acquire in Leonardo's work.

14. Study for St Peter,
c. 1495. Leonardo

15. Detail of 13

The use of perspective which Leonardo would have observed
already in Castagno's scene, and even more so in Ghirlandaio's,
undergoes a similar transformation. With bold logicality he employs
and develops it to create an apparent extension of the real room and
thus endows the mere illusionistic effect with symbolic content.
One may go further, for Leonardo seems to have determined the
outer limits of his pictorial space according to mathematical pro-

16. Detail of 11

portions which correspond to the harmonic ratios of music. Recently a very searching and stimulating analysis of the space construction of *The Last Supper* [21] has suggested that Leonardo observed the ratio $12:6:4:3$ or $1:\frac{1}{2}:\frac{1}{3}:\frac{1}{4}$. Thus, it appears that he used numerical proportions which are identical with the Pythagorean intervals in the sense of a *musica mundana* as they are treated by Leonardo's musician friend, Franchino Gafurio, in his *Theorica musice* printed in 1492 – and as they were to appear in a woodcut in his slightly later *Angelicum* [17] printed in 1508, and, nearly twenty years later, in the well-known Pythagorean tablet in Raphael's *School of Athens*.

17. Woodcut from Franchino
Gafurio, *Angelicum*, 1508

18 (*opposite*). *Agape*,
wall painting, late second century.
Rome, catacombs

19 (*below right*). *The Last Supper*,
sixth century Ms. Rossano

Since Leonardo painted no other comparable interior scene the
pictorial space of *The Last Supper* would be a unique case, by which
he endowed *prospettiva* – that almost obsessional preoccupation of
contemporary art-theorists – with an altogether new and wider
dimension: that of the *harmonia perfecta maxima*.

In its content Leonardo's painting shares only its theme with
earlier pictures known to him; in his conception and pictorial treat-
ment of the subject he treads a completely new path. In order to
gauge the full significance of the new interpretation given by Leon-
ardo to the episode described in the Gospel it will be useful to
glance back at the historical development of the iconography of the
Last Supper.

From the start, representations of the Last Supper – the earliest
versions of the subject are inspired by scenes showing the *agape* or
'love feast' in Early Christian catacomb paintings [18] and begin to
appear round the end of the fifth and beginning of the sixth century

20. *The Last Supper*,
early sixth-century mosaic.
Ravenna

[19, 20] – clearly show the desire to illustrate simultaneously the
two main ideas handed down in the Gospel texts: a reference to the
Passion in the announcement of the betrayal, and the inauguration
of the sacrifice of the New Covenant.[22] Where the Last Supper
forms part of a Passion cycle, two particular iconographic motifs
emerge and are stressed. On the one hand the identification of the
traitor Judas is established by specific gestures described in the
Gospels. Christ gives Judas a piece of bread: 'Jesus answered, He
it is, to whom I shall give a sop, when I have dipped it. And when
he had dipped the sop, he gave it to Judas Iscariot, the son of Simon'
(John xiii, 26). Judas puts his hand in the dish: 'And he answered
and said, He that dippeth his hand with me in the dish, the same
shall betray me' (Matthew xxvi, 23); or rests it on the table: 'But,
behold, the hand of him that betrayeth me is with me on the table'
(Luke xxii, 21). Sometimes the evil spirit is shown entering into
Judas in the form of a bird or monster [21, 22, 23]: 'And after the
sop, Satan entered into him. Then said Jesus unto him: That thou

21. *The Last Supper,*
c. 1250–1300 Mosaic.
Florence, Baptistery

22. *The Last Supper*, sixth–century
Byzantine Ms. Milan,
Biblioteca Ambrosiana

23. *The Last Supper*,
twelfth century, Volterra

24. *The Last Supper*,
c. 1303–13. Giotto

doest, do quickly' (John xiii, 27). In contrast – as a sort of counter-motif to this indication of the betrayal – we find the tender group consisting of John reclining his head against the breast of the Lord: 'Now there was leaning on Jesus' bosom one of his Disciples, whom Jesus loved' (John xiii, 23). This gives the composition a centre of tension both in form and content.

It was this pictorial tradition, familiar to Leonardo from his pre-decessors in Florence, that was also his point of departure as he took up his task. It is significant that he should have ignored another equally widespread and long-established iconographical composi-tion. I refer here to the arrangement of the disciples round a circular or square table, as developed by Giotto from medieval models [24] and also used with variations by Duccio in the Maestà and later by Sassetta in his picture of the Last Supper [25]. Leonardo could even have seen a derivative of this type outside the gates of Milan in the

25. *The Last Supper*, 1423–6. Sassetta

38

Abbey of Viboldone [26].[23] The necessity in this kind of composition of depicting some of the disciples somewhat thanklessly from behind must have been in direct opposition to Leonardo's desire for an expressive and well differentiated characterization of each of the Apostles; and in general it must have seemed to him that it would provide an inadequate opportunity for exploiting the dramatic ele-

26. *The Last Supper*, late fourteenth century, Viboldone

27 (*opposite*). *The Last Supper*, *c.* 1448–61. Fra Angelico

ment. Leonardo also disregarded the lyrical conception to be found in Fra Angelico's paintings of this subject: the calm scene of the 'Apostles' Communion' on the wall of one of the cells in the monastery of San Marco, Florence, and the small, tenderly painted panel in the Passion cycle on a sacristy cupboard [27] executed for

GNVM EIVSDEM ANNI INMACVLATVM FACIET SACRIFICIVM EÇECHIEL·XLVI·

PARAVERVNT PASCA 7 CVM ESSET HORA DISCVBVIT ÿHS 7 DVODIM DISCIPVLI. LVCE·XXII·

NE TIME A QVIA TECV̄ SVM EGO DEVS CONFORTAVI TE· YSAIE·XXXXI·

the church of SS. Annunziata, Florence (now in the Museo di San Marco, Florence).[24]

Leonardo's first preliminary studies for the composition, namely the drawing at Windsor (12542 r) [28] and the sheet in Venice [29]

28 (*opposite*). Study for *The Last Supper*, *c.* 1495–7. Leonardo

29 (*above*). Study for *The Last Supper*, *c.* 1495–7. After Leonardo

(the authenticity of which is disputed, but it was unquestionably produced in his studio) testify that his conception of the theme was completely dominated by the idea of bringing out the announcement of the betrayal as the dramatic central motif. In the Windsor sketch we recognize on the right the traditional central group: John, his head almost touching the table and leaning against the breast of the Lord, and Christ about to dip his hand in the dish together with

Judas, who is rising from his seat [30]. In the upper left sketch the group at the table is enlarged [31]. We can count eleven figures, each one of whom repays study, especially as these Apostles largely correspond to the types as planned by Leonardo and described in one of his note-books:[25]

'One who was drinking has left his glass in its position and turned his head towards the speaker. Another twists the fingers of his hands together and turns with a frown (con rigide ciglia) to his companion. Another with hands spread open showing the palms, shrugs his shoulders up to his ears and makes a grimace of astonishment (fa la bocca della maraviglia). Another speaks into his neighbour's ear and the listener turns to him to lend an ear, while he holds a knife in one hand and in the other the loaf half cut through by the knife; and in turning round another, who holds a knife, upsets with his hand a glass on the table.'

A BC D E F G H I J K

On the Windsor drawing the figures from left to right comprise: (A) a bearded man with head turned to the right, his right hand raised with outstretched forefinger and in his left hand a knife (Peter? This figure is very similar to the drawing of St Peter in Vienna [14]); (B/C) the group consisting of Christ and John, only faintly indicated but corresponding perfectly to the detail sketch alongside; (D) a bearded figure turning to the left with a cup in his raised hand; (E/F) a group of two: the man sitting behind bends over to the one in front who rests his arms with clasped hands on the table, a gesture which Leonardo might have known from Castagno's picture; (G) Judas, on the near side of the table stretching his arm out towards the dish; (H/I/J) a group of three, one of whom leaning back, turns his head to his bearded neighbour, into whose ear the third whispers; (K) a man sitting at the end of the table, raises a piece of bread or a cup to his mouth.

It is only in making a detailed examination of this drawing – the one belonging to the Venetian Academy [29] is a variation on the same theme[26] – that we are able to appreciate the radical alteration which distinguishes Leonardo's final composition from all earlier pictures of the Last Supper. This alteration consists in the attempt to arrange the Apostles no longer individually or in pairs beside each other but in interconnected and expressive groups.[27] As a result, in comparison with earlier or even with almost contemporary versions [32], Leonardo's scene is endowed with much more drama and

movement and is thereby significantly enhanced. Now it is highly revealing for Leonardo's free use of certain forms of expression of his own invention that in these first sketches for *The Last Supper* he quite openly adopts and remoulds an idea that he had already conceived many years earlier in a quite different context. Among his designs for the altarpiece of the *Adoration of the Magi* in the Uffizi, begun in 1481 in Florence and left behind there unfinished, a sheet in the Louvre shows a background scene of servants from the Magi's retinue conversing at table, three of them forming an integrated group [33]. It is noteworthy that below this group, and obviously

32. *The Last Supper*, *c.* 1485–90. Sansovino

33 (*opposite*). Sheet of studies, *c.* 1481. Leonardo

therefore arising out of the same thought, there is a Christ pointing to his plate, the Christ of the Last Supper, who utters the words 'He that putteth his hand with me in the dish, the same shall betray me' (Matthew xxvi, 23).

A long road leads from this first early inspiration, which came to Leonardo when he was occupied with a totally different task, to the shaping of the present theme almost fifteen years later. We see from the grouping of the Apostles how persistently an artistic idea once conceived, although in an entirely different context, remained rooted in Leonardo's mind, and came again to the fore at the requisite moment, as if in response to a summons, to fulfil its new function.

However, between these preliminary studies and the execution of the picture a second, and more profound transformation of the basic idea took place. This was in the precise moment in the Gospel account which he chose to illustrate. What we see in the painting is not, as was usual, the dramatic instant of the traitor's identification, but the immediately preceding and even more significant moment: the first and to the disciples still mysterious reference to treachery: 'Amen dico vobis quia unus vestrum me traditurus est' – 'Verily I say unto you that one of you shall betray me'.[28] In the Gospel (Matthew xxvi, 21) it goes on to say 'And they were exceeding sorrowful, and began every one of them to say unto him, Lord, is it I?' This is expanded in John xiii, 22 ff: 'And the disciples looked one on another, doubting of whom he spake. Now there was leaning on Jesus' bosom one of his disciples, whom Jesus loved. Simon Peter therefore beckoned to him, that he should ask who it should be of whom he spake.'

This new and truly great idea must have occurred to Leonardo from his own direct study of the Gospels. We possess no preparatory drawing of the composition as a whole that has any bearing on this decisive alteration, while on the other hand all the detail studies for the Apostles' heads, with the exception of the Vienna St Peter

which belongs to the first project [14], correspond with the finished painting [34] and thus also with the new conception. Leonardo appears to have been the first to have chosen this shattering moment,

34. *The Last Supper*, 1494–8. Leonardo

the first indication of the betrayal *before* the identification of Judas, as a theme for his Last Supper, and he thereby shifted the whole emphasis from the outward effect (the identification of Judas) to the inner motivation, the prophetic words needed to produce the result. Every expression and every gesture, each individual figure or group is related to this most tense moment and gains thereby in content and meaning. But at the same time the composition – freely and naturally though it seems to fit together – observes a strict, carefully thought-out arrangement that takes account of the company of the disciples as a whole and of their relations to each other and among themselves down to the last detail. Thus all the twelve

35 (*opposite*). Judas, St Peter
and St John,
detail from *The Last Supper*

36. Study for Judas,
1494–7. Leonardo

37. Study for the hands
of St John, 1494–7. Leonardo

38 (*below right*). Study for the arm
of St Peter, 1494–7. Leonardo

Apostles, again for the first time in the centuries-old history of pictures of the subject, are individually distinguished one from another, not just by the indication of their names or by outward attributes but by the portrayal of their specific qualities as they are known to us from the Gospels, the liturgies of their feasts and from legend.[29]

Let us call to mind the groups and individual figures: to the left of Christ sit first John and, prompting him, Peter, while Judas leans backward between them [35, 36, 37, 38]. Next comes Andrew, Peter's brother, then James the Greater, the elder brother of John; he touches Peter's shoulder and thus forms a link with Peter and John. These are the true Apostles who witnessed the Transfiguration

39 (*left*). St Bartholomew, detail from *The Last Supper*

40 (*above*). Study for St Bartholomew, 1494–7. Leonardo

41 (*opposite*). St Thomas, St James the Less and St Philip, detail from *The Last Supper*

and who accompanied Jesus to the Garden of Gethsemane (Matthew xvii,1 and xxvi, 36–7). At the end of the table stands Bartholomew, the steward [39, 40]. To the right of Christ sits James the Less, 'the Lord's brother' (Galatians i, 19), like him in feature and also with outspread arms, though his gesture is only a reaction, whereas in Christ it is the expression of a just completed action itself. Behind James the Less stands the doubting Thomas with upraised finger, and alongside him Philip, who, when supper was over joined with Thomas (according to John xiv, 5–8) in putting questions to Jesus [41, 42, 43]. James and Philip have also a link, in that they share a common feast-day.

42 (*left*). Study for St James the Less,
1494–7. Leonardo

43 (*above*). Study for St Philip,
1494–7. Leonardo

44 (*opposite*). St Matthew, St Jude
and St Simon,
detail from *The Last Supper*

This **group is** followed by St Matthew, **and** lastly **come** St Jude,
brother of James the Less, and St Simon [44]; these two disciples
were martyred together so that they too have a single feast. Thus
not only are the Apostles arranged in four groups, according to

45 (*opposite*). Christ,
detail from *The Last Supper*

46. Detail from a copy of
The Last Supper, *c*. 1510–14

47. *Head of Christ*.
Follower of Leonardo

48. *Head of Christ*.
Follower of Leonardo

kinship and the personal links between them, but each of the twelve, taken individually, also exhibits an emotional and temperamental reaction appropriate to the character attributed to him in the Gospel text. Goethe (see Appendix 2) gives such a masterly interpretation of what is taking place that we can confine ourselves to the bare essentials.

Christ has uttered the words: 'Verily, verily, I say unto you that one of you shall betray me!' The Apostles are horrified; among his shocked and questioning disciples only Christ remains tranquil and composed. And so we see him [45, 46, 47, 48] – in the midst of his most faithful followers, who are after all only men, able to grasp the external event but without understanding its inner meaning – as the suddenly isolated God, alone in the knowledge of his destiny which only he can see as sacrifice and mystery. All the disciples react, each in his own way, as men. Their excitement increases to right and to left; the wave of emotion – expressing itself both in bodies and hands – moves outward and at the same time back to the centre.[30] Engulfing all but Christ, it leaves only one other unaffected: Judas. Remaining outside the circle of those innocently smitten, he, who alone shares the secret with Christ, is the second lone figure in

49. *The Adoration of the Magi, c.* 1481. Leonardo

the picture; but his isolation is due to guilt. Even though as yet they know nothing of his guilt, he is an outcast from the community, although outwardly he remains in close contact with them. He is more clearly abandoned than any earlier picture of the Last Supper had ever been able to express, although these do put Judas in emphatic isolation. He is the only one who sits in shadow; his sombre profile stands out darkly against the bright heads of the two favourite disciples, Peter and John, and the fateful connection with Christ, expressed in the hands that approach each other as well as in Judas's look, becomes at the same time an unbridgeable gulf. In such subtle differentiation of the characters of each Apostle Leonardo's art of expression reaches its climax. Here we are once again reminded of his great *Adoration of the Magi* [49] where his endeavour to grasp and represent the 'motions of the mind by gestures and movements' is manifested for the first time, particularly in the group of shepherds. Leonardo was deeply concerned with the problem of expression in art. And he committed some of his thoughts about it to paper:

'The movement of men are as varied as are the emotions which pass through their minds. And each emotion moves men more or less, depending on its greater or lesser force, and also on the age of the man, for in the same situation a young man will act otherwise than an old one.'

'Mental stimuli or thoughts produce in the body simple and easy action, and not great coming and going, for the object of attention is in the mind which, concentrated upon itself, does not direct the senses to bodily expression.'

'Emotions move the face of man in different ways, for one laughs, another weeps, one becomes gay, another sad, one shows anger, another pity, some are amazed, others are afraid, distracted, thoughtful or reflective. In these states the hands and the whole person should follow the expression of the face.'

50 and 51. Detail of 49

These passages from Leonardo's *Treatise on Painting* might almost be read as a commentary on his own pictorial work. In facial expression and gesture the figures of the *Adoration* reflect all degrees of human feelings [50, 51]; but this multitude of juxtaposed faces is fused into a 'polyphony of emotion' which expresses a unity of wonder [52]. A similar 'polyphony of emotion' is again evident in the figures of the Apostles in *The Last Supper* [53]. In the differentiation of their individual features various 'emotions which pass through their minds' coalesce into a like unity. At the same time

each individual figure forms an integral part of mankind's response
to the words spoken by Christ.

Yet Leonardo's pictorial concept is not exhausted with the
portrayal of this dramatic moment of the announcement of the

52. Detail of 49

betrayal. On the contrary this 'episode' is only the framework designed to direct our thoughts to the essential meaning of the sacred scene, the institution of the eucharistic sacrifice.[31] The dominant position of Christ is impressively emphasized by the empty space

53. Detail of *The Last Supper*

around him ('with no one crowding him, no one too close at his side', as Rubens says) and by the wonderful background motif of the pedimented doorway, which frames his figure against the view out into the countryside. Jesus lets both hands rest on the table: his left hand – lying between the cup and the still unbroken bread – seems to point with this silently expressive gesture to the bread

54. Detail of copy of
The Last Supper,
1794. André Dutertre

55 (*opposite*).
Detail of *The Last Supper*

and wine. His countenance and glance follow the same direction, thereby leading our attention also to the centre of action. And here we note another curious thing: the orderly arrangement of the objects on the table in front of Christ [54, 55]; immediately to the left and right of him they begin to fall into disarray.[32] Thus the space before the Lord is prepared, so to speak, for the sacred action which Christ – rising above the wave of emotion still seething round him among the disciples – is making ready to accomplish, submissive and sublime in the divine resolve, still hidden from his human companions, to offer himself as a sacrifice.

Thus in Leonardo's composition the age-old striving to combine the event of the Passion with the institution of the sacrament finds a new and uniquely effective solution.[33] Never has the symbolic element in this event been represented more humanly, more nobly or more simply. Deep insight into humanity and the ways in which its various qualities find expression was needed – and here we re-

call once again the words of Rubens – to express this in the figures
of the Apostles with such rich variety and force. Apart from the two
preparatory sketches for the composition as a whole, the studies for
the Apostles' heads are the only remaining evidence for Leonardo's
preliminary work, although it must certainly have been unusually
intensive.

So far we have spoken exclusively of the content of the work, but
its fame rests equally on its perfection of form. Leonardo's *Last
Supper* is a masterpiece of composition on a monumental scale.

The scene is set in a relatively confined space. The figures who
throng round the table are mighty ones; if they were to rise there
would not be room enough for them. A principle of classical com-
position is here applied for the first time: the figures are oversized
in relation to the surrounding space. It is true that the setting is
strictly 'correct' from the standpoint of perspective construction:
the simulated extension of the refectory demanded tectonically clear
and unambiguous architecture for the room. Squaring of the floor,
a coffered ceiling, tapestries on the walls, articulation of the window
and the table are the apparently simple but in fact very carefully
thought-out means adopted to produce this effect. An artistic de-
vice is used here which completely changes the relation between the
group of figures and the surrounding space without offending
against the laws of perspective construction: the painted border
surrounding the scene cuts so much off the ceiling and also the side
walls that the table and figures appear to spring forward *in front of*
the setting and thus seem to form part of the refectory itself. This
artistic device is accompanied by another: the figures are not ar-
ranged in accordance with the vanishing line of the architecture;
on the contrary each figure or group is depicted as if it had its own
frontal plane and were being looked at *en face*. Besides these two
modifying factors Leonardo made use, as we have seen, of over-
sized figures. Within the given space they possess a supernatural
size; their existence seems to demand more room than they have at

their disposal. And it is this space-demanding force, implicit in their movements, which is one of the causes underlying the picture's monumental effect.

The careful application of the laws of geometrical perspective is complemented and heightened by the perspective of atmosphere and colour that Leonardo never tires of developing and expounding in his *Treatise on Painting*.

'The first task of painting is that the objects it presents should appear in relief, and that through the use of the three perspectives, the backgrounds surrounding them with their several distances should appear to be contained within the wall on which the painting is created. These perspectives are diminution of the forms of objects, diminution of their magnitudes, and diminution of their colours. The first of these three perspectives originates in the eye; the other two derive from the air lying between the eye and the objects seen by the eye. The second task of painting is to create actions and varied postures appropriate to the figures, so that the men do not look like brothers.'

'If we see that the true quality of colours is known through light, it is to be concluded that where there is more light, the true quality of the illuminated colour is better seen; and where there is more darkness, the colour is tinged with the colour of that darkness. Therefore, painter, remember to show true colour in the illuminated parts of your painting.'

'Nothing ever looks to be its real colour, if the light which strikes it is not all of that colour.

'This assertion is demonstrated in the colours of draperies, where the illuminated sides of folds reflect and give light to the shadowed folds opposite, making them show their true colour. The same thing is done with the bay leaf when one colour gives light to another, and the contrary results when light is taken from another colour.'

'No colour that is reflected on the surface of another body will tinge that surface with only its own colour, but it will mingle with

the concurrence of the other reflected colours which rebound on the same place.'

Among the benefits of the most recent restoration of *The Last Supper* has been the invaluable gain that Leonardo's great skill with colour now exerts a direct and strong effect, even from the little that remains of the picture's original condition. The room lies in a muted yet clear illumination. There are two sources of light: the last gleams of the dying day, which enter from behind through the window with its charming view of the countryside; and the light coming from the left in front – from the window of the refectory itself. This makes it possible for Leonardo to give his group of figures, which stands between, so to speak, these two zones of light, a very finely graduated relief. His coloration is in the highest sense 'painting in tones of light'. The colours of Christ's garments – red tunic, blue cloak – are both reflected in the pewter plate in front of him; similarly the plate in front of Philip reflects the red of his cloak. The colours of the Apostles' robes are distributed across the painting in a wonderful gradation. To the right of Christ the pale green tunic of James the Less forms a transition between Christ's blue cloak and the red one of Philip, whose blue sleeves are a carefully considered shade brighter than the tone of Christ's cloak. In the second group on the right Matthew is clothed in bright blue, which together with Jude's ochre tunic and the carmine-violet shot effect of Simon's cloak forms a perfect three-note chord. The *changeant* robes of Simon anticipate the painting of Andrea del Sarto. A figure such as this shows him to have been heir to Leonardo in his use of colour.

In the group to the left of Christ, consisting of John, Peter and Judas, the traitor's isolation is also emphasized by the blending of colours: his grey-blue garment is the only one whose tone remains indefinite and dull; it forms an effective contrast to the strong hues of John's dark, rust-red cloak and bluish-green tunic and to the powerful dark blue of Peter's sleeve (over a little piece of carmine-coloured cloak behind the knife). In the outer left-hand group, which

stands in front of a darker background, even richer shades of colour are employed: Andrew, with a green cloak over a golden yellow undergarment, James the Greater, in reddish clothing, and Bartholomew, in a violet-blue tunic and dark olive cloak, form, in their stronger coloration, a carefully weighed equivalent to the outer right-hand group which stands in brighter light.

Thus the colours pass over from the pure primary tones in the clothing of Christ into increasingly subtle blends on each side; at each end they reach colour values soon afterwards to become characteristic of early Cinquecento painting in Florence – the phase in which the principles of the classical High Renaissance style were evolved.

Only now since the last restoration of *The Last Supper* has it become possible for us to understand fully the unbounded admiration expressed by the hyper-critical Florentines for Leonardo's mastery when, after his return there from Milan, he began to paint his *St Anne, Madonna and Child*.[34] It was the luminosity of his colours that became a model for the younger generation of artists, together with his perfect 'relievo' and 'sfumato', i.e. that mode of painting in the most delicate gradations of light and shade which lends substance to a picture painted on a flat surface. For it is on the interplay of light and colour, bright and dark, that a picture depends for its three-dimensional sculptural values, which in turn ensure its "naturalness' – the highest demand of contemporary artistic theory.

According to Leonardo this 'naturalness' also demands in the end – and here we come back once again to his art of expression – that 'harmony between mental and physical motion', as we have already seen.

This correspondence between physical movement and mental emotion is perfectly achieved in the scene of the Last Supper. The momentary pause between two great emotions – the horror of being startled out of tranquillity, the momentary stiffening at the extreme point of excitement, about to dissolve again at once into the cross currents of differing emotions – this 'transitory moment' between

a preceding and a following action is fixed pictorially in a perfect form. The gradations of mimicry and gesture, of expression and emotion, the combination of types that complement each other in their outward or inward reactions – all this unites formal and thematic values in that perfection of effect which assured *The Last Supper* the unique fame which it has retained until this day.

This fame is attested not so much by the innumerable reproductions and – mostly somewhat weak – variations of the painting which begin with Leonardo's immediate successors, reach well into the Cinquecento and extend to France and the Netherlands, but rather by those works of great artists which are modelled on the 'Idea' of Leonardo's picture. We are not thinking so much of pictures like Andrea del Sarto's lively scene in S. Salvi [56], greatly as it is in-

56. *The Last Supper*, *c.* 1520–25. Andrea del Sarto

debted to Leonardo and which in its turn influenced Raphael's composition as we know it from the engraving by Marc Antonio Raimondi. One can feel his influence more strongly in Titian's pathos-filled *Last Supper* in the Escorial [57]. But it is above all two of the great masters of Northern Europe who should be named here.

57. *The Last Supper*,
1564. Titian

Albrecht Dürer, in his late woodcut of 1523 [58], has given us one of the most striking and original variations on Leonardo's theme; and one which can be understood in a specifically Lutheran context[35]; and secondly the impressive and deeply moving drawing by Rembrandt, who never saw the original and only knew it from mediocre engravings and drawings [59]. It is in this drawing that we certainly find the most beautiful and harmonious adaptation that Leonardo's work has ever undergone.[36]

Round about 1800 the last phase in the fame of *The Last Supper* began. The impulses mentioned earlier on gave rise to the famous engravings by Raphael Morghen [6] and Giacomo Frey, which made their way all over the world. They have been joined by the innumerable reproductions produced in subsequent periods.

58. *The Last Supper*, 1523. Dürer

59 (*opposite*). *The Last Supper*, *c.* 1635. Rembrandt

Thus Leonardo's *Last Supper* is one of the very few pictures of a Christian subject – perhaps the only one – that has become identified with its theme throughout the world. No other version, from Giotto through Raphael, Tintoretto, Rubens and down to Tiepolo, has been able to affect the absolute preeminence of Leonardo's achievement. His work has remained untouched by interdenominational strife and has maintained its effect unimpaired right down to the present.

Appendix 1:
The Gospel Accounts of the Last Supper,
from the Vulgate
and from the Douai Translation[37]

ST MATTHEW, CHAPTER XXVI, VERSES 20-30

20. But when it was evening, he sat down with his twelve disciples.

21. And whilst they were eating, he said: Amen I say to you, that one of you is about to betray me.

22. And they being very much troubled, began every one to say: Is it I, Lord?

23. But he answering, said: He that dippeth his hand with me in the dish, he shall betray me.

24. The Son of man indeed goeth, as it is written of him: but woe to that man by whom the Son of man shall be betrayed: it were better for him, if that man had not been born.

25. And Judas that betrayed him, answering, said: Is it I, Rabbi? He saith to him: Thou has said *it*.

26. And whilst they were at supper, Jesus took bread, and blessed, and broke: and gave to his disciples, and said: Take ye, and eat. This is my body.

27. And taking the chalice, he gave thanks, and gave to them, saying: Drink ye all of this.

28. For this is my blood of the new testament, which shall be shed for many unto remission of sins.

29. And I say to you, I will not drink from henceforth of this fruit of the vine, until that day when I shall drink it with you new in the kingdom of my Father.

30. And a hymn being said, they went out unto mount Olivet.

20. Vespere autem facto, discumbebat cum duodecim discipulis suis.

21. Et edentibus illis, dixit: Amen dico vobis quia unus vestrum me traditurus est.

22. Et contristati valde, cœperunt singuli dicere: Numquid ego sum, Domine?

23. At ipse respondens, ait: Qui intingit mecum manum in paropside, hic me tradet.

24. Filius quidem hominis vadit, sicut scriptum est de illo; væ autem homini illi, per quem Filius hominis tradetur! bonum erat ei, si natus non fuisset homo ille.

25. Respondens autem Judas, qui tradidit eum, dixit: Numquid ego sum, Rabbi? Ait illi: Tu dixisti.

26. Cœnantibus autem eis, accepit Jesus panem, et benedixit, ac fregit, deditque discipulis suis, et ait: Accipite, et comedite; hoc est corpus meum.

27. Et accipiens calicem, gratias egit, et dedit illis, decens: Bibite ex hoc omnes.

28. Hic est enim sanguis meus novi testamenti, qui pro multis effundetur in remissionem peccatorum.

29. Dico autem vobis: non bibam amodo de hoc genimine vitis, usque in diem illum, cum illud bibam vobiscum novum in regno Patris mei.

30. Et hymno dicto, exierunt in montem Oliveti.

ST MARK, CHAPTER XIV, VERSES 12-26

12. Now on the first day of the unleavened bread, when they sacrificed the pasch, the disciples say to him: Whither wilt thou that we go, and prepare for thee to eat the pasch?

13. And he sendeth two of his disciples, and saith to them: Go ye into the city; and there shall meet you a man carrying a pitcher of water, follow him;

14. And whithersoever he shall go in, say to the master of the house, The master saith, Where is my refectory, where I may eat the pasch with my disciples?

15. And he will shew you a large dining room furnished; and there prepare ye for us.

16. And his disciples went their way, and came into the city; and they found as he had told them, and they prepared the pasch.

17. And when evening was come, he cometh with the twelve.

18. And when they were at table and eating, Jesus saith: Amen I say to you, one of you that eateth with me shall betray me.

19. But they began to be sorrowful, and to say to him one by one: Is it I?

20. Who saith to them: One of the twelve, who dippeth with me his hand in the dish.

21. And the Son of man indeed goeth, as it is written of him: but woe to that man by whom the Son of man shall be betrayed. It were better for him, if that man had not been born.

22. And whilst they were eating, Jesus took bread; and blessing, broke, and gave to them, and said: Take ye. This is my body.

23. And having taken the chalice, giving thanks, he gave *it* to them. And they all drank of it.

24. And he said to them: This is my blood of the new testament, which shall be shed for many.

25. Amen I say to you, that I will drink no more of the fruit of the vine, until that day when I shall drink it new in the kingdom of God.

26. And when they had said an hymn, they went forth to the mount of Olives.

ST MARK, CHAPTER XIV

12. Et primo die Azymorum, quando pascha immolabant, dicunt ei discipuli: Quo vis eamus, et paremus tibi ut manduces pascha?

13. Et mittit duos ex discipulis suis, et dicit eis: Ite in civitatem, et occurret vobis homo lagenam aquæ bajulans, sequimini eum;

14. Et quocumque introierit, dicite domino domus, quia Magister dicit: Ubi est refectio mea, ubi pascha cum discipulis meis manducem?

15. Et ipse vobis demonstrabit cœnaculum grande, stratum; et illic parate nobis.

16. Et abierunt discipuli ejus, et venerunt in civitatem; et invenerunt sicut dixerat illis, et paraverunt pascha.

17. Vespere autem facto, venit cum duodecim.

18. Et discumbentibus eis, et manducantibus, ait Jesus: Amen dico vobis, quia unus ex vobis tradet me, qui manducat mecum.

19. At illi cœperunt contristari, et dicere ei singulatim: Numquid ego?

20. Qui ait illis: Unus ex duodecim, qui intingit mecum manum in catino.

21. Et Filius quidem hominis vadit, sicut scriptum est de eo; væ autem homini illi, per quem Filius hominis tradetur! Bonum erat ei, si non esset natus homo ille.

22. Et manducantibus illis, accepit Jesus panem, et benedicens fregit, et dedit eis, et ait: Sumite, hoc est corpus meum.

23. Et accepto calice, gratias agens dedit eis, et biberunt ex illo omnes.

24. Et ait illis: Hic est sanguis meus novi Testamenti, qui pro multis effundetur.

25. Amen dico vobis, quia jam non bibam de hoc genimine vitis, usque in diem illum, cum illud bibam novum in regno Dei.

26. Et hymno dicto, exierunt in montem Olivarum.

ST LUKE, CHAPTER XXII, VERSES 7–38

7. And the day of the unleavened bread came, on which it was necessary that the pasch should be killed.

8. And he sent Peter and John, saying: Go, and prepare for us the pasch, that we may eat.

9. But they said: Where wilt thou that we prepare?

10. And he said to them: Behold, as you go into the city, there shall meet you a man carrying a pitcher of water: follow him into the house where he entereth in.

11. And you shall say to the goodman of the house: The master saith to thee, Where is the guest chamber, where I may eat the pasch with my disciples?

12. And he will shew you a large dining room, furnished; and there prepare.

13. And they going, found as he had said to them, and made ready the pasch.

14. And when the hour was come, he sat down, and the twelve apostles with him.

15. And he said to them: With desire I have desired to eat this pasch with you, before I suffer.

16. For I say to you, that from this time I will not eat it, till it be fulfilled in the kingdom of God.

17. And having taken the chalice, he gave thanks, and said: Take, and divide *it* among you:

18. For I say to you, that I will not drink of the fruit of the vine, till the kingdom of God come.

19. And taking bread, he gave thanks, and brake; and gave to them, saying: This is my body, which is given for you. Do this for a commemoration of me.

20. In like manner the chalice also, after he had supped, saying: This is the chalice, the new testament in my blood, which shall be shed for you.

21. But yet behold, the hand of him that betrayeth me is with me on the table.

22. And the Son of man indeed goeth, according to that which is determined: but yet, woe to that man by whom he shall be betrayed.

23. And they began to inquire among themselves, which of them it was that should do this thing.

24. And there was also strife amongst them, which of them should seem to be the greater.

25. And he said to them: The kings of the Gentiles lord it over them; and they that have power over them, are called beneficent.

26. But you not so: but he that is the greater among you, let him become as the younger; and he that is the leader, as he that serveth.

27. For which is greater, he that sitteth at table, or he that serveth? Is not he that sitteth at table? But I am in the midst of you, as he that serveth:

28. And you are they who have continued with me in my temptations:

29. And I dispose to you, as my Father hath disposed to me, a kingdom;

30. That you may eat and drink at my table, in my kingdom: and may sit upon thrones, judging the twelve tribes of Israel.

31. And the Lord said: Simon, Simon, behold Satan hath desired to have you, that he may sift you as wheat:

32. But I have prayed for thee, that thy faith fail not: and thou, being once converted, confirm thy brethren.

33. Who said to him: Lord, I am ready to go with thee, both into prison, and to death.

34. And he said: I say to thee, Peter, the cock shall not crow this day, till thou thrice deniest that thou knowest me. And he said to them:

35. When I sent you without purse, and scrip, and shoes, did you want anything?

36. But they said: Nothing. Then said he unto them: But now he that hath a purse, let him take it, and likewise a scrip; and he that hath not, let him sell his coat, and buy a sword.

37. For I say to you, that this that is written must yet be fulfilled in me: *And with the wicked was he reckoned.* For the things concerning me have an end.

38. But they said, Lord, behold here *are* two swords. And he said to them, It is enough.

7. Venit autem dies Azymorum, in qua necesse erat occidi pascha.

8. Et misit Petrum et Joannem, dicens: Euntes parate nobis pascha, ut manducemus.

9. At illis dixerunt: Ubi vis paremus?

10. Et dixit ad eos: Ecce introeuntibus vobis in civitatem, occurret vobis homo quidam amphoram aquæ portans; sequimini eum in in domum, in quam intrat,

11. Et dicetis patrifamilias domus: Dicit tibi Magister: Ubi est diversorium, ubi pascha cum discipulis meis manducem?

12. Et ipse ostendet vobis cœnaculum magnum stratum; et ibi parate.

13. Euntes autem, invenerunt sicut dixit illis, et paraverunt pascha.

14. Et cum facta esset hora, discubuit, et duodecim apostoli cum eo.

15. Et ait illis: Desiderio desideravi hoc pascha manducare vobiscum, antequam patiar.

16. Dico enim vobis, quia ex hoc non manducabo illud, donec impleatur in regno Dei.

17. Et accepto calice, gratias egit, et dixit: Accipite, et dividite inter vos.

18. Dico enim vobis quod non bibam de generatione vitis, donec regnum Dei veniat.

19. Et accepto pane, gratias egit, et fregit, et dedit eis, dicens: Hoc est corpus meum, quod pro vobis datur; hoc facite in meam commemorationem.

20. Similiter et calicem, postquam cœnavit, dicens: Hic est calix novum testamentum in sanguine meo, qui pro vobis fundetur.

21. Verumtamen ecce manus tradentis me mecum est in mensa.

22. Et quidem Filius hominis, secundum quod definitum est, vadit; verumtamen væ homini illi, per quem tradetur.

23. Et ipsi cœperunt quærere inter se, quis esset ex eis, qui hoc facturus esset.

24. Facta est autem et contentio inter eos, quis eorum videretur esse major.

25. Dixit autem eis: Reges gentium dominantur eorum, et qui potestatem habent super eos, benefici vocantur.

26. Vos autem non sic; sed qui major est in vobis, fiat sicut minor; et qui præcessor est, sicut ministrator.

27. Nam quis major est, qui recumbit, an qui ministrat? nonne qui recumbit? Ego autem in medio vestrum sum, sicut qui ministrat.

28. Vos autem estis, qui permansistis mecum in tentationibus meis;

29. Et ego dispono vobis sicut disposuit mihi Pater meus regnum,

30. Ut edatis et bibatis super mensam meam in regno meo, et sedeatis super thronos, judicantes duodecim tribus Israel.

31. Ait autem Dominus: Simon, Simon, ecce Satanas expetivit vos ut cribraret sicut triticum;

32. Ego autem rogavi pro te ut non deficiat fides tua; et tu aliquando conversus confirma fratres tuos.

33. Qui dixit ei: Domine, tecum paratus sum et in carcerem et in mortem ire.

34. At ille dixit: Dico tibi, Petre, non cantabit hodie gallus, donec ter abneges nosse me. Et dixit eis:

35. Quando misi vos sine sacculo, et pera, et calceamentis, numquid aliquid defuit vobis?

36. At illi dixerunt: Nihil. Dixit ergo eis: Sed nunc, qui habet sacculum, tollat, similiter et peram; et qui non habet, vendat tunicam suam, et emat gladium.

37. Dico enim vobis, quoniam adhuc hoc quod scriptum est, oportet impleri in me: Et cum iniquis deputatus est. Etenim ea, quæ sunt de me, finem habent.

38. At illi dixerunt: Domine, ecce duo gladii hic. At ille dixit eis: Satis est.

ST JOHN, CHAPTER XIII, VERSES 1-30

1. Before the festival day of the pasch, Jesus knowing that his hour was come, that he should pass out of this world to the Father: having loved his own who were in the world, he loved them unto the end.

2. And when supper was done, (the devil having now put into the heart of Judas Iscariot, the son of Simon, to betray him,)

3. Knowing that the Father had given him all things into his hands, and that he came from God, and goeth to God,

4. He riseth from supper, and layeth aside his garments, and having taken a towel, girded himself.

5. After that, he putteth water into a basin, and began to wash the feet of the disciples, and to wipe them with the towel wherewith he was girded.

6. He cometh therefore to Simon Peter. And Peter saith to him: Lord, dost thou wash my feet?

7. Jesus answered, and said to him: What I do thou knowest not now; but thou shalt know hereafter.

8. Peter saith to him: Thou shalt never wash my feet. Jesus answered him: If I wash thee not, thou shalt have no part with me.

9. Simon Peter saith to him: Lord, not only my feet, but also my hands and my head.

10. Jesus saith to him: He that is washed, needeth not but to wash his feet, but is clean wholly. And you are clean, but not all.

11. For he knew who he was that would betray him; therefore he said: You are not all clean.

12. Then after he had washed their feet, and taken his garments, being set down again, he said to them: Know you what I have done to you?

13. You call me Master, and Lord; and you say well, for so I am.

14. If then I being *your* Lord and Master, have washed your feet; you also ought to wash one another's feet.

15. For I have given you an example, that as I have done to you, so you do also.

16. Amen, amen I say to you: The servant is not greater than his lord; neither is the apostle greater than he that sent him.

17. If you know these things, you shall be blessed if you do them.

18. I speak not of you all: I know whom I have chosen. But that the scripture may be fulfilled: *He that eateth bread with me, shall lift up his heel against me.*

19. At present I tell you, before it come to pass: that when it shall come to pass, you may believe that I am he.

20. Amen, amen I say to you, he that receiveth whomsoever I send, receiveth me; and he that receiveth me, receiveth him that sent me.

21. When Jesus had said these things, he was troubled in spirit; and he testified, and said: Amen, amen I say to you, one of you shall betray me.

22. The disciples therefore looked one upon another, doubting of whom he spoke.

23. Now there was leaning on Jesus' bosom one of his disciples, whom Jesus loved.

24. Simon Peter therefore beckoned to him, and said to him: Who is it of whom he speaketh?

25. He therefore, leaning on the breast of Jesus, saith to him: Lord, who is it?

26. Jesus answered: He it is to whom I shall reach bread dipped. And when he had dipped the bread, he gave it to Judas Iscariot, *the son* of Simon.

27. And after the morsel, Satan entered into him. And Jesus said to him; That which thou dost, do quickly.

28. Now no man at the table knew to what purpose he said this unto him.

29. For some thought, because Judas had the purse, that Jesus had said to him: Buy those things which we have need of for the festival day: or that he should give something to the poor.

30. He therefore having received the morsel, went out immediately. And it was night.

ST JOHN, CHAPTER XIII

1. Ante diem festum Paschæ, sciens Jesus quia venit hora ejus ut transeat ex hoc mundo ad Patrem, cum dilexisset suos, qui erant in mundo, in finem dilexit eos.

2. Et cœna facta, cum diabolus jain misisset in cor, ut traderet eum Judas Simonis Iscariotæ,

3. Sciens quia omnia dedit ei Pater in manus, et quia a Deo exivit, et ad Deum vadit,

4. Surgit a cœna, et ponit vestimenta sua, et cum accepisset linteum, præcinxit se.

5. Deinde mittit aquam in pelvim, et cœpit lavare pedes discipulorum, et extergere linteo, quo erat præcinctus.

6. Venit ergo ad Simonem Petrum. Et dicit ei Petrus: Domine, tu mihi lavas pedes?

7. Respondit Jesus, et dixit ei: Quod ego facio, tu nescis modo, scies autem postea.

8. Dicit ei Petrus: Non lavabis mihi pedes in æternum. Respondit ei Jesus: Si non lavero te, non habebis partem mecum.

9. Dicit ei Simon Petrus: Domine, non tantum pedes meos, sed et manus, et caput.

10. Dicit ei Jesus: Qui lotus est, non indiget nisi ut pedes lavet, sed est mundus totus. Et vos mundi estis, sed non omnes.

11. Sciebat enim quisnam esset qui traderet eum; propterea dixit: Non estis mundi omnes.

12. Postquam ergo lavit pedes eorum, et accepit vestimenta sua, cum recubuisset iterum, dixit eis: Scitis quid fecerim vobis?

13. Vos vocatis me: Magister, et Domine; et bene dicitis; sum etenim.

14. Si ergo ego lavi pedes vestros Dominus et Magister, et vos debetis alter alterius lavare pedes.

15. Exemplum enim dedi vobis, ut quemadmodum ego feci vobis, ita et vos faciatis.

16. Amen, amen dico vobis: Non est servus major domino suo; neque apostolus major est eo qui misit illum.

17. Si hæc scitis, beati eritis si feceritis ea.

18. Non de omnibus vobis dico; ego scio quos elegerim; sed ut adimpleatur Scriptura: Qui manducat mecum panem, levabit contra me calcaneum suum.

19. Amodo dico vobis, priusquam fiat, ut cum actum fuerit, credatis quia ego sum.

20. Amen, amen dico vobis: Qui accipit si quem misero, me accipit; qui autem me accipit, accipit eum qui me misit.

21. Cum hæc dixisset Jesus, turbatus est spiritu, et protestatus est, et dixit: Amen, amen dico vobis, quia unus ex vobis tradet me.

22. Aspeciebant ergo ad invicem discipuli, hæsitantes de quo diceret.

23. Erat ergo recumbens unus ex discipulis ejus in sinu Jesu, quem diligebat Jesus.

24. Innuit ergo huic Simon Petrus, et dixit ei: Quis est, de quo dicit?

25. Itaque cum recubuisset ille supra pectus Jesu, dicit ei: Domine, quis est?

26. Respondit Jesus: Ille est cui ego intinctum panem porrexero. Et cum intinxisset panem, dedit Judæ Simonis Iscariotæ.

27. Est post buccellam, introivit in eum Satanas. Et dixit ei Jesus: Quod facis, fac citius.

28. Hoc autem nemo scivit discumbentium ad quid dixerit ei.

29. Quidam enim putabant, quia loculos habebat Judas, quod dixisset ei Jesus: Eme ea, quæ opus sunt nobis ad diem festum; aut egenis ut aliquid daret.

30. Cum ergo accepisset ille buccellam, exivit continuo. Erat autem nox.

Appendix 2:
Goethe and Leonardo's Last Supper

Goethe saw Leonardo's *Last Supper* in May 1788 when he stopped in Milan on his way north on leaving Italy, but of course he already knew it well from copies. Indeed he had mentioned the previous year his hopes of arranging in Rome for a print to be made from a copy he had seen there. 'It would be the greatest blessing if a faithful reproduction could become available to a wide public.' After seeing the original he wrote to his friend and patron Duke Karl August of Weimar on 23 May 1788: 'Leonardo's *Last Supper* is truly a key-work in the sphere of artistic conceptions. It is quite unique and there is nothing that can be compared to it.'

His famous description of it was written almost thirty years later, being published in 1817 as part of a book review or rather essay: 'Joseph Bossi über Leonards da Vinci Abendmahl zu Mailand' in *Über Kunst und Alterthum*, III, Weimar, 1817.

The following translation is by G. H. Noehden and was first published in his *Observations on Leonardo da Vinci's Celebrated Picture of The Last Supper*. By J. W. de Goethe translated by G. H. Noehden, London, 1821. Noehden spent the winter of 1818–19 in Weimar and his translation was approved by Goethe: see Lavinia Mazzucchetti, *Goethe e il Cenacolo di Leonardo*, Milan, 1939.

THE LAST SUPPER

We now come to what is the particular object of our attention, The Last Supper of our Lord, which was painted upon the wall, in the convent *alle Grazie*, at Milan. If the reader will please to take before

him Morghen's print,* it will enable him to understand our remarks, both in the whole, and in detail.

The place, where the picture was painted, is first to be considered: for here the judgment of the artist appears to the greatest advantage. There is hardly a subject that could be fitter, and more becoming, for the refectory of a holy fraternity, than the parting meal, which was to be a sacred remembrance for all ages to come.

We have, in our travels, seen this refectory, several years ago, yet undestroyed. Opposite to the entrance, at the bottom, on the narrow side of the room, stood the Prior's table; on both sides of it, along the walls, the tables of the monks, raised, like the Prior's, a step above the ground: and now, when the stranger, that might enter the room, turned himself about, he saw, on the fourth wall, over the door, not very high, a fourth table, painted, at which Christ and his Disciples were seated, as if they formed part of the company. It must, at the hour of the meal, have been an interesting sight, to view the tables of the Prior and Christ, thus facing each other, as two counterparts, and the monks at their board, enclosed between them. For this reason, it was consonant with the judgment of the painter to take the tables of the monks as models; and there is no doubt, that the table-cloth, with its pleated folds, its stripes and figures, and even the knots, at the corners, was borrowed from the laundry of the convent. Dishes, plates, cups, and other utensils, were, probably, likewise copied from those, which the monks made use of.

There was, consequently, no idea of imitating some ancient and uncertain costume. It would have been unsuitable, in the extreme, in this place, to lay the holy company on couches: on the contrary, it was to be assimilated to those present. Christ was to celebrate his last supper, among the Dominicans, at Milan.

*Any other print would, of course, equally answer this purpose of reference. The smallest by Mocchetti would have suited the present publication, and I regret I am not furnished with a sufficient number of these prints, to give them as accompaniments. I have six of them, and can accordingly only supply with them so many copies. (Trans.)

In several other respects also was the picture calculated to produce a great effect. Being raised about ten feet* above the ground, the thirteen figures, exceeding by nearly one half the natural size, occupy the space of twenty-eight feet, Parisian measure, in length. Two of them only, at the opposite ends of the table, are seen entire: the rest are half figures, but even here the artist derived an advantage from the necessity of his situation. Every moral expression appertains only to the upper part of the body: the feet are, in such cases, generally in the way. Here the artist produced eleven half figures, of which the thighs and knees are covered by the table and table-cloth, and the feet below are scarcely noticed, in their modest obscurity.

Transfer yourself into this place, and picture to your mind the decorous and indisturbed calm, which reigns in such a monkish refectory; then you will admire the artist who knew how to inspire into his work a powerful emotion and active life, and, while approximating it to nature, as much as possible, at the same time, effected a contrast with the scenes of real existence, that immediately surrounded it.

The means of excitement, which he employed to agitate the holy and tranquil company, at table, are the words of the Master, *There is one among you that betrays me*. The words are uttered, and the whole company is thrown into consternation: but *he* inclines his head, with bent-down look, while the whole attitude, the motion of the arms, the hands, and every thing, seems to repeat the inauspicious expressions, which silence itself confirms: *Verily, verily, there is one among you that betrays me*.

But, before we proceed any farther, let us analyse one great expedient, whereby Leonardo chiefly enlivened his picture: it is the motion of the hands. This resource was obvious to an Italian. In this nation, the whole body is animated, every member, every limb participates

* According to my measurement, the picture is only about 8 feet raised above the ground, and its extent, in width, along the wall, exceeds 28. (Trans.)

in any expression of feeling, of passion, and even of thought. By a varied position and motion of the hands, the Italian signifies: *What do I care! – Come! – This is a rogue – take care of him! – His life shall not be long! – This is the point! – Attend to this, ye that hear me!*

Such a national peculiarity could not but attract the notice of Leonardo, who was, in the highest degree, alive to every thing, that appeared characteristick, and, in this particular, the picture before us, is strikingly distinguished, so that it is impossible, with this view, sufficiently to contemplate it. The countenance and action are in perfect unison, and there seems to be a co-operation of the parts, and at the same time, a contrast, most admirably harmonized.

The figures, on both sides of our Lord, may be considered by *threes* together, and thus they appear, as if formed into *unities*, corresponding, in a certain relation, with each other. Next to Christ, on the right hand, are *John*, *Judas*, and *Peter*.

Peter, the farthest, when he has heard the words of the Lord, rises quickly, in conformity with his vehement character, behind *Judas*, who, terrified and looking upwards, leans over the table, holding the purse with his right hand, which is tightly compressed, but making, with his left, an unvoluntary convulsive motion, as if to say, *what is the matter? what is to happen?* Peter, in the mean time, has, with his left hand, grasped the right shoulder of *John*, who is bending towards him, and pointing to Christ, seems to signify to the beloved disciple, that he should ask, who is the traitor. Holding a knife in his right hand, he accidentally, and without design, touches with the handle of it the side of Judas, by which the attitude of the latter, who is stooping forward, as if alarmed, and by this motion overturns a salt-cellar, is happily effected. This group may be regarded as the one first conceived in the picture; it is certainly the most perfect.

While on the right hand, with a certain degree of emotion, immediate revenge seems to be threatened, horrour and detestation of the treachery manifest themselves on the left. *James* the elder draws back, from terrour, spreads his arms, gazes, his head bent down,

like one who imagines that he already sees with his eyes those dreadful things, which he hears with his ears. *Thomas* appears from behind his shoulder, and, advancing towards the Saviour, lifts up the forefinger of the right hand towards his forehead. *Philip*, the third of this group, completes it in a most pleasing manner: he is risen, and bending forward, towards the Master, lays the hands upon his breast, as if distinctly pronouncing: *Lord, I am non he - Thou knowest it - Thou seest my pure heart - I am non he!*

And now the three last figures, on this side, afford new matter for contemplation. They are conversing together on the dire intelligence they have just received. *Matthew* turns his face, with an eager expression, to his two companions, on the left, while he extends his hands, with a quick motion, towards the Master; and thus unites his group, by an admirable contrivance, with the foregoing. *Thaddaeus* shows the utmost surprise, doubt, and suspicion: he has placed the left hand open on the table, and raised the right in such a manner, as if he were going to strike, with the back of it, into the left, a movement, which may sometimes be observed in common life, when at some unexpected occurrence a man would say, *Did I not tell you so! - Did I not always suspect it!* *Simon* sits, with great dignity, at the bottom of the table; his whole form, therefore, is to be seen. He, the oldest of all, is dressed in a full garment. His countenance and motion indicate that he is troubled, and in thought, though not agitated and terrified.

If we turn our eyes at once to the opposite end of the table, we see *Bartholomew*, who is standing on the right foot, the left being crossed over, his body bent forward, and supported with both hands, which are placed on the table. He listens, as if to hear what John may learn from the Lord: for altogether, the application to the favourite disciple seems to proceed from this side. *James* the younger, near Bartholomew, but behind him, puts his left hand upon the shoulder of Peter, in a similar manner as Peter had laid his on the shoulder of John; but James appears mild, as if only desiring information, whereas Peter seems to threaten vengeance. And, as Peter did be-

hind Judas, so James the younger stretches out his hands behind *Andrew*, who, being one of the most prominent figures, expresses, by his half uplifted arms, and outspread hands, the fixed horrour with which he is seized. This expression only occurs once in the picture, though it is sadly repeated in inferior works, composed with less genius and reflection.

Appendix 3:
Condition and Restoration

The long history of the many restorations of *The Last Supper* begins in 1726 with that by the painter Michelangelo Bellotti. There had presumably been earlier restorations for the picture's deplorable condition was well known and had been frequently commented on, as we have seen (p. 16f. above) from within a few years of its completion. Cardinal Federico Borromeo mentions in his *Musaeum Bibliothecae Ambrosianae* (Milan, 1625) that he discussed the problem of 'saving' the painting, but this appears to have resulted only in his commissioning a copy to be painted of it by Vespino (now in the Ambrosiana, Milan). There is, in fact, no record of any sixteenth- or seventeenth-century restoration.

Before recounting what little is known about Bellotti's restoration of 1726 (all trace of which was of course removed during subsequent restorations) it may be useful to give here Jonathan Richardson's account of the painting shortly before Bellotti began work on it.

'Milan, *The Monastery of the* Dominicans. In the Refectory over a very high door, is the famous Picture of the Last Supper, figures as big as the life; it is excessively ruin'd, and all the Apostles on the Right-hand of the *Christ* are entirely defaced; the *Christ* and those on his Left-hand appear pretty plain, but the Colours are quite faded, and in several Places only the bare Wall is left; that which is next but one to the *Christ* is the best preserved, (he that crosses his Hands upon his Breast) and has a marvellous Expression, much stronger than I have seen in any of the Drawings. *Armenini* (who wrote about the year 1580) says, this Picture was half spoil'd in his

time. That Story of the Head of the *Christ* being left unfinish'd, Lionardo conceiving it impossible for him to reach his Own Idea is certainly false, because one part of the Head which remains entire is highly finished in his usual manner. They have nail'd the Emperor's Arms over the *Christ's* Head so low that it almost touches his Hair, and hides a great part of the Picture.' (J. Richardson: *An Account of Some of the Statues, Bas-reliefs, Drawings and Pictures in Italy &ca with Remarks.* London, 1722, p. 23).

In the early eighteenth century it was thought, both because of Lomazzo's description of the painting and because of its surface appearance, that Leonardo had used oil paint. In 1726, therefore, Bellotti finished his work by giving the whole painting a coating of oil varnish. He was also said, by Carlo Bianconi (*Nuova Guida di Milano*, Milan, 1787, p. 329), to have repainted it from top to bottom but this seems to have been an exaggeration, though his restoration evidently included numerous retouchings, repaintings and reworkings of the original paint surface where necessary to accommodate his 'restored' areas. (These reworkings and repaintings were entirely scraped off by the next restorer, Giuseppe Mazza, but an example of Bellotti's own painting can still be seen on the façade of S.Maria delle Grazie where he painted in 1729 the fresco in the lunette above the main door.)

It is from contemporary reports on Mazza's restoration that much of what is known about Bellotti's work has been recorded. Earlier accounts, written while Bellotti's restoration was still visible, are very inconclusive. It was praised by S.Latuada ('fu però di nuovo con somma attenzione e pazienza ridotto a perfezione', *Descrizione di Milano*, Milan, 1738, vol. iv, p. 384), and Francesco Bartoli ('Bellotti Pittore, con un suo particolare segreto ha ravvivata questa pittura, e l'ha resa stimabile, bella quale fu un giorno', *Notizie delle Pitture, Sculture ed Architetture* &ca., Venice, 1776, p. 192); but it was severely criticized by Charles-Marie de La Condamine ('On est étonné de trouver aujourd'hui très-frais un

tableau qui parut si noir et si gâté à Misson il y a quatre-vingt ans, que ce voyageur assure qu'il n'y put rien distinguer. Il ne suffit donc pas supposer que depuis vingt-cinq ou trente ans il ait été nettoyé par un secret inconnu, comme on le dit aux voyageurs, mais il faut qu'il ait été repeint entièrement. C'est ce qui m'a été confirmé de bonne part. Il y a donc bien d'apparence que la belle ordonnance, le choix des attitudes, la distribution des figures, la composition en un mot est aujourd'hui presque la seule chose dans ce tableau qui appartienne bien sûrement à son premier auteur.' 'Extrait d'un journal de voyage en Italie' in *Histoire de l'Académie Royale de sciences.* Année 1757, Paris, 1762, p. 404) and by Carlo Bianconi ('Quindi lavatala, sicuramente con corosivi, e di poi redipinta la fece vedere quasi come nuova. Così resta coperta quel poco che a noi era rimasta di Lionardo, dal pennello, ci sià permesso il dire, dispregevole a fronte del primo, del Bellotti . . . Non è meglio l'avere un pezzo benchè guasto d'uno de' primi Pittori, de quello che sotto l'aspetto di falso rinovazione non avere che un empiastro vergognoso, e lontano dall'originale', *Nuova Guida di Milano*, Milan, 1787, p. 329). Bianconi also criticised Bellotti for not having kept any record of his work or of the process he employed. However, he would seem to have agreed, perhaps inadvertently and in any case only by implication, with Bellotti's defenders who claimed that he had not removed any of the original paint surface which remained when he began his restoration. For Bianconi stated that the original paint surface could still be seen in the three Apostles on the left, which were, as we shall see, the only part of the painting which Mazza did not touch but which had, of course, been restored by Bellotti.

By 1770 *The Last Supper* had again visibly deteriorated to such an extent that the Dominicans of S. Maria delle Grazie decided to embark on another attempt, this time employing the painter Giuseppe Mazza, an artist otherwise unknown. By chance the Irish painter James Barry visited Milan in 1770 and saw Mazza at work. He left a vivid description of it (see pp. 18-19 above) and it may have

been partly due to Barry that when it was realized that Mazza was using a scraper on the paint surface in order to erase Bellotti's re-paintings and retouchings, he was promptly halted by the Prior, Padre Galliani (himself a painter and former pupil of Lazzarini). Unfortunately, however, by the time Padre Galliani intervened Mazza had already scraped a great deal of the painting – all but three of the Apostles, in fact. Nevertheless, even Mazza was not without his defenders (see Emilio Motta, 'Il Restauro del Cenacolo nel Secolo XVIII e l'auto-difesa del Pittore Mazza' which prints the long defence by Giuseppe Frattini presented to Count Firmian on 20 May 1780, in *Raccolta Vinciana*, 1907, pp. 127–38).

Shortly after Napoleon established his Italian Republic (formerly the Cisalpine Republic) in Milan in 1802, the neo-classical painter Andrea Appiani carried out a detailed examination of *The Last Supper* and submitted a report to the Napoleonic government. He found – as had Padre Bosca in 1672 – that the chief cause of the painting's physical deterioration was the excessive humidity of the refectory, but he reported that it would, for various reasons, be im-possible to detach the painting from the wall and remove it to less humid conditions. He recommended that any restoration should be limited 'à reparer et assurer les croutes de cet œuvre'. (Report by Appiani 2 September 1802). In 1819, by which time Milan was under Austrian control, a further attempt at restoration was made. The Austrian authorities recommended that *The Last Supper* be protected with glass but the Accademia di Belle Arti in Milan was more ambitious. The painter-restorer Stefano Barezzi had recently successfully 'detached' frescoes from their supporting wall and transferred them to new supports. There had been earlier attempts to do this (e.g. by Antonio Contri of Ferrara at the beginning of the eighteenth century) but Barezzi had invented a new and successful method. (The novelty and success lay in the way he transferred the fresco to canvas rather than in the way he detached the fresco from the wall. The best known example of his method is the series of Luini frescoes from the Villa Pelucca near Monza which he detached

in 1821-2. They are now in the Brera, Milan). Barezzi proposed to the Accademia that he detach *The Last Supper* from the wall and his proposal was favourably received. But the Austrian authorities advocated caution and Barezzi was instructed to make a preliminary experiment on a small section of the table cloth. Unfortunately, he exceeded his instructions and experimented on an area which included one of Christ's hands as well as a section of the cloth. The Austrian authorities intervened and Barezzi's work was suspended. The English painter William Brockedon wrote from Milan on 24 August 1824: 'When I was here in 1821 a wretched quack in art had undertaken to restore this celebrated work. After having daubed over the left hand of Christ (his own ought to have shrunk at the attempt), and repainted part of the table and things upon it, he had so evidently betrayed his presumption and his ignorance, that public spirit enough was found, even in Milan, to appeal to the authorities, and stop his sacrilegious proceedings, which would have gone far with the next generation in blasting the reputation of Leonardo da Vinci'. (*Journals of Excursions in the Alps* . . ., London, 1833.)

After this disaster no further restorations were attempted for thirty years, though re-touching still went on apparently. At any rate William Boxall, later to become director of the National Gallery in London, wrote to his sister from Milan on 14 September 1845 that 'The picture is fast perishing, and the Head of Christ is much changed since I was here before when I made the sketch of it. It has also suffered from retouching since that time . . . the original is now little more than a shadow and I fear a few years more will wear it quite away.' (J. H. Liversidge: 'John Ruskin and William Boxall: unpublished correspondence' in *Apollo*, January 1967, p. 39).

By this date the painting seems to have been generally regarded as little more than a pathetic ruin. Kugler remarked, in the second edition of his *Handbook* (1847) that now 'when the ruins of the picture only exist, a custode has been appointed, and a scaffolding erected to admit of closer examination – not of Leonardo's work, for almost all trace of it has disappeared, but of its sad vicissitudes

and of the outrages which have been committed upon it.' In 1851, however, the President of the Accademia in Milan invited the chemist Kramer to study and report on the physical condition and composition of the painting and shortly afterwards (in September 1852) Barezzi once again applied to the Austrian authorities for permission to renew his experiments on *The Last Supper*, though these were no longer to be directed towards 'detaching' the painting from the wall but only towards re-laying with some strong glue the fragments of paint which were flaking off. Once again Barezzi's request was supported by the Accademia and in due course he was authorized to proceed, after a successful trial conducted before and examined by two Viennese scientists, Bohn and Engarth. Barezzi completed his restoration in 1855. It was later described by Adolfo Venturi as having been calamitous and it certainly did nothing to arrest the progress of deterioration and decay, as was reported only five years later by Mongeri who described the appearance of some alarming symptoms in St Philip's arm, the head of St Jude and the tunic of St Matthew.

In 1870 the glass-painter and fresco-restorer Guglielmo Botti, later Director of the Accademia in Venice, reported most unfavourably on the painting's condition and this was followed by a similar report from Pavesi by whom the 'intonaco' was chemically examined. But although Botti had put forward a proposal for detaching the painting from the wall, nothing appears to have been done except for improving the ventilation of the refectory. In fact, effective restoration did not begin until after 1900.

In 1891 Luca Beltrami became Superintendent of Monuments in Lombardy and in 1896 he had the original windows of the refectory re-opened in order to restore the original lighting conditions. At about the same time he set up a scientific commission, headed by Professors Carneluti, Gebba and Murani, to study and report on the structural, atmospheric and other physical conditions of the refectory and to make a chemical analysis of the paint surface and its support. Finally, in 1904, after a large scale photographic survey

had been made of all the heads and many other areas of the paint surface, L. Cavenaghi carried out two trial campaigns of 'consolidation'. These were judged successful and Cavenaghi was authorized to carry out a complete restoration, which he finished in 1908. His subsequent report on the condition and restoration of *The Last Supper* revealed that the painting had been executed in *tempera forte* on a complex prepared ground of two layers above the wall itself. (The second of these two layers, being predominantly of gesso, was not resistant to damp.) It also revealed that numerous traces of previous restorations remained but were confined for the most part to the background and the clothes of the Apostles, not to the heads or hands, with the exception of St Philip and the top of the table. Before beginning to restore the painting, Cavenaghi strengthened and consolidated the surface 'with a gum mastic diluted in suitable substances on which the hygrometric conditions would have the least possible effect'. But despite Cavenaghi's careful work and despite the various measures subsequently taken to reduce humidity and maintain an even temperature in the refectory, mould again appeared on the paint surface in 1911, and in 1921, according to E. Möller who was able to examine the paint surface closely from scaffolding, a considerable amount of paint had flaked off since 1908 when he had previously examined it at close range. Möller thought that very little indeed of the original paint surface was visible in 1921. In 1924 another restoration campaign began and was partially completed (by O. Silvestri) but by 1930 traces of mould and other indications of corrosion caused by the decay of earlier restorations were observed and yet another restoration campaign was proposed. It was not, however, carried out until after the Second World War, during which, from 1943 to 1946, the refectory was without a roof and open to the elements. *The Last Supper* survived behind a protective layer of sand-bags. After the war Mauro Pelliciolli carried out a thorough restoration which resulted in the recovery of a considerable amount of the original paint surface. (Cf. note 18.)

Appendix 4:
Copies of Leonardo's Last Supper

Leonardo's *Last Supper* has been copied almost continuously from the time it was painted until today [60], in media ranging from fresco and oil paint to tapestry, mosaic, stained glass and sculpture, and by artists as different as Rubens and Dominic Zappia, whose

60. The refectory *c.* 1900

life-size sculptural group in basswood was made in 1962 and is now in the Protestant Chapel at John F. Kennedy Airport, New York [61] – not to mention the full-scale reproduction in stained glass at the Forest Lawn Cemetery at Los Angeles, the famous Whispering Glades of Evelyn Waugh's *The Loved One*. Engravings and other reproductions, frequently made from copies and not from the original – as we have already seen Goethe proposed to have an engraving made from a copy he saw in Rome – began equally early with the contemporary copper engraving ascribed to the Master of the Sforza Book of Hours [65]. (See A. M. Hind: *Early Italian Engraving*, London 1900, Part II, vol II, pp. 88-9.) And of course prints and reproductions by various processes have continued ever since.

61 (*opposite*). *The Last Supper*, 1962. D. Zappia

62. The Beggar's Banquet scene from Luis Buñuel's film *Viridiana*, 1961

The interest of these innumerable copies lies in their value as records of *The Last Supper* at various stages of its physical deterioration and also, of course, as testimony of its continuous influence and fame – though perhaps such travesties as that of the beggars' banquet sequence in Buñuel's film *Viridiana* of 1961 provide the most convincing evidence of the latter [62]. It would, I think, be true to say that no other work of art could be used in such a way by a filmmaker with any chance of it being recognized and understood by his public – except the *Mona Lisa*.

Several copies made during Leonardo's lifetime still survive but, as we have already mentioned, the best and most valuable copy is that made considerably later by André Dutertre and now in the Ashmolean Museum in Oxford [63].

63. Copy of *The Last Supper*, 1789–94. André Dutertre

The earliest surviving copy appears to be that made by Antonio da Gessate in 1506 but it is in almost as poor condition as *The Last Supper* itself. (It was removed from the Ospedale Maggiore, Milan, in 1890 to S. Maria delle Grazie where it still remains.) Also dating from Leonardo's lifetime is the fresco of 1510-14 attributed to Andrea Solari, originally in the Hieronymite monastery at Castelazzo near Milan but now at S. Maria delle Grazie. (The famous drawings of the Apostles' heads, attributed to Solari and now in the museum at Weimar have been associated with this copy.) Also attributed to Solari is the copy now at Tongerlo in Belgium. This has been identified by Emil Möller (*Das Abendmahl des Leonardo da Vinci*, Baden Baden, 1952) with the copy mentioned in an inventory of 13 November 1540 of the castle of Gaillon belonging to Georges d'Amboise, archbishop of Rouen and prime minister to Louis XII. (See also R. H. Marijnissen, *Het da Vinci-Dock van de Abdij van Tongerlo*, Tongerlo, 1959.) Probably from about the same date – 1510-14 – is the copy in oil on canvas attributed to Marco d'Oggiono and, more recently, to Gianpietrino and now in the Royal Academy in London. It was recorded in the Certosa at Pavia in the seventeenth century and has been in England since 1815. It was engraved early in the nineteenth century by Giacomo Frey. Other copies attributed to Marco d'Oggiono are in the Louvre in Paris and the Hermitage in Leningrad.

Of about the same early date is a copy by Alessandro Araldi now in the Galleria Nazionale at Parma, though it is not recorded until 1530 when it was given to the Compagnia di SS. Cosma e Damiano in Parma. Slightly later, probably *c.* 1530, is the copy by Anselmi formerly in the now demolished S. Pietro Martire in Parma, and the interesting copy with variations at Ponte Capriasca near Lugano (dated 1547 and probably painted by Giovanni Pedrini). It includes an *Agony in the Garden* and a *Sacrifice of Isaac*. Among the later sixteenth-century copies should be mentioned that in fresco by Luini in S. Maria degli Angeli, Lugano, and those in the Capella di Revello near Saluzzo, in the Museo at Vercelli, in the Palazzo

Archivescovile at Milan, in the Chiesa dell'Assunta at Morbegno, in the cathedral at Turin, in the Pinacoteca at Teramo and in S. Germain l'Auxerrois in Paris. A drawing by Gaudenzio Ferrari is in the Brera, Milan. The copy by Vespino, commissioned by Cardinal Borromeo in 1612-13, is now in the Ambrosiana, Milan. Of the later copies that by Bossi was of course the best known, if only because of Goethe's essay, but it was destroyed in 1943. A version of Bossi's copy in mosaic by G. Raffaelli was made in 1816 for the Minoritenkirche in Vienna where it remains.

(For copies after Leonardo's *Last Supper* see G. Dehio: *Zu den Kopien nach Leonardos Abendmahl* Berlin, 1896; C. Horst in *Raccolta Vinciana*, Milan, 1930-34; Emil Möller: *Das Abendmahl des Leonardo da Vinci*, Baden Baden, 1952; Ludwig H. Heydenreich: 'André Dutertres Kopie des Abendmahls von Leonardo da Vinci' in *Münchener Jahrbuch der bildenden Kunst*, 1965, pp. 217ff. and A. Ottino della Chiesa: *L'opera completa di Leonardo pittore*, Milan, 1967.)

Notes

1. Carlo Cantù, 'Il convento e la chiesa delle Grazie e il Sant'Ufficio' in *Archivio Storico Lombardo* VI, 1879, pp. 223 ff.

2. After the completion of the choir the building of a splendid façade was also planned, and possibly the rebuilding of the nave although it had only been standing for ten years; in 1497 Lodovico was already demanding the plans for this. See Carlo Cantù, op. cit., loc. cit. and Arnaldo Bruschi, *L'Opera architettonica del Bramante*, Turin, 1969, p. 751.

3. On fol. 64 of Leonardo's notebook H (Paris, Bibliothèque Nationale) there is an entry: 'Quante braccie è alto il pian della mura. Quant'è larga la sala. Quant'è larga la ghirlanda. A di 29 de gienaro 1494'. (See L. Beltrami; *Documenti e memorie riguardanti la vita e le opere di Leonardo da Vinci*, Milan, 1919, doc. 61.) These questions as to the dimensions of a room have been connected by many scholars – with good reason in my view – with the commission for *The Last Supper*. As 'ghirlanda' can mean 'cornice' as well as 'garland', the word could refer to the painted moulding which originally ran round the whole refectory (see illustration 60). After the destruction of the room in 1944 only a fragment of this is preserved today, on the left-hand side wall.

4. In a list of instructions which Lodovico Sforza sent to his court marshal, Marchesino Stanga, under the date 29 June 1497 (see L. Beltrami, op. cit., doc. 76) is the passage: 'Item de' solicitare Leonardo Fior. no perchè finisca l'opera del Refettorio delle Gratie principiata, per attendere poi ad altra Fazada d'esso Refettorio et se faciamo con lui li capituli sottoscripti de mane sua che lo obligiano ad finirlo in quello tempo se convenera con lui . . .' The second part of the sentence suggests that Lodovico was considering stripping Montorfano's fresco of the Crucifixion off the opposite wall, although it had only been completed in 1494, and having it replaced by a painting by Leonardo, possibly another Crucifixion. (See W. von Seidlitz, *Leonardo da Vinci*, Berlin, 1909, p. 469; Aldo de Rinaldis, *Storia dell'opera pittorica di Leonardo*, Bologna, 1926, p. 14; and Angela Ottino della Chiesa, *Leonardo Pittore*, Milan, 1967, p. 99.) In the same year 1497 a bigger payment was recorded:

'per lavori facti in lo refectorio dove depinge Leonardo li apostoli'. (L. Beltrami, op. cit., doc. 77). Bandello's encounter with Leonardo occurred at the same period; it can be dated to 1497 by the documented simultaneous presence in the monastery of the Cardinal von Gurk. (L. Beltrami: op. cit., doc. 79; and W. von Seidlitz: op. cit., p. 153).

5. Matteo Bandello, *Le Novelle*, Bari, 1910, vol. II, p. 283. Translation by K. Clark, *Leonardo da Vinci*, Cambridge, 1939, pp. 92–3.

6. Leonardo was said to have searched for a long time in Borghetto, the slums of Milan, for a model for the head of Judas (Giambattista Giraldi, *Discorsi intorno al comporre dei romanzi . . .*, Venice, 1554, p. 194). Vasari also describes Leonardo's concern to work out and clarify the contrast between Christ and Judas as a dominant theme of the composition, and says that he left the head of Christ unfinished 'non pensando poter il dare quella divinità celeste che al'imagine di Christo si richiede' (feeling unable to represent the celestial beauty which the portrayal of Christ demanded). And Lomazzo (*Trattato* I, 80) reports that the painter Bernardo Zenale, when asked for advice by Leonardo, encouraged him not to finish it.

7. Antonio de Beatis, *Die Reise des Kardinals Luigi d'Aragona*, ed. Ludwig Pastor, Freiburg, 1905, p. 176.

8. G. B. Armenini, *De'veri precetti della pittura*, Ravenna, 1587 p. 172.

9. G. Vasari, *Le Vite . . .*, ed. Milanesi, Florence, 1880, vol. VI, p. 491.

10. The story of the decay and successive restorations of the picture is well summarised in W. von Seidlitz, op. cit., p. 155 and p. 470. See also L. Beltrami, *Le Vicende del Cenacolo dal 1495 al 1908*, Milan, 1909: Emil Möller, *Das Abendmahl des Leonardo da Vinci*, Baden Baden, 1952, p. 75 ff.; Angela Ottino della Chiesa, op. cit., pp. 96 ff., and our Appendix 2.

11. Roger de Piles, *Abrégé de la vie des peintres*, Paris, 1715, p. 161 ff.

12. *Lectures on Painting by the Royal Academicians. Barry, Opie and Fuseli*, ed. Ralph N. Wornum, London, 1848, pp. 128–9. Another version of the story was quoted by Allan Cunningham, *The Lives of the Most Eminent British Painters*, 1833 (ed. Mrs C. Heaton, London 1879, vol. i, pp. 384–9). For Giuseppe Mazza whom Barry calls Pietro Mazzi, see Emilio Motta in *Raccolta Vinciana* III, Milan, 1906–7.

13. K. T. Parker in *Ashmolean Museum, Report of the Visitors*, Oxford, 1958, p. 65 f.; L. H. Heydenreich, 'André Dutertres Kopie des Abendmahls von Leonardo da Vinci' in *Münchner Jahrbuch der bildenden Kunst* N.F. XVI, 1965, p. 217 f. Executed between 1789 and 1794, Dutertre's copy of *The Last Supper* is of particular significance in that it is the only

one which reflects the state of preservation of the picture immediately before it suffered fresh and serious damage during the military occupation of the monastery between 1796 and 1801. The original intention was that Raphael Morghen should make his engraving of *The Last Supper* after Dutertre's copy, and it was a great misfortune, in my opinion, that the political disturbances of the following years should have prevented this. Dutertre's reconstruction surpasses all other copies in that it has the exactness of an inventory [63]. This extends right down to the smallest details: the ornamental design in the tapestries, the pattern of the table cloth, the number and arrangement of the dishes of food and cutlery on the table, and especially the floor area – and square slabs of the pavement, the trestles supporting the table and, last but not least, the shape and position of the feet, a not unimportant part of the composition as a whole and nowhere rendered better or with greater exactitude than here.

Two details acquire some importance in connection with the problem of reconstructing *The Last Supper*. One is the fact that Dutertre's, in contrast to almost all older copies, does *not* let show the so-called 'left hand of Thomas' as part of Leonardo's final version of the picture. On the contrary, he gives most carefully the alteration as we see it now in the painting: a small plate with fruit on it and beside it a roll of bread have taken the place of a second hand beside the hand of James. Dutertre had thus consciously ignored this *pentimento* of Leonardo's – which had evidently become visible again in the course of the process of decay – and given preference instead (and certainly rightly, in my view) to the final version as adopted by Leonardo himself. On this see L. H. Heydenreich, op. cit., p. 228, note 37.

The second point concerns Peter's knife. While many copies show the knife in its sheath, here too Dutertre follows the painting as we see it today and shows a bare knife. This is an incomparably more effective motif, which in my view is also to be understood as an allusion to Peter's violent reaction when Christ was taken prisoner.

14. On the studies by Appiani and Matteini and the Strasbourg and Weimar series of Apostles' heads, see E. Möller, op. cit., p. 99 and W. von Seidlitz, op. cit., p. 169: on the engravings by Morghen and Frey see E. Möller, op. cit., p. 168. In the latter book there is a reproduction (plate no. 114) of Giuseppe Bossi's copy which was lost in the last war. The reproduction is valuable since the photographic negative was also destroyed during the war together with the rest of the contents of the Castello Sforzesco photographic library in Milan.

15. G. Bossi, *Del Cenacolo di Leonardo*, Milan, 1810, p. 200.

16. Gabriele d'Annunzio, *Tutte le opere, Versi d' Amore e di Gloria* II, Verona, 1952, p. 483.

17. Gino Chierici, 'Il Refettorio delle Grazie' in *Proporzioni* III, 1950.

18. The best account is to be found in Fernanda Wittgens, 'Restauro del Cenacolo' in *Leonardo: Saggi e ricerche*, Rome, 1954, p. 1 ff.

19. There is however one earlier, possibly archetypal example – the fresco of the Last Supper in the refectory of S. Paulo fuori le Mura in Rome, painted during the Papacy of Gregory VII (1073–85), but of which only a few fragments survive, see J. Wilpert, *Die römischen Mosaiken und Wandmalereien des Kirchlichen Bauten des IV bis XIII Jahrhunderts*, Freiburg, 1916, text II, 3, p. 847; pl. IV, 233.

20. See Artur Rosenauer, 'Zum Stil der frühen Werke Domenico Ghirlandajos' in *Wiener Jahrbuch für Kunstgeschichte*, XXII, 1969, pp. 59 ff., especially pp. 71 ff. See also L. Vertova, *I Cenacoli Fiorentini*, Turin, 1965, p. 41 and plates 1, XII and XIV. Leonardo may have known, before his move to Milan in 1480, many other depictions of the Last Supper in Florence, for example, Stefano di Antonio di Vanni's picture in the refectory of the Ospedale di S.Matteo painted in 1465-6 (see L. Vertova, op. cit., plate X) and the fresco from the same studio in the presbytery of Sant'Andrea at Cercina, near Florence (see L. Vertova, op. cit., fig. 18); but these were certainly not works that provided any inspiration. The works with which Leonardo would have been more or less familiar in Trecento panel painting can be deduced from the long catalogue of paintings of the Last Supper which R. Offner attached to his discussion of the Last Supper predella by the 'Master of the Fabriano Altarpiece' in Lord Bearsted's collection, see R. Offner: *Corpus of Florentine Paintings*, Section III, vol. VIII, New York, 1958, pp. 170 ff. But fundamentally the theme was still far from Leonardo's thoughts in his Florentine years and he had no reason to go into it in any detail at that time.

21. Thomas Brachert, 'A Musical Canon of Proportion in Leonardo da Vinci's *Last Supper*' in *Art Bulletin*, vol. LIII, no. 4, December 1971, pp. 461-7. Although Brachert's argumentation is not always impeccable – for instance, the cavalier treatment of the numerals inscribed on the Windsor drawing 12542 and the incorrect dating of Gafurio's publications – his main thesis is persuasive. His scheme of proportions makes it credible that Leonardo, in his space construction, had the congruence of perspective and musical proportions in mind. In his notes Leonardo compares them more than once. On the identity of harmonic proportions

in architecture and music, however, he never wrote explicitly although this notion had been familiar in art theory since Alberti (see the lucid exposition of this theory in R. Wittkower, *Architectural Principles in the Age of Humanism*, London, 1952, Part II 'The Problem of Harmonic Proportions in Architecture', pp. 89 ff., and see also the expanded edition *Grundlagen der Architektur im Zeitalter des Humanismus*, Munich, 1969, pp. 83 ff.

22. The best survey of this extensive and uncommonly varied material – a central theme in both the Eastern and Western Churches – is provided by H. Aurenhammer in his *Lexikon der christlichen Ikonographie*, Vienna, 1967, vol. I, pp. 11–15, where the older literature is also listed. Valuable for their rich illustration are: H. Detzel, *Christliche Ikonographie*, Freiburg in Breisgau, 1933, and G. Schiller, *Ikonographie der christlichen Kunst*, Gütersloh, 1966. See also K. Künstle, *Ikonographie der christlichen Kunst*, Freiburg, 1926–8, vol. I, pp. 413 ff.

23. P. Toesca, *La pittura e la miniatura nella Lombardia*, Turin, 1966, vol. I, p. 114 and fig. 187.

24. 'The Apostles' Communion' came to form a special type separate from the Last Supper theme, e.g. Justus van Ghent's picture at Urbino. A Last Supper in the proper sense of the phrase was painted by Fra Angelico only in the Passion cycle here illustrated [27].

25. Ms. South Kensington Museum II, fol. 62 verso/63 recto, printed in J. P. Richter, *The Literary Works of Leonardo da Vinci, compiled and edited from the original manuscripts*, London, 1883, vol. I, nos 665–6.

26. The drawing presents a number of problems. The execution is weak. The apparent pathos of the gestures lacks meaning and force; the lyrical motif of John lying on the breast of Our Lord is spoilt by exaggeration. The individual figures give for the most part an impression of plumpness; the hands are even clumsy. Nevertheless, it is an important fact that the Apostle second from the end on the right (Simon) was the only one to be incorporated almost unaltered in the painting (A. von Scheltema, *Über die Entwicklung der Abendmahlsdarstellung*, Leipzig, 1912, p. 61). Philip, however – second from the right in the lower sketch – also shows a resemblance, though not a close one, to James the Greater, the middle figure in the left-hand outer group in the painting. (In my view the Philip in the painting was originally rendered with one arm reaching down to the table, but in order to avoid an accumulation of hands in a narrow space Leonardo appears to have changed his mind and shown him with hands crossed on his breast.) All these considerations

suggest that the drawing may, after all, have been closely connected with Leonardo. Since the names written in above the Apostles to identify them are also almost certainly authentic (though A. M. Brizio considers them just as spurious as the drawing) this would seem to prove that Leonardo did make use of the drawing. In my view it could well be a studio copy of a preliminary design, in which even the left-hand shading has been reproduced. Discussion of the drawing has recently been revived, though without producing any absolutely convincing arguments on either side. See A. M. Brizio, 'Lo studio degli Apostoli della Cena dell'Accademia di Venezia' in *Raccolta Vinciana* XVIII, 1959, pp. 45 ff.; Carlo Pedretti, *Leonardo da Vinci inedito. Tre Saggi.* Florence, 1968, pp. 59-60; Luisa Cogliati Avane, *I disegni di Leonardo e della sua scuola a Venezia*, Venice, 1966, pp. 30 ff.

27. The studies at Venice and Windsor show this striving unmistakably. The use of the very old 'dialogue motif' has appeared since time immemorial in the iconography of the Apostles. In the Last Supper it is made use of for the first time, to the best of my knowledge, by Ghirlandaio. We find it again even more clearly in Cosimo Rosselli's *Institution of*

64. *The Institution of the Eucharist*, 1481-2. Cosimo Rosselli

the Eucharist in the Sistine Chapel, painted in 1481-2 [64]; and about the same time Andrea Sansovino (1483) also arranged his beautiful predella group on the Corbinelli altar in S. Spirito in the same way [32]. But the group of three is, in my view, not prefigured anywhere: it is Leonardo's most individual idea.

28. This text appears as an inscription on the contemporary copper engraving of *The Last Supper* [65] which Hind ascribes to the Master of

65. Engraving after *The Last Supper*.
Attributed to the Master
of the Sforza Book of Hours

the Sforza Book of Hours (A. M. Hind, *Early Italian Engraving*, London, 1948, part II, vol. V, pp. 88-9). This print, or a copy of it, may have been the model for Rembrandt's version, see note 36 below, as Hind rightly deduces from the adoption of the little dog, which does not appear elsewhere.

29. In the iconographical tradition of the East and West throughout the centuries it is always just the two favourite disciples Peter and John and the guilty Judas who stand out or are made recognizable in various ways.

On the other hand, sometimes all the Apostles are identified by the addition of their names, for example by Castagno [11], though without giving them any distinguishing characteristics. It was this individual characterization at which Leonardo aimed - to be achieved through an intensive study of the scriptural texts.

My identification of the Apostles is supported by the copy of the *Last Supper* at Ponte Capriasca near Lugano (dated 1547 and probably painted by Giovanni Pedrini) on which the names are given. Only James the Greater and James the Less are there confused in my opinion. See also E. Möller, *Das Abendmahl des Leonardo*, Baden Baden, 1952, pp. 56-7.

30. Dutertre's drawing, and also the painting at Tongerlo, reveal more clearly than any other copies, the important part played by the feet of the Apostles and of Christ and of their garments in so far as they are perceptible in the semi-darkness under the table. It is only when seen as a whole that the quiet composure of the figure of Christ is fully realized. In contrast to his still, firmly planted feet the restless positions of those of the Apostles form a sort of counterpart to the gestures of the hands above.

31. On this point see H. von Einem: *Das Abendmahl des Leonardo da Vinci*, Cologne and Opladen, 1961, pp. 62 ff.

32. In Dutertre's reconstruction this very carefully thought-out arrangement of the objects on the table is particularly clear. It is also to be seen in the Tongerlo copy.

33. The complexity of the painting has opened the door to a variety of interpretations. For example, Edgar Wind (*Listener*, 8 May 1952, pp. 747–8) drew attention to several possible layers of meaning in the painting, stressing 'one of the cardinal points in theological interpretation, that any event that is announced in the Bible can be interpreted in four ways – the literal, the moral, the mystical, and the anagogical. . . . It seems to me, if one looks at these four groups, each composed of three characters on either side of Christ, they really express by their gestures, very simply and eloquently, these four states: the anagogical, leading up to the acceptance of the bread and the wine in the group at the extreme right: the mystical in the ecstatic, excited reaction in the next group, also on the right of Christ; and literal, on the left side – the negative side, where the hand of Christ is cramped and semi-closed; the moral at the extreme left in the violence with which St Andrew and St Bartholomew react to the announcement.' And Wind goes on to suggest that each of the groups may also be identified with one of the four temperaments.

34. See Vasari's lively account, ed. Milanesi IV, p. 38.

35. See E. Panofsky, *The Life and Art of Albrecht Dürer*, Princeton, 1955, pp. 221–3.

36. See K. Clark, *Rembrandt and the Italian Renaissance*, London, 1966, pp. 53 ff.

37. For literary reasons quotations from the Gospels throughout the text are from the King James Bible.

List of Illustrations

Colour plate and title page: *The Last Supper*. By Leonardo da Vinci, 1494–8. Tempera 460 x 880 cm. Milan, S. Maria delle Grazie. (Photo: Soprintendenza.)

1. Detail of the *Pala Sforzesca*. Anonymous, *c*. 1495. Milan, Pinacoteca di Brera. (Photo: Alinari.)

2. Choir of S. Maria delle Grazie, Milan. By Bramante, 1492. (Photo: Paoletti.)

3. Plan and section of the refectory, S. Maria delle Grazie, Milan. Drawn by Giuseppe Chigiotti.

4. The refectory, S. Maria delle Grazie, Milan. (Photo: Soprintendenza.)

5. Copy of *The Last Supper*. By André Dutertre, 1789–94. Oxford, Ashmolean Museum. (Photo: Museum.)

6. Engraving after *The Last Supper*. By Raphael Morghen, 1800. Florence, Uffizi (Photo: Museum.)

7. The bombed refectory, 1943. *The Last Supper* is behind the sandbags, bottom right. (Photo: Emmer.)

8. *The Last Supper*. By Leonardo da Vinci, 1494–8, after the 1954 restoration. (Photo: Soprintendenza.)

9. *The Last Supper and Other Scenes*. By Taddeo Gaddi, *c*. 1350. Fresco. Florence, S. Croce. (Photo: Alinari.)

10. Fragment of *The Last Supper*. By Andrea Orcagna's workshop, *c*. 1365. Fresco. Florence, S. Spirito. (Photo: Soprintendenza.)

11. *The Last Supper, Crucifixion, Entombment and Resurrection* (before the recent cleaning and restoration). By Andrea del Castagno, *c*. 1450. Fresco. Florence, S. Apollonio. (Photo: Alinari.)

12. *The Last Supper*. By Domenico Ghirlandaio, 1480. Fresco. Florence, Monastery of Ognissanti. (Photo: Soprintendenza.)

13. *The Last Supper*. By Domenico and Davide Ghirlandaio, *c*. 1470–79. Fresco. Passignano, Monastery. (Photo: Soprintendenza.)

14. Study for St. Peter. By Leonardo da Vinci, *c*. 1495. Pen and ink over metal-point on blue prepared surface, 14.5 x 11.3 cm. Vienna, Albertina. (Photo: Museum.)

15. Detail of 13.

16. Detail of 11.

17. Woodcut from Franchino Gafurio, *De Harmonia musicorum instrumentorum*, 1518. It was first printed in Gafurio's *Angelicum* of 1508. (Photo: John R. Freeman.)

18. *Agape*. Wall painting, late second century. Rome, catacomb of Priscilla. (Photo: Pont. Comm. di Arch. Sacra.)

19. *The Last Supper*. From the Codex Rossanensis, sixth century. Rossano. (Photo: Giraudon.)

20. *The Last Supper*. Mosaic, early sixth century. Ravenna, S. Apollinare Nuovo. (Photo: German Archaeological Institute, Rome.)

21. *The Last Supper*. Mosaic, c. 1250-1300. Florence, Baptistery. (Photo: Soprintendenza.)

22. *The Last Supper*. Sixth century. Milan, Biblioteca Ambrosiana, Ms. D.67. 73v. (Photo: Ambrosiana.)

23. *The Last Supper*. Marble, twelfth century. Volterra Cathedral, detail of pulpit. (Photo: Alinari.)

24. *The Last Supper*. By Giotto, c. 1303-13. Fresco, Padua, Scrovegni Chapel. (Photo: Anderson.)

25. *The Last Supper*. By Sassetta, 1423-6. Siena, Pinacoteca. (Photo: Alinari.)

26. *The Last Supper*. Lombard School, late fourteenth century. Viboldone, Abbazia di S. Pietro. (Photo: Soprintendenza.)

27. *The Last Supper*. By Fra Angelico, c. 1448-61. Florence, Museo di San Marco. (Photo: Brogi.)

28. Study for *The Last Supper with Architectural Figures and Calculations*. By Leonardo da Vinci, c. 1495-7. Windsor, Royal Library, no. 12542. Pen and ink, 26 x 21 cm. (Photo: Royal Library, reproduced by gracious permission of H.M. the Queen.)

29. Study for *The Last Supper*. After Leonardo da Vinci, c. 1495-7. Red chalk, 26 x 39 cm. Venice, Academy. (Photo: Anderson.)

30. Detail of 28.

31. Detail of 28.

32. *The Last Supper*. By Andrea Sansovino, c. 1485-90. Marble. Florence, S. Spirito. Detail of the Corbinelli altar. (Photo: G. Laurati.)

33. Studies for *The Adoration of the Magi*. By Leonardo da Vinci, c. 1481. Pen, ink and metal-point, 27.8 x 20.8 cm. Paris, Louvre. (Photo: Museum.)

34. *The Last Supper*. (Photo: Soprintendenza.)

35. Detail of 34. (Photo: Soprintendenza.)

36. Study for the head of Judas. By Leonardo da Vinci, 1494–7. Red chalk, 18 x 15 cm. Windsor, Royal Library no. 12547. (Photo: Royal Library, reproduced by gracious permission of H.M. the Queen.)

37. Study for the hands of St John. By Leonardo da Vinci, 1494–7. Black chalk, 11.7 x 15.2 cm. Windsor, Royal Library no. 12543. (Photo: Royal Library, reproduced by gracious permission of H.M. the Queen.)

38. Study for the arm of St Peter. By Leonardo da Vinci, 1494–7. Black chalk, heightened with white, 16.6 x 15.5 cm. Windsor, Royal Library no. 12546. (Photo: Royal Library, reproduced by gracious permission of H.M. the Queen.)

39. Detail of *The Last Supper*. (Photo: Soprintendenza.)

40. Study for St Bartholomew. By Leonardo da Vinci, 1494–7. Red chalk, 19.3 x 14.8 cm. Windsor, Royal Library no. 12548. (Photo: Royal Library, reproduced by gracious permission of H.M. the Queen.)

41. Detail of *The Last Supper*. (Photo: Soprintendenza.)

42. Study for St James the Less. By Leonardo da Vinci, 1494–7. Red chalk and pen and ink, 25.2 x 17.2 cm. Windsor, Royal Library no. 12552. (Photo: Royal Library, reproduced by gracious permission of H.M. the Queen.)

43. Study for St. Philip. By Leonardo da Vinci, 1494–7. Black chalk, 19 x 15 cm. Windsor, Royal Library no. 12551. (Photo: Royal Library, reproduced by gracious permission of H.M. the Queen.)

44. Detail of *The Last Supper*. (Photo: Soprintendenza.)

45. Detail of *The Last Supper*. (Photo: Soprintendenza.)

46. Detail from a copy of *The Last Supper*. Attributed to Marco d'Oggiono, *c.* 1510–14. London, Royal Academy. (Photo: Royal Academy.)

47. *Head of Christ*. By a follower of Leonardo. Milan, Pinacoteca di Brera. (Photo: Soprintendenza.)

48. *Head of Christ*. By a follower of Leonardo. Strasbourg, Musée de la Ville. (Photo: Museum.)

49. *The Adoration of the Magi*. By Leonardo da Vinci, *c.* 1481. Florence, Uffizi. (Photo: Alinari.)

50. Detail of 49. (Photo: Soprintendenza.)

51. Detail of 49. (Photo: Soprintendenza.)

52. Detail of 49. (Photo: Alinari.)

53. Detail of *The Last Supper*. (Photo: Soprintendenza.)

54. Detail of 5.

55. Detail of *The Last Supper*. (Photo: Soprintendenza.)

56. *The Last Supper*. By Andrea del Sarto, *c.* 1520–25. Florence, S. Salvi. (Photo: Brogi.)

57. *The Last Supper*. By Titian, 1564. The Escorial. (Photo: Anderson.)

58. *The Last Supper*. By Dürer, 1523. (Photo: The Warburg Institute.)

59. *The Last Supper*. By Rembrandt, *c.* 1635. New York, the Robert Lehman Collection. (Reproduced by courtesy of the Robert Lehman Collection, New York.)

60. The refectory, S. Maria delle Grazie, *c.* 1900. (Photo: Brogi.)

61. *The Last Supper*. By Dominic Zappia, 1962. Basswood. New York, the Protestant Chapel, John F. Kennedy International Airport. (Reproduced by courtesy of the Protestant Chapel, John F. Kennedy International Airport, New York.)

62. The Beggars' Banquet scene from Luis Buñuel's film *Viridiana*, 1961. (Photo by courtesy of the National Film Institute, London.)

63. Copy of *The Last Supper*. By André Dutertre. (See illustration 5.)

64. *The Institution of the Eucharist*. By Cosimo Rosselli, 1481–2. Rome, Vatican, Sistine Chapel. (Photo: Biblioteca Hertziana, Rome.)

65. Engraving after *The Last Supper*. Attributed to the Master of the Sforza Books of Hours.

Bibliography

More has been written about Leonardo's *Last Supper* than about any other work of art, with the possible exception of the Ghent Altarpiece, so the following bibliography is necessarily summary.

Monographs begin with Domenico Pino, *Storia genuina del Cenacolo insigne dipinto del Leonardo da Vinci nel refettorio di S. Maria delle Grazie di Milano*, Milan, 1796, and continue with Giuseppe Bossi, *Del Cenacolo di Leonardo. Libri Quattro . . .* , Milan, 1810, which collects numerous early descriptions; A. Guillon: *Le Cénacle de Léonard de Vinci*, Milan, 1811; [Giuseppe Bossi], *Postillo alle Osservazione sul volume intitolato Del Cenacolo di Leonardo da Vinci. Libri Quattro . . .* , Milan, 1812; Hermann Dalton, *Lionardo da Vinci und seine Darstellung des heiligen Abendmahls*, St Petersburg, 1874; E. Frantz, *Das heiliges Abendmahl des Leonardo*, Freiburg, 1885; O. Hoerth, *Das Abendmahl des Leonardo*, Leipzig, 1907; C. Ricci, *Il Cenacolo di Leonardo da Vinci*, Rome, 1907; L. Beltrami, *Il Cenacolo di Leonardo 1495–1908*, Milan, 1908; A. Melani, *Il Cenacolo di Leonardo*, Pistoia, 1908; E. Schaeffer, *Leonardo da Vinci. Das Abendmahl*, Berlin, 1914; G. Galbiati, *Il Cenacolo di Leonardo da Vinci del pittore Giuseppe Bossi nei giudizi d'illustri contemporanei*, Milan-Rome, 1919; M. Salmi, *Il Cenacolo*, Milan n.d. [1927]; A. Pica, *L'opera di Leonardo al convento delle Grazie in Milano*, Rome, 1939; S. Bottari, *Il Cenacolo di Leonardo*, Bergamo, 1948; E. Möller, *Das Abendmahl des Leonardo da Vinci*, Baden Baden, 1952; Paolo d'Ancona, *Das Abendmahl der Leonardo da Vinci*. Milan, 1955; L. H. Heydenreich, *Leonardo da Vinci. Das Abendmahl*, Stuttgart, 1958; H. von Einem, *Das Abendmahl des Leonardo da Vinci*, Cologne and Opladen, 1961; F. Wittgens, *Il Cenacolo di Leonardo da Vinci*, Milan, 1964; F. Mazzini, *Il Cenacolo di Leonardo e la Chiesa delle Grazie*, Milan, 1966; P. Angelo M. Caccin, *S.Maria delle Grazie e il Cenacolo Vinciano*, Milan, 1967.

Many descriptions and analyses of *The Last Supper* have been published of which the following may be mentioned here: A. von Scheltema, *Über die Entwicklung der Abendmahlsdarstellung*, Leipzig, 1912; C. Horst, 'L'Ultima Cena di Leonardo nel riflesso delle copie e delle imitazione' in

Raccolta Vinciana XIV, 1930–34, pp. 118–200; Edgar Wind, 'The Last Supper' in the *Listener*, 8 May, 1952; A. Bovi, 'La visione del colore e della luce nella Cena' in *Raccolta Vinciana* XVII, 1954, pp. 315 ff.; V. Mariani: 'Della "Composizione" nel Cenacolo di Leonardo' in *Arte Lombarda* II, 1956, pp. 65 ff.; G. Castelfranco in *Storio di Milano* VIII 'Fra Francia e Spagna', Milan, 1957, pp. 514 ff.

General accounts of *The Last Supper* may be found in J. Burckhardt, *Cicerone*, 1855; G. Séailles: *Leonardo da Vinci*, Paris, 1892; H. Wöfflin, *Classic Art*, Munich, 1898, London, 1952; W. von Seidlitz, *Leonardo da Vinci*, Berlin, 1909; Vienna, 1935; A. de Rinaldis, *Storia dell'opera pittorica di Leonardo*, Bologna, 1926; K. Clark, *Leonardo da Vinci*, Cambridge, 1939; L. H. Heydenreich, *Leonardo da Vinci*, Berlin, 1943; Basle, 1954.

On the Milanese background there is F. Malaguzzi-Valeri, *La Corte di Lodovico il Moro*, Milan, 1915, vol. II.

On the drawings there are A. E. Popham, *The Drawings of Leonardo da Vinci*, London, 1946; K. Clark and C. Pedretti, *The Drawings of Leonardo da Vinci in the Collection of H.M. the Queen at Windsor Castle* (1935), revised edition, London, 1968; Luisa Cogliati Avane: *I disegni di Leonardo e della sua scuola a Venezia*, Venice, 1966.

On the colour there is J. Shearman: 'Leonardo's Colour and Chiaroscuro' in *Zeitschrift für Kunstgeschichte* XXV, 1962, pp. 13–47.

On iconography there are the classic articles by E. Dobbert in *Repertorium für Kunstwissenschaft* XIII (1890) 281 ff., 303 ff., 423 ff.; XIV (1891) 175 ff., 451 ff.; XV (1892) 357 ff., 506 ff.; XVIII (1895) 336 ff., and, for Byzantine iconography, G. Millet, *Recherches sur l'iconographie de l'Evangile aux XIVe XVe et XVIe siècles d'après les monuments de Mistra, de la Macédoine et du Mont Athos*, Paris, 1916. An excellent survey is contained in H. Aurenhammer, *Lexikon der christlichen Ikonographie*, Vienna, 1967, vol. I, pp. 11–15 including a useful list of the older literature of which the following may be mentioned here especially for their abundant illustrations – H. Detzel, *Christliche Ikonographie*, Freiburg in Breisgau, 1933; G. Schiller, *Ikonographie der christlichen Kunst*, Gütersloh, 1966; K. Künstle: *Ikonographie der christlichen Kunst*, Freiburg in Breisgau 1926–8, vol. 1, pp. 413 ff. and Luisa Vertova, *I Cenacoli Fiorentini*, Turin, 1965.

Special studies relating to Leonardo's *Last Supper* include Anon, *Le Vicende del Cenacolo di Leonardo da Vinci nel secolo XIX*, Milan, 1906 (relating mainly to cleaning and restoration); G. Dehio, *Zu den Kopien*

nach Leonardos Abendmahl, Berlin, 1896; Fernanda Wittgens in *Saggi e Ricerche*, Rome, 1953; T. Brachert, 'A Musical Canon of Proportion in Leonardo da Vinci's Last Supper' in *Art Bulletin* vol. LIII, no. 4, December 1971.

Index

Bold numbers refer to illustration numbers

Making a
SAMPLER
QUILT

Making a SAMPLER QUILT

Lynne Edwards

THE READER'S DIGEST ASSOCIATION, INC.

Pleasantville, New York/Montreal

To the ever supportive Brian, Dickon, and Tom,
Mum and Dad.
To Wendy Crease and Pepper Cory, dear friends
whose help and encouragement has opened so
many exciting doors.
Finally, to all those nervous, anxious-to-please,
first-time quilters who signed on and turned up
to make a sampler quilt. My local classes are my
bread and butter. They are also the jam and the
icing on the cake. Heartfelt thanks.

Lynne

A Reader's Digest Book

Edited and produced by David & Charles

First published in the UK in 1996
Text and designs Copyright © 1996 Lynne Edwards
Photography and layout Copyright © 1996 David & Charles

Library of Congress Cataloging in Publication Data
has been applied for

ISBN 0-89577-911-0

Photography by Alan Duns and Paul Biddle
Book design by Maggie Aldred

Printed in Italy

CONTENTS

INTRODUCTION

A sampler quilt is one of the best ways to get started on patchwork and quilting. It allows you to try a variety of sewing and design techniques and see how you like them. While some of these will become favorites, others will be put into the "never again" category. It also encourages you to experiment with color, combining plain fabrics with different patterns or textures. Although everyone finds this particular skill intimidating at first, it does get easier the more often you do it. But best of all, you get to make a real quilt from start to finish, joining the quilted squares, dealing with borders and quilt edgings, and then finally stitching your name and the date on the completed heirloom.

For several years I have run a one-year class on making a sampler quilt. It comprises five full-day sessions over each of three terms, with the students learning two techniques at each session: one based on handwork, the other using a quick machine method. Usually the hand-sewn design is begun in class and then taken away, hopefully to be finished during the intervening two weeks. The machine-stitched design is often completed during the session.

After the first three or four sessions, I teach hand-quilting, so that the squares, known as blocks, can be quilted individually before they are joined together at the finish. This "quilt as you work" approach is not favored by some other experienced quilters, but I believe it is preferable to joining all the completed blocks together at the end of the course and then sending everyone on their way to try and quilt it for themselves. The size of the project would be too overwhelming for first-time quilters, and many would never finish.

By the third term, all the different techniques have been taught, and the students have made at least 20 blocks. They now learn how to join the blocks together, how to design and make the borders, and how to finish off. I *have* had students whose diligence and commitment have been exemplary and who have kept up with every stage, quilting away during the Christmas vacation, completing squares over Easter, and bringing their quilts for signing at the last session. I have also known some equally enthusiastic quilters who have taken 2 years to finish, because families, careers, and simply life in general have got in the way. None of this matters: the object of the exercise is just to enjoy.

This book has been derived from my classes and can be used in several ways. You can simply start at the first technique and work through each block, just as if you were attending the class. The order of the blocks has been carefully sequenced so that the skills learned from one technique are used and built on in the next. The book can also be used as an encyclopedia of techniques. You can select individual designs and try them, using the instructions given for that block to make a single 12-inch finished sample, which can then be developed into a project like a pillow, bag, or small wallhanging. If you prefer, you can make a quilt using just one block repeated as many times as you wish, or from a combination of two or three blocks arranged and repeated in whatever way you find most pleasing.

The section at the end of the book takes some of the techniques and expands them into a variety of projects of all sizes. I hope this particular section will help and inspire quilters to use their favorite designs from the sampler quilt and develop them into projects of their own in the future.

Remember: Make a quilt for someone only if you know that person is aching to possess it. Make it for yourself because you want to. Keep it yourself and enjoy it until the right person comes along and falls in love with it. You will then know you have found the right owner for your handiwork.

Opposite *Lynne Edwards, pictured top right, runs a popular course on making a sampler quilt.*

GETTING STARTED

So you are thinking about making a sampler quilt? No doubt you have a long list of questions you would like answered before you can even begin thinking about putting needle to fabric. To get you started, here are some of the facts you need to know about choosing and preparing the materials.

How Much Fabric Do I Need?

For a single-bed quilt, you need about 6 yards of 45-inch-wide fabric for the front of the quilt. For a double-bed quilt, you need about 9 yards for the quilt top. Although it seems logical to plan all the fabrics needed for the quilt first and buy them all at once, selecting one fabric for the strips that frame each block and another for the border, etc., experience has taught me otherwise. Actually it is better to wait until several blocks have been made and the overall balance of color is developing before choosing the fabric, or fabrics, to frame the blocks. Choosing border fabrics really does need to be left until the blocks are joined, because only then can you lay other fabrics beside the work to see which effect looks best. This seems like living dangerously — what if they haven't got any more of that fabric left? What if you don't have enough? When that happens, you just have to choose something else, which will make the quilt richer and livelier.

Initially work with about six fabrics, possibly half patterned and half plain; 20 inches of each will be enough. As the quilt grows, you will need more, but it is easier to choose when you have some completed blocks to refer to. If it is not possible to buy some more of one of your chosen fabrics, find another one similar in color; you can get a great deal of pleasure adding to your palette of fabrics as you go along. Special quilt stores stock a huge selection of fabrics manufactured especially for patchwork, and many operate a mail-order service.

With the "quilt as you work" technique, both batting, the layer between the front and back of the quilt, and backing fabric are cut into 15-inch squares, rather than used in one large piece, so any width is suitable. As a guide, you need 6 yards of 45-inch-wide batting and backing fabric for a single-bed quilt. You may have to do some calculations to find the equivalent amount if either batting or backing fabric is much wider than this. When in doubt, always buy too much if you can afford to; any excess can always be used in future projects. If you are on a very limited budget, you could use a variety of fabrics for the backing squares, and that way you get a patchwork effect on both sides.

What Sort Of Fabric Can I Use?

The traditional image of a patchwork quilt is that of an economy craft, patched and pieced together with any scraps available. This can still be true today, but it is good to know what fabrics to avoid and what to choose to make the cutting and stitching easier and more enjoyable, and to make sure that the completed quilt becomes a long-lasting heirloom.

Many dressmaking scraps are made of synthetic materials, like polyester. Unfortunately, these do not combine very successfully with other fabrics, unless the project is a marvelously textured contemporary wall hanging and durability is not a consideration. If you want to make a patchwork quilt that will last for years, mellowing and becoming even more beautiful as it ages, then use a combination of pure cotton fabrics. The thickness of these fabrics needs to be consistent: a medium-weight cotton is easier to work with than lightweight ones; heavier upholstery and decorator fabrics are fine for machined quilts that use large pieces, but would not be suitable for this sampler.

Look for fabrics that provide a good balance of solids, large and small designs, and light, medium, and dark color values. This may seem impossible when you begin, but it gets easier as the work progresses, so limit your initial selection of fabrics.

I'm No Good at Choosing Colors

This is a familiar cry. It should really be replaced with, "I'm not experienced in choosing colors that give the mixture balance." Color itself is very personal — it is also strongly influenced by fashion. As a young girl I learned that "blue and green should never be seen," and I remember the shock of seeing pink and orange together in the 1960s. But fashion moves on, and the unacceptable becomes comfortable; even the names change, so fawn and beige have

◆◆

become ecru and taupe. Designs for decorator fabrics play their part too. The first quilt you make is usually for a planned position, and has to go in a certain room matching the carpet and wallpaper. It must coordinate, rather than make its own statement, so soft shades are the most desirable. Sunshine and quality of light will also influence your choice.

In low-lying East Anglia, in England where I have my home, the sky is more often gray-blue than blue, just like the sea. I like to work in subtle shades of cool colors, which I am sure is dictated by the quality of the light. Warmer countries with fierce sunshine, a deep blue sky, and vivid landscapes demand stronger colors. My silvers, grays, and blues would look very out of place in California, and if I lived there, it would not be long, I'm sure, before I began working with a palette of clear, vibrant colors. Add to these external influences your own personal preferences, and you can see the impossibility of dictating what anyone should or should not choose.

Start by selecting a fabric that you really like. Don't worry if everyone else thinks it is dull or sweetly pretty, brash or downright ugly. If it jumps off the shelf at you, crying "Take me, I'm yours," then start with that fabric. If you want your quilt essentially just one color, then make sure there is plenty of variation in the values you use. You will need some light or pale shades in addition to some dark or stronger ones. Place your chosen fabrics together and look at them through half-closed eyes. If it is difficult to see where one fabric ends and another begins, you will need to introduce some that give definition to your selection. Otherwise, your quilt could look very bland, as if it had been printed, rather than assembled from different fabrics.

If you want a real contrast of colors, like a red-and-white quilt, add textures, polka dots, checks, and small and large patterns to the basic plain red-and-white scheme. Do not overcoordinate, or it will resemble the printed patchwork look. Introduce something surprising, an element only you could have thought of. A large print, which uses red-and-white, plus black, might just give that extra accent or zing to the quilt.

Seek advice from another quilt enthusiast or from someone whose color sense you admire; you will never be imposing on the time of a true fabric addict. Do not bother the rest of your family if they do not share your enthusiasm and if they sigh and shift from foot to foot after 5 minutes in a fabric or quilt store. Finally, when everyone has offered their opinion, remember that it is your quilt and it has to please *you*. The limited selection of fabrics that you start with will grow, along with your confidence, as work on the blocks progresses.

What About the Batting?

Between the front and back of the quilt is the layer known as batting, or batt, which gives the padded effect. Suppliers offer a wide range of different sheet battings, some polyester, some cotton, and some even pure silk. Save your experimenting for small projects, though, because once you start on your sampler quilt, you need to use the same batting throughout.

Like cotton batting, polyester batting is lightweight, washable, and easy to quilt; however, polyester is a little firmer and creates a denser effect when quilted. Polyester batting is available in 2- to 6- and even 8-ounce weights, although the thicker battings are more suitable for tied quilts and not for a hand-quilted project like this. For your sampler quilt, I would recommend a 2-ounce, low loft, polyester batting. Because the blocks are quilted individually, you do not need to buy a large piece of batting. You may change your mind about the final size of your quilt, so make sure your batting comes from a reliable supplier who will always have that particular brand in stock.

How Do I Prepare the Fabrics?

It has always been impressed upon me that all fabrics must be washed before they are used for patchwork, and it is the safest thing to do. However, if, like me, you enjoy working with fresh, crisp, unwashed fabric, you must at least test any strong or dark colors for colorfastness before you begin. Wash these separately, using a powdered laundry detergent or a gentle liquid detergent, and check that the color does not leak out into the water. You just cannot take risks with colors like red, indigo, burgundy, etc., and I have several disaster stories to prove it. As for shrinkage, I do not worry about this when I am using special patchwork fabrics, but I certainly do not trust decorator cotton fabrics or designer fabrics, and I always wash them before use. Try to iron the fabrics while they are still slightly damp to make sure their finish is smooth.

It may be stating the obvious, but batting does not usually need prewashing (unless it is one of the newer cotton varieties, which come with appropriate instructions), and it certainly does not need ironing. *Never* put an iron directly onto polyester batting, because it melts instantly. You should iron only batting that is sandwiched between layers of fabric, but avoid using steam or a hot iron, since the batting can bond to the fabric and give an unattractive stiff feeling. Press batting only if you really have to, if you use a cool, dry iron, there should be no problem.

BASIC EQUIPMENT

An increasingly wide range of tools and gadgets designed especially for quilters is available from special sewing stores and quilt shows. On many occasions, students have shown me a special ruler or odd-shaped piece of plastic and said, "I know this is really useful, but I can't remember why." If you are a beginner and the sampler quilt is your first major project, stick to the basic equipment listed in this section. When you become totally hooked and have the next three quilt projects planned, then you will find all sorts of wonderful aids to accuracy and other helpful devices that you cannot live without.

For Hand-sewing

Needles Personally I really dislike packs of assorted needles because they usually contain only two sizes that you can use; the rest may be useful for trussing the turkey at Thanksgiving! Try to buy packs of only one size, if possible, because it is more economical. Also, if you lose needles as often as I do, you will need a whole pack on you as you work. Size 9 or 10 sharps are best for piecing and appliqué, while size 9 or 10 betweens are best for quilting.

Pins There are many types of pins to choose from, and each one has a different function. I like to use long, fine dressmaker's pins (called extra-fine, extra-long), although other people favor the colored, glass-headed type because they are easier to hold and to find when dropped on the floor. Buy the smaller, fine variety, rather than the huge quilt pins (these should be used only to pin thick, layered quilts together and are just too big for normal pinning). You can buy plastic-headed pins, but remember that the plastic heads will melt under a hot iron. If you use these pins, this is not a big problem, but just be careful when you are pressing. Another type is a tiny pin used for appliqué, which is useful for holding small pieces in position. These pins are known as lills, or appliqué pins. You do not need all the types of pins described; one type will do as long as it is fine and you are comfortable using the pins.

Thimble I was never taught to sew with a thimble. For years I stitched without a thimble, but then found I needed one for quilting, and now I cannot work without one. Wear a thimble for handwork if you like but do not feel you absolutely *have* to.

However, a thimble really is needed for quilting, to protect the middle finger of your dominant hand. A flat-topped thimble is the best shape for quilting.

Thread For sewing cotton fabrics, I like to use a good-quality, pure cotton thread, although cotton-coated polyester is a suitable alternative. Try to match the color of the thread as closely as possible to the fabrics. If using a mixture of colors, go for a darker rather than a lighter shade. The best test for color matching is to lay a thread across the fabric to see if it virtually disappears.

For quilting, pure cotton quilting thread is ideal. It is stronger, thicker, and waxed to give a smooth thread that tangles less than ordinary sewing thread.

Scissors You will need a sharp, medium-size pair of scissors for cutting the fabric, plus a larger pair for paper cutting. A pair of small, really sharp sewing or embroidery scissors with good points will be useful for clipping seams and trimming thread.

Fabric Markers A quilt should last decades, so you should think of its future. Although you need some sort of fabric marker to mark template shapes onto the fabric and indicate quilting lines, avoid marking pens, even if their ink is water-erasable. They are excellent for dressmaking, but they make a harsh line, and it is not known whether the chemicals used in them will eventually rot the fabric.

Special quilt stores sell silver, white, and yellow marking pencils, which can be sharpened to a fine point for accuracy. Read the directions carefully before you use them. If they say "will not fade," the pencil is fine for marking around templates but not suitable for quilting. Always test the marker on a spare piece of fabric before you start work, and make certain that it can be erased. You can buy a fabric eraser to use with these markers.

For quilting, I use water-soluble colored pencils in the softest quality available; they can be bought from art supply stores. Choose a shade similar to the fabric, but dark enough to be seen clearly. The line wears off the fabric as it is worked and can be lightly sponged if necessary to remove final traces.

The patchworker will find lots of wonderful aids on the market; but if you are a beginner stick to the basics pictured opposite.

Tape Measure Extra-long tape measures are now available, and are 100 inches long or longer with metric markings on the reverse side. They are particularly useful for the longer measurements required when you are making up a quilt. Remember, too, that your grandmother's ancient linen tape could have stretched and may no longer be accurate.

Quilter's Quarter and Seam Wheel These two tools are used to draw an accurate $\frac{1}{4}$-inch cutting line beyond the template outline. The quarter is placed against the marked line and drawn along the outer edge. The seam wheel is rolled around the edge of the template itself by a pencil point that is attached in the center hole. As the wheel moves around, the pencil marks a line $\frac{1}{4}$ inch from the template edge.

Bias-Maker and Bias Bars The bias-maker is a dressmaking tool that turns cut bias strips into the familiar folded strip of fabric seen in commercial bias binding. In the sampler quilt, it is used to create the strips for the leaded effect in stained-glass patchwork. The width of bias-makers ranges from $\frac{1}{2}$ inch to 2 inches, but the $\frac{1}{2}$-inch is most suitable for stained-glass patchwork. Bias bars are another useful tool, produced specifically for quilters to make Celtic patchwork, where narrow strips of fabric are appliquéd onto a background in traditional Celtic interlaced patterns. There are several widths of bias bar, from the narrowest at $\frac{1}{8}$ inch to $\frac{1}{2}$ inch. The $\frac{1}{4}$-inch width is the size most suitable for stained-glass in the sampler quilt.

Masking Tape Special $\frac{1}{4}$-inch masking tape is sold in quilt stores and is really useful for marking the straight lines for quilting. Avoid the wider varieties sold in stationery and harware stores, because they are not the low-tack variety you need for taping onto fabric. Even when using the $\frac{1}{4}$-inch tape, do not leave it on the fabric any longer than necessary, just in case it leaves a mark.

For Making the Templates

Many of the block designs need templates, which have to be copied from instructions and transferred onto cardboard or template plastic. Accuracy is critical here, so you will need very sharp pencils, a good pencil sharpener, eraser, ruler, tracing paper, and cardboard or template plastic.

Template plastic is widely available from special quilt stores and other outlets selling sewing equip-

ment. It makes a good alternative to cardboard because templates made from it can be saved and used over and over again. The plastic is clear and firm, yet pliable and easy to cut with scissors, and it is available in two types: a plain, clear variety and one that is marked with a measured grid. Both are usually sold in packs of sheets in standard sizes.

You also need a water-soluble glue stick and a 12-inch ruler.

Graph paper is very useful for drafting your own patterns and borders. Major stationery stores, as well as quilt and other needlecraft and hobby stores, sell it. Buy pads marked in $\frac{1}{4}$-inch squares. Quality art supply stores usually stock large sheets of graph paper, but avoid buying any with $\frac{1}{10}$-inch markings, because they do not show the $\frac{1}{4}$-inch divisions, and if you find anything other than simple sums difficult, it could present a problem.

Freezer Paper Freezer paper is becoming very popular for appliqué work. It looks like baking parchment, but is slightly thicker and has a shiny side that sticks to the fabric when it is ironed. This makes it particularly useful for appliqué work because it makes small shapes firm while they are being stitched in place. After use, the freezer paper can be peeled off the fabric, without leaving any marks, and reused.

An alternative is the thick paper used to wrap large packs of photocopying paper. If you know any- one who works in an office, ask them to save some for you.

For Machine Work

Sewing Machine This does not have to be a state-of-the-art-model. It just needs to be one you enjoy using and is reliable, a machine that will not suddenly go haywire and chew up your fabric. If you have had your machine for years and never changed the needle or oiled it, this could be classed as criminal neglect. Treat the poor thing to a tune-up, or at least a new needle, a thorough cleaning, and some oil before you embark on your sampler quilt.

Use a size 11/80 needle for medium-weight cotton fabrics and remember that it should be changed after at least every 8 sewing hours. You soon clock up the hours with machine patchwork, so buy a packet of needles and *use* them.

A useful addition to your sewing machine, a walking foot (seen in the foreground in the photograph on page 13) is an attachment that replaces the usual machine foot. It moves the top fabric along at the same time as the lower fabric is moved and prevents the top fabric from creeping and shifting.

A straight-stitch foot is ideal for machine patch-work. You need to stitch straight seams that are exactly ¼ inch from the needle, so a narrow straight-stitch foot is very helpful. The ¼-inch foot that some sewing machine manufacturers have produced especially for quilters is also useful. A walking foot is useful for stitching through layers of fabric and batting because it prevents the top fabric from creeping ahead of the other layers and giving a twisted effect. It also makes sewing on the final binding to the quilt much easier, and it is essential if you venture into machine-quilting.

Thread Use the same cotton or cotton-coated polyester thread as for hand-sewing. A sewing machine is colorblind and is quite happy to have one shade as the top thread and another on the bobbin; what it does hate is mixing different brands of thread, because the different brands do not have the same density. Choose one manufacturer and stick to its thread throughout.

Seam Ripper An invaluable little tool, although I rarely use it for unpicking stitches. I do use it as an extra finger to hold fabric in place while feeding it under the machine foot. The point sticks into the

A well-maintained sewing machine is an essential for machine work on the sampler quilt. New needles and good quality thread will help get good results.

fabric slightly and keeps the layers in place right up to the needle without any danger. It can also prevent the seam allowances from being pushed in the wrong direction by the machine foot as you sew.

Pins For any machine work, I prefer extra-fine, extra-long pins because they slip out of the fabric so easily. However, if you like glass- or plastic-headed pins, and you can use them efficiently, then do so.

For Rotary Cutting

Once you start using a rotary cutter, ruler, and mat, you will wonder how you ever managed without them. These three items are expensive, so you may want to borrow them for a while from a fellow quilter until you have mastered their use. However, you will soon find that you cannot get along without them and you'll have to invest in your own set.

There are several different mats on the market, but do get one with an inch grid marked on it. The back is usually plain, which makes it a useful surface

for arranging designs, because it is also nonslip. There are several sizes of mat, but the most useful for patchwork is 23 x 17 inches. If you try to economize and buy a smaller size, you will soon regret it. The really big mat is ideal if you have a permanent work counter at home, but is very awkward to take out to classes because it must not be rolled. Whatever you do, do not leave your mat in the back of the car in summer, or against a radiator in winter; it will warp and nothing you do will return it to its original flat state. Always follow the instructions printed on the mat itself, and store it flat and out of direct sunlight.

The mat is also self-healing when a rotary cutter is used on it, and the cutting marks disappear, providing you use the appropriate cutter. Craft knives and other blades do real damage, so do not let the family model-maker near it.

Cutters vary in design and more are appearing on the market. Ask other quilters or needlecraft specialists what they recommend, try their suggestions, and use the one you like best. I still like the cutter I started with, which is what many quilters seem to do. Cutters come in several sizes, so if you feel nervous, it is a good idea to start with a smaller one, which does not seem so lethal. A small cutter can cut through four layers of fabric efficiently and is always the best one to use when cutting around small shapes, especially curved edges. I own both large and small cutters, which I use for different tasks. I also have ultra-large cutters, which cut 16 layers or more, but since that seems just a little like boasting, I won't mention them again.

The blades do get blunt with use and must be replaced at intervals. If your blade is leaving tiny fibers of thread trapped in the cut surface of the mat, you need a new one. Often it is only when you use someone else's cutter that you realize just how blunt your own has become. If you are unlucky enough to run over a pin when cutting, the cutting edge will be damaged and you will need a new blade. The large cutter is obviously more dangerous, and you need to develop the habit of always pushing the guard back into place after you have finished using it. The assembly nut should be loosened when it is in use, and then tightened up again for storage. Occasionally the whole thing should be dismantled and cleaned with a smidgen of oil on a soft cloth.

Special rulers have to be used with the mat and cutter. This is not just a marketing ploy. The cutter will actually shave the edges off wooden and ordinary plastic school rulers and even off metal rulers. Rotary rulers are about $1/8$ inch thick and are made of tough plastic. There are dozens of different types:

some nonslip; some with black, yellow, or white markings; some narrow; and some wide. Choose one with markings that you feel comfortable reading, one that measures up to 24 inches. This size will work well on your folded fabric and on the medium-size cutting mat. Because each block for the sampler quilt has to measure exactly $12^{1}/_{2}$ inches square before the framing divider strips are added, a $12^{1}/_{2}$-inch square plastic ruler would make a wonderful addition to your equipment — if you can afford it. However, it is purely a luxury item and not at all essential.

Quilters often find it difficult to cut small pieces of fabric freehand using a rotary cutter. There is a device called a guide arm that you can attach to either a large or small cutter to help you. It can be adjusted so that the black arm is $1/4$ inch from the blade. Using it in this way, you can cut around a drawn shape exactly $1/4$ inch from the line without measuring. The arm also helps to steady the cutter, making it easier to use freehand.

All this fine equipment is useless if it is not used properly and with confidence. The section on rotary cutting (see pages 17–20) gives step-by-step instructions on how to cut the strips and squares you need for the various techniques. Just follow the pictures and you will be successful.

Other Useful Items

Display Board A piece of white felt or flannelette stretched over a bulletin board makes a good surface for placing your pieces and planning your designs, because the cut pieces will "stick" to the fabric without pins. Work with the board upright if you can, as you get a much better idea of the effect than if the board is lying flat on the table. A large cork or styrofoam tile also works well, but with both of these you will need pins to keep the pieces in position.

Light Box A light box for tracing designs onto fabric can be bought from office supply stores, but it is very expensive. All you really need is a flat, clear surface that is lit from below so that the lines to be traced are highlighted through the fabric. A glass-topped table with a light placed underneath it will give the same effect. I use a square of clear plastic supported by four plastic beakers with a light fixture placed underneath it; it's completely portable and very efficient. If all else fails, tape the design to a large window, tape the fabric over the top, and you will be able to see through to trace the outline; obviously, this works only in the daytime.

BASIC TECHNIQUES

Making a sampler quilt is not particularly complex, although it does require an ability to sew and an enjoyment of combining fabrics. Nevertheless, some aspects require a certain amount of expertise to make the finished product as nearly perfect as you would like. This section looks at some of the basic techniques you need to master.

Making Templates

Many of the blocks in this sampler quilt use specific shapes that are joined together to create the overall design. Outlines of these shapes are given with the individual block instructions, and should be traced from the page and made into templates as required.

The templates can be made by tracing each shape and transferring it onto cardboard or template plastic. If using cardboard, first trace the shape onto tracing paper. When tracing straight lines, such as a diamond, mark the corners with a dot and then carefully join the dots with a ruler and a sharp pencil (Figs. 1a and 1b). This makes a more accurate outline than tracing lines directly onto the paper. Slope the pencil at an angle of 45° to the ruler to keep the lines accurate. Mark the arrow to show the direction of the grain of the fabric. Cut out the traced shape roughly, keeping about ¼ inch outside the drawn outline (Fig. 1c). If you are going to piece by machine you could make a template that includes the seam allowance. Glue this onto cardboard, and then cut out the exact outline through both tracing paper and cardboard. Try to cut just inside the drawn lines because this keeps the measurements accurate as you draw around the template onto the fabric.

If using template plastic, trace over the outline and grain arrow in the way described above. Cut out the template carefully with scissors, again cutting just inside the lines to keep the measurements accurate. Label each template clearly, and put them all in an envelope or transparent wallet or folder so you can use them again.

When you get more adventurous and want to draft your own patchwork blocks, draw the design accurately on graph paper first, and then make templates following the instructions above.

Fig. 1a

Fig. 1b

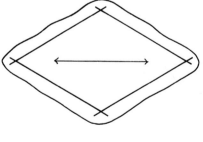

Fig. 1c

Pressing

A good iron and ironing board are essential for all sewing work. Press all your fabric before you use it, because wrinkled fabric leads to inaccuracy. When pressing seams in patchwork, use a dry iron because steam can distort, especially on bias seams. There are times, of course, when you actually want to distort the fabric; for example, when two sides that should match, do not. At such times, having a steam option on your iron is good news.

Try to resist the temptation to press seams in patchwork from the back. It does seem the logical thing to do, so that you can make sure the seams are

all lying flat to one side. However, you could press little pleats in the fabric over the seams, which you discover only when you turn the piece over to the front. These tiny, roll-over creases are hard to press out and can lead to inaccuracy. So always press from the front, guiding the seams away from the iron with your other hand so that the iron itself is pushing the seams to one side as it presses (Fig. 2).

Fig. 2

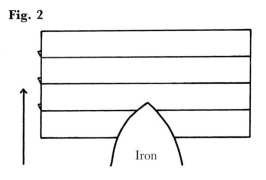

Iron

Setting Up the Machine

It is important to have your sewing machine and chair at the right height. An office chair might be a good investment because it can be adjusted to your personal requirements; alternatively, firm cushions on an ordinary chair may solve any problem.

If you are short of space and cannot leave your sewing machine permanently in position, do all the preliminary cutting work first, and then clear a space for the machine. Most of the machined techniques require you to sew, cut, and sew in sequence, so you will still need to find a space for the cutting mat once the machine is in use. But at least by then, the pieces of fabric will be smaller and the whole space easier to organize.

Thread the machine to prepare it for use. If it has an extension plate that fits on to create a larger surface, use it, because it supports the patchwork and stops it from pulling away from the needle as you stitch. Set the stitch length to a shorter stitch than used for dressmaking — about two-thirds the usual size, or about 15 stitches to the inch. This will be small enough to prevent the seams from coming undone when they are cut, but not so small that you could never unpick the stitches if necessary.

Many people find stitching a straight line very difficult. If you can get a $1/4$ inch foot will fit on to your machine, it really will help. One trick is to tape a strip of masking tape onto the machine exactly $1/4$ inch away from the needle. This makes a good edge to line your fabric against as you sew. Measure the distance from the needle by taking a piece of thin cardboard and drawing a line exactly $1/4$ inch from

the edge. Lift the machine pressure foot and position the needle down into the cardboard on the drawn line. Now tape a strip of masking tape beside the edge of the cardboard (see the picture below). This should be exactly $1/4$ inch from the needle. If you still find it difficult to stitch straight, tape a double layer of masking tape onto the machine, $1/4$ inch away from the needle so that there is a ridge of tape to push the fabric against as you sew. Use the point of a seam ripper to help guide the fabric accurately you are while stitching.

Masking tape helps keep the $1/4$-inch seams accurate.

TESTING FOR ACCURACY

There is a useful test to find out whether your $1/4$-inch seam is accurate. The seam may be just right mathematically, but because the seams are pressed to one side rather than pressed open, it makes the seams a tiny bit wider, so you need to stitch a slightly skinny $1/4$ inch to finish up with the correct sizing. (I can hear the mathematicians shuddering as they read this, questioning how you can have skinny seams and fat seams, but that is what you get if you work with fabric and not with well-behaved paper.)

Take a strip of one of your fabrics, 2 inches wide and about 18 inches long, and cut it into three lengths (Fig. 3a). Stitch these three lengths together with a $1/4$-inch seam allowance. Press the seams to one side, from the front of the work, so the seams are really flat (Fig. 3b). Now measure the work from side to side. It should be exactly 5 inches. If it is smaller than this, your seams are too wide; if it is more than 5 inches, your seams are too narrow. Try the test again, adjusting the position of your masking tape until you get exactly the right seam allowance.

Fig. 3a

Fig. 3b

Press in this
direction from
the front of
the work.

Once this has been done, you are set up for all your
future patchwork.

Rotary Cutting

To cut the fabric, place it on the mat and align the
woven threads of the fabric (called the grain) with the
gridlines on the mat. Position the ruler on the fabric
and hold it firmly so your hand forms an arch and is
not lying flat, since there is more strength in your fin-
gers than in the flat of the hand. Hold the cutter at
an angle of 45° to the mat, not leaning to one side
or the other. The flatter side of the cutter should be
against the side of the ruler, not the side with the
assembly nut. Snap down the safety guard only when
you are ready to cut (picture 1). Left-handed users
simply cut from the left side rather than from the
right. Get into the habit of always cutting *away* from

2. Cut firmly along the edge of the ruler.

3. Hold the ruler in position with the left hand.

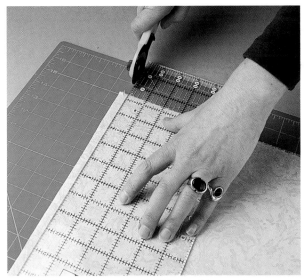

1. Ruler and cutter are held in position ready to cut.

4. Move the left hand up the ruler as you cut.

you. Start at the near side of the mat and begin cutting before the blade reaches the fabric, pressing down firmly and evenly in one continuous movement (picture 2, page 17). If the ruler has a tendency to slip to one side as you cut, stop cutting and move your hand, crablike, up the ruler before starting to cut again. Flip the cut edge of the fabric back so there is a clear space of mat on which to restart cutting (pictures 3 and 4, page 17).

CUTTING STRIPS

Remember that strips cut from the width of the fabric will be stretchy, so whenever possible cut strips down the side parallel to the selvage. If you are working with more than a couple of yards of fabric, cutting from the long side of the fabric will also keep the length intact for use in borders later. Many quick machined patchwork techniques require accurately cut strips of fabric, and these long lengths mean more speed and less waste.

Turn the cutting mat so the longer side runs from top to bottom to give a longer cutting distance. If the piece of fabric is too long for the mat, fold it carefully as many times as needed to make it fit on the cutting mat with the selvage edges *exactly* on top of each other. It may help to press the layers together with an iron, but do not use pins in case you accidentally run over a pin with the cutter and ruin the blade. Place the fabric on the mat with the folded edge along a horizontal gridline (picture 5). This is very important to avoid getting V-shapes in the final long strip.

Place the ruler on one of the vertical gridlines on the mat and trim off the selvages (picture 6). To cut a strip of a measured width, use the marked measurements at the top and bottom of the mat. I never trust my arithmetic, so I actually count the number of inches along the top markings on the mat. Move the ruler to this position, hold it firmly, and cut along its edge. Before moving the ruler, check that all the layers have been completely cut through. If not, recut the whole strip instead of sawing away at the uncut section.

Lift the ruler and reposition it for cutting the next strip (picture 7). Continue to cut until the necessary number of strips has been cut (picture 8, page 19).

5. To cut strips, fold fabric to fit mat (if needed). Line up folds with a horizontal gridline on the mat.

6. Selvages are trimmed away, using a vertical gridline on the mat as a guide.

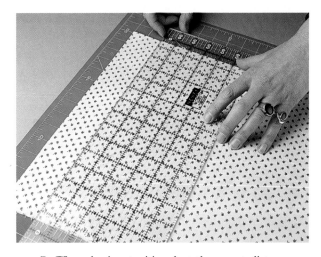

7. The ruler is repositioned at the correct distance for the strip width, using the mat markings as measurements.

◆◆

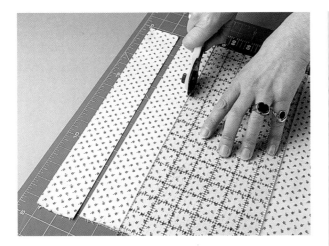

8. Continue to move the ruler across the fabric and cut strips in the same way, using the mat markings as measurements.

AN ALTERNATIVE METHOD FOR CUTTING STRIPS

When cutting strips or drawing a grid for quick-pieced triangles, measurements like $3\frac{7}{8}$ inches are quite common. It is all too easy to mismeasure when using the mat markings as a guide. Instead, after trimming the selvages, turn the mat 180° without disturbing the fabric, or walk around the mat to the other side if necessary. Start cutting from the left-hand side instead of from the right. If you are left-handed, just reverse these directions (picture 9). Pass the ruler over the cut edge until the fabric edge lines up with the required measurement on the ruler itself; ignore the markings on the mat, except as a general indication that the ruler is staying truly vertical (picture 10). Cut along the ruler's right side and

9. Alternatively, start by cutting from the left-hand side.

remove the cut strip (picture 11). Move the ruler across the fabric until the new cut edge matches up with the required measurement on the ruler, and cut once more. Continue to do this across the fabric as many times as necessary.

10. Pass the ruler over the fabric edge to the required width.

11. Cut along the ruler's right side and remove the strip.

CUTTING A SQUARE

If the fabric will fit onto the mat without hanging over the edge, place it down with the grain parallel to the mat's gridlines. Straighten one edge of the fabric by lining up the ruler with a vertical gridline and cutting against it. Without moving the fabric, cut a second vertical line at the desired distance from the first one. Personally, I've found it a good idea always to count the squares to make sure that I have got it right. Turn the mat 90° and trim the other two sides of the square in the same way.

If the piece of fabric is too big for the mat, you

could cut out the square roughly first, and then trim it on the mat as described above, or alternatively use one of the large square rulers. Place a corner of the fabric on the mat, matching the fabric grain with the mat's gridlines. Position the square ruler on it with about ½ inch of fabric to spare on two sides. Trim

12. Trim two sides of the fabric with a square ruler.

13. Move the ruler over the cut edges.

14. Trim the remaining two sides of fabric.

along these sides with the cutter (picture 12). Turn the square so the diagonal line marked 0 is at the trimmed corner. Move it across the cut edges until the chosen measurement on the two sides of the ruler lines up with the cut edges (picture 13). Trim the remaining two sides to complete the square (picture 14). This way, the square is cut with very little waste.

USING THE SEAM GUIDE

Once you are accustomed to using the rotary equipment, you may find it frustrating to slowly cut around shapes with scissors. When preparing for American pieced patchwork blocks, like Card Trick, I draw around each template, and then, cut the extra ¼-inch seam allowance needed with a small rotary cutter. The guide arm attachment for the cutter gives greater accuracy and makes the cutter steadier.

Attach the black arm at a distance of ¼ inch from the blade. If you have a small cutter, you'll find it ideal. With the wrong side facing up, place the fabric on the mat so the drawn template shapes can be seen. Smooth down the fabric to make cutting easier.

Run the cutter around each shape with the black arm running exactly on the drawn outline. The blade will automatically cut at a distance of ¼ inch from the line (picture 15).

Do not think that you *have* to use this gadget. It may suit the less patient person who likes to whip through everything quickly. But if you enjoy the quiet tranquillity of cutting each piece as you sit, then that has to be the best way for you.

15. To cut a ¼-inch seam allowance, use a guide arm.

MAKING THE BLOCKS

You are now almost ready to start making the blocks for your sampler quilt. Each design and technique you will need is fully described, with step-by-step instructions, and I have tried to give some suggestions for selecting colors and fabrics for each one. If you look at the quilt photographs throughout the book most made by first-time quilters, you will get some ideas for your own color schemes.

The blocks are presented in sequence, so the skills learned in one design are built upon in the following block. Probably the best way to use the book is to work through the block instructions, one by one. However, if you absolutely hate all machine work, then just leave out all the machine blocks and make twice as many hand-pieced blocks. In the same way, if you find a block that you feel is not for you, then just leave it out. It is, after all, your quilt, and you are allowed to pick and choose.

The advantage of making and quilting the blocks individually, and then assembling them, is that you can decide how many you want to make. Whether they finish up as a huge king-size quilt, a baby's crib quilt, or a series of cushions, it is up to you.

Detail from a quilt made by Sue Fitzgerald.

ENGLISH PATCHWORK

BABY BLOCKS

Patchwork over papers is a traditional English method of patchwork. Some people believe that hand-stitching hexagons is the best form of patchwork there is, while those with more experience in quilt-making often see the hexagon as a design cliché lacking in imagination and creativity. Although this can be true, I have seen some beautiful hexagon quilts made in recent years, where scraps of many fabrics have been blended and balanced for color and design. These quilts are destined to become

heirlooms, passed on and treasured independently for their looks as well as for their nostalgia. The almost mindless repetition involved in this method is wonderfully soothing and therapeutic to do, and I have seen many a quilter abandon a challenging project in times of stress, unhappiness, or sheer fatigue to take up a piece of English patchwork over papers.

It is not just hexagons that are stitched in this way, but any geometric shape that does not fit neatly into squares and rows, such as diamonds, octagons, and equilateral triangles. The papers give a rigid outline to the shapes, which makes it easy to join them together with great accuracy. Once completed, the papers are all removed and can be reused on another project.

For the sampler quilt, I have chosen a design called Baby Blocks, an arrangement of diamonds that gives the illusion of a three-dimensional tower of blocks. It is also known as Tumbling Blocks.

COLOR CHOICES

The design is made up of groups of three diamonds arranged to form a hexagon. To obtain the three-dimensional effect, use three different fabrics: one dark, one light, and one medium. Place the three fabrics beside each other to verify that one stands out as being lighter and another definitely darker; the third fabric will lie between these two extremes as a medium value. The contrasts do not have to be great, but should be enough to register on the eye, or the illusion of a tower of bricks will be lost. Half-closing your eyes when looking at the fabrics will help you see the difference in shade. A fourth fabric is needed for the background on which the tower sits. You may like to use the same background fabric for all of your blocks to give continuity to the quilt, or you may decide to vary the background from block to block. A plain fabric is the obvious choice, but also consider a small pattern or textured design; even a small check or dot will read from a distance as plain, but could add more interest.

The possibilities are there for you to make your own personal choice. Do not rush. Place the three fabrics for the Baby Blocks in the middle of your background choice and consider the effect. If you are not sure, try another background, and then go back to the first. If you are still unsure, make the Baby Blocks first, then arrange them on various fabrics to see what looks best. All the time you are sewing the diamonds, you can be quietly thinking about the options for the background and could come to a decision before you get anywhere near the final stage of patchworking.

CONSTRUCTION

1 Make a template by tracing the diamond shape from Fig. 1, cutting it out, and gluing it onto cardboard, or use template plastic. See page 15 for instructions on making templates.

Fig. 1

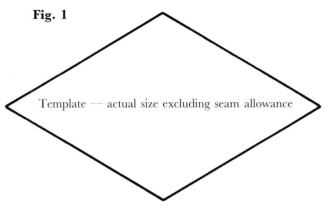

Template — actual size excluding seam allowance

2 Using a really sharp pencil to keep the shape accurate, draw around the template on thick paper; sketching paper or the paper in children's coloring books is ideal. Do not use cardboard because it is too thick. Mark the corners of the diamonds by continuing the drawn lines to just beyond the template corners so that they cross. This cross marks the exact corner and will make cutting out more accurate (Fig. 2).

Fig. 2

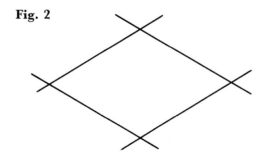

3 Cut out 18 paper diamonds, cutting just inside the drawn lines to prevent the shapes becoming larger than the original diamond. On the wrong side of each fabric, pin six paper shapes, following the straight grain of the fabric and leaving a 1/4-inch gap around each paper, as shown in Fig. 3.

Fig. 3

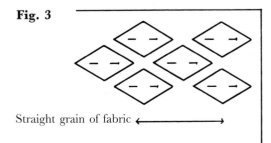

Straight grain of fabric ⟷

23

4 Cut around each paper, adding a ¼-inch seam allowance on all sides. A quilter's quarter or a seam wheel will help to make this seam allowance accurate. Try to avoid cutting a seam allowance less than ¼ inch because this makes basting difficult. The points at the long corners can be shortened to leave a ¼-inch margin of fabric beyond the paper (Fig. 4).

Fig. 4

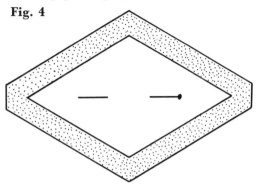

5 Thread a needle — I use either crewel needles or size 8 or 9 sharps — with basting thread. Begin with a knot. Baste fabric to paper by folding the seam allowance tightly over the paper and stitching it down. The corner of folded fabric extending beyond the diamond can be ignored at this stage (Fig. 5).

Fig. 5

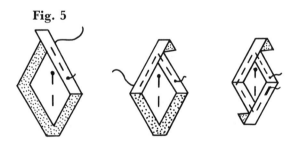

6 Turn the basted shape over and check that the corners exactly outline the shape of the paper beneath it (Fig. 6). Remove the pins.

Fig. 6

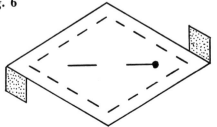

7 Arrange one light, one medium, and one dark diamond in the desired design (Fig. 7). I have put the lightest fabric horizontally across the top of each block, but you may like to arrange them

Fig. 7

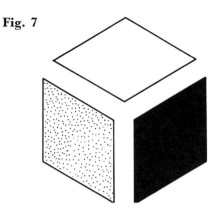

differently. If all six blocks are identical, you can place the diamonds however you like. Thread a needle with no more than 18 inches of coordinating thread. If stitching two differently colored fabrics together, match the thread to the darker fabric because it is always less obvious than the lighter.

8 Take two diamond shapes and place them right sides together, ready to sew. If one edge seems longer than the other (this happens more often than you would think, so do not blame yourself), place them so the shorter edge is lying on top as you work. As you sew, the top layer stretches, just as it does on a sewing machine, so you can ease the shorter edge to fit the longer. Pin the corner you are working toward (Fig. 8) so that the two corners will match exactly as you sew. Starting with a double stitch to secure the thread, overcast with small even stitches, making sure that the two sets of corners match exactly.

Fig. 8 Pin

FINISHED QUILT BY SHIRLEY STOCKS

"Making the sampler quilt really increased my understanding and confidence in choosing and matching colors and patterns. I found the hand quilting on the deep borders very hard to master, but convinced myself that it was character-building."

9 The stitches should be about the same distance apart as small machine stitches. If you stitch too closely, you can weaken the fabric and make an almost a satin-stitch effect, which will prevent the finished seam from lying flat (Fig. 9).

Fig. 9

WS

10 As you sew the corners, push the seam allowances to one side so they stick out beyond the edges (Fig. 10). When the papers are removed, these extra flaps dovetail with each other without adding extra bulk. Do not trim down these flaps, because that can weaken the seams. Finish sewing with a double stitch and cut the thread, leaving about ¼ inch for safety. Open out the two diamonds and attach the third diamond in the same way, sewing another double stitch at the meeting point of all three diamonds to strengthen the hexagon.

Fig. 10

WS

11 Assemble all six hexagons in this way, and join them together to make the tower shape (Fig. 11). Press before removing the papers so the outer seam allowances remain turned under. Remove basting by undoing the final stitch and pulling firmly on the knot to pull the basting thread out in one length. The papers can then be lifted out and stored. Baste around the edges of the tower shape to keep the seam allowances in place, folding back any flaps that are sticking out under the main shape and including them in the basting. Cut a 13-inch square of fabric for the background. Although the finished size will be 12¹/₂ inches square when one fabric is stitched onto another (known as appliqué), the bottom fabric often draws up slightly to finish up smaller than when you started. By using a 13-inch square, you can trim it accurately to 12¹/₂ inches when the tower has been stitched in place.

Fig. 11

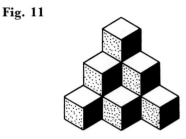

12 Place the tower in the center of the background fabric. Fold the square in four and crease it lightly with your fingers to make guidelines for centering the tower. Pin or baste the tower onto the background square. Using thread to match the tower and not the background, sew the tower onto the fabric. Sew a double stitch at each corner to secure it (Fig. 12).

Fig. 12

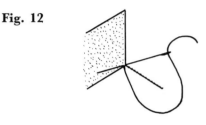

13 Before an appliquéd shape is quilted, its thickness can be reduced by cutting away the fabric from behind the appliqué. This is not compulsory. However, it does make the piece easier to quilt and allows it to lie flatter.

Turn the block to the back and, with your fingers, just pull away the backing from the appliqué at the center. Make a small cut in the backing fabric. Once you have done this, carefully cut away the backing up to ¼ inch from the stitching line of the appliqué, leaving the appliqué itself intact (Fig. 13).

Fig. 13

WS

Trim the finished block to an exact 12¹/₂ inches square and add the framing divider strips, or sashing, (see page 110 for instructions). If you have not yet chosen the sashing fabric, leave the block until you have completed enough other blocks to help you make your decision.

MACHINED STRIP PATCHWORK

RAIL FENCE

This block is a traditional strip design, which in the past was made by hand, using a template for each strip. We can now use a rotary cutter and ruler to cut the strips and a sewing machine to stitch the block quickly and accurately.

The design is made by sewing together three long strips of different fabrics and then recutting this band into squares. The squares are then arranged and joined together to make the block. The project on page 135 uses Rail Fence blocks to make a quillow.

COLOR CHOICES

For this block you need three fabrics. The same combination of fabrics used in Baby Blocks (see page 22) could be used again, or you could make a new selection. Fold the fabrics into narrow strips and place them next to each other on a flat surface so you can see how they look together. If you are unsure about the effect, cut four strips of each fabric, measuring $\frac{1}{2}$ x $1\frac{1}{2}$ inches, and arrange them in various combinations until you get the best effect. Glue the chosen fabric onto cardboard or paper.

CONSTRUCTION

1 From each fabric, cut one strip measuring $2\frac{1}{2}$ inches wide and 28 inches long (Fig. 1). If you are trying to cut your strips parallel to the selvage and cannot cut a strip 28 inches long, cut two 14-inch-long strips of each fabric instead. See page 18 for instructions on cutting strips.

Fig. 1

2 Set the stitch length on your sewing machine to about two thirds the size of the usual dressmaking stitch, small enough to prevent the seams from coming undone when the strips are cut across, but not so small that you could never unpick the stitches. See page 16 for setting up the machine. Make sure that the sewn seams are a scant $\frac{1}{4}$ inch. A strip of masking tape stuck onto the machine plate at the correct distance from the needle can provide a useful guide. Stitch the three strips together. I do not use pins, but stop every 3 to 4 inches and line up the next section of fabric edges as I go. Alternate the direction you sew the strips to keep the band straight, not slightly rippled (Fig. 2). Try not to stretch the strips, but guide them gently, using small scissors or the point of a seam ripper to keep the edges in position.

Fig.2

3 Press the band from the front with the seams all in one direction (Fig. 3). See page 15 for general advice on pressing.

Fig. 3

4 Place the fabric band horizontally on the cutting mat, lining up the top edge with one of the horizontal markings on the mat. If you are lucky, the band will be perfect and lie flat. It is more likely to have a slightly wavy or rippled effect, the result of joining together three different fabrics. You cannot help this, so just place the band as flat as possible and continue. Measure the width of the band. If you have stitched an accurate scant $\frac{1}{4}$ inch, the band should be $6\frac{1}{2}$ inches. Using the rotary ruler and cutter, trim one end of the band to straighten it and cut four sections, each $6\frac{1}{2}$ inches long, to make four squares (Fig. 4).

If your band does not measure $6\frac{1}{2}$ inches, even if it is only $\frac{1}{8}$ inch off, take the width measurement you have and cut the four squares to match it. This way, you will have true squares even if they are slightly more or less than intended. You can make adjustments later on if necessary.

Fig. 4

FINISHED QUILT BY DAPHNE GREEN

"This quilt nearly became another unfinished statistic because of the problems I had with the borders. Still, with a great deal of help and encouragement, it was finally completed!"

◆◆

5 Arrange the four squares to make the block design (Fig. 5). Pin and machine-stitch the top two squares together with a ¼-inch seam.

Fig. 5

6 If you place the pins at right angles to the seams, you will be able to stitch right up to each pin before removing it (Fig. 6). If the two edges do not match exactly, because one is shorter than the other, pin and stitch with the shorter edge on top. This will stretch slightly as you stitch and should solve the problem. Press the seams to one side from the front of the joined squares.

Fig. 6

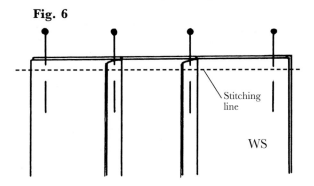

Stitching line

WS

7 Pin and machine-stitch the second pair of squares. Press the seams in the opposite direction to the first half (Fig. 7).

Fig. 7

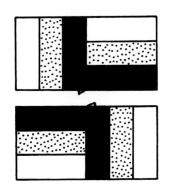

8 Join the two halves by stitching across with a ¼-inch seam, being careful to match the center seams. Pressing the center seams of each half in opposite directions will help you to match them accurately, because they lock into each other as you sew. Pin diagonally to help keep both sets of seam allowances flat while stitching (Fig. 8).

Fig. 8

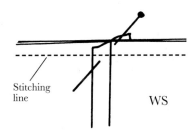

Stitching line

WS

9 The final long seam can be pressed to one side, or if this makes it too bulky, press the seam open (Fig. 9). Trim the block to an exact 12½ inches square. If it is too small, cut it down a little more and add an extra border with a fabric that frames the block well. See page 117 for instructions on trimming and bordering blocks. This border can then be trimmed down to make the completed block exactly 12½ inches square. If you have chosen the fabric for the sashing strips, add them, following the instructions on page 110. If not, just leave your decision until you have made a few more blocks.

Fig. 9

Seams pressed open

WS

AMERICAN PIECED PATCHWORK

MAPLE LEAF

It was seeing the quilt collection in the American Museum at Claverton Manor, near Bath, England, that started my life long love affair with quilts and quilt-making. Previously I had seen only museum exhibits of Victorian hexagon or octagon English pieced quilts, often unfinished, and until then I had no idea what a rich mix of shape and color had been established in traditional American quilts.

Many people dismiss the idea of piecing patchwork using papers. But a different technique of hand-piecing

evolved in America when the early settlers from Europe found themselves facing cruel winters without sufficient warm covers. They needed to make thick comforters as quickly as possible from the few cloth scraps and rags available, so they joined squares, rectangles, and strips into a blanket-shaped piece. Another similar shape was made, and a filling of rags, wool, and feathers or corn husks was placed between the two to give warmth. To keep the filling in place, an even running stitch was made through the layers.

In time, the makers of these quilts used the traditions of quilt-making that had been brought with them from Europe to turn the random piecing of patches into regular designs. The designs took the form of squares, called blocks, of sizes varying from 10 inches to 16 or 18 inches, which were repeated and joined to make quilts. There are now hundreds of traditional block designs, many appearing in different areas of the US under a variety of names. Some of their names reflect the life of those early settlers, such as Bear's Paws, Goose Tracks, and Hovering Hawks. Others show a religious influence, like Jacob's Ladder, Hosanna, and Steps to the Altar, and others have been named after a person.

The stitching in these blocks did not need to be as strong as that in English patchwork because the quilting stitches that crossed and recrossed the quilt through all the layers reinforced the fabrics and took the strain off the linking stitches. The traditional American method of patchwork uses templates to mark the fabrics, and the pieces are joined by matching up and stitching along the drawn lines.

The block I have chosen to introduce this traditional technique is the Maple Leaf (shown below). It is a design based on nine squares, some of which are divided into smaller shapes. Any pattern that has these nine basic squares is called a Nine Patch, and many Nine Patch designs can be found among the traditional patchwork blocks. A border strip has been added to the left side and along the bottom of the block. I especially like the diagonal slant to this block because it gives a lovely feeling of movement when repeated on a large quilt. It is ideal for a corner block in a sampler quilt, where it draws the eye from the corner into the main quilt.

COLOR CHOICES

This block needs three fabrics: one for the leaf itself, one for the background, plus another fabric for the border strips. The corner square at the bottom left corner of the design could be made from the leaf fabric, the background fabric, or another fabric altogether. Do not think that you need to choose a correct leaf color. The *shape* is a maple leaf, but the colors can be whatever suits your own quilt. You need a smaller square of background fabric than for the Baby Blocks. Here every piece is cut to shape and joined with its neighbor to form the complete block.

CONSTRUCTION

1 Make templates by tracing the five shapes on page 34, cutting them out, and gluing them onto cardboard, or use template plastic (see page 15 for instructions on making templates). On the wrong side of each fabric, draw accurately around the templates using a sharp marking pencil. This marks the sewing line. Leave at least ½ inch between each drawn outline so a seam allowance of ¼ inch can be added to each shape when cutting out (Fig. 1).

Fig. 1

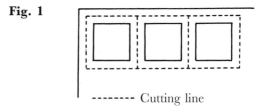

-------- Cutting line

2 For the leaf, you will need three of square A, four of triangle B, and one of stem-shape C. Save space by arranging the shapes on the fabric as shown in Fig. 2. For the background, you need one of square A, four of triangle B, and two of triangle D. For the border, you need two of rectangle E and one of square A.

Fig. 2

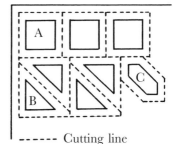

------ Cutting line

3 Cut out each shape (Fig 3, page 34) to include the ¼-inch seam allowance, by using a ¼-inch ruler known as a quilter's quarter or a seam wheel (see Basic Equipment, pages 10–14). I like to cut

FINISHED QUILT BY MARION EDWARDS

*"My memory of my sampler quilt is of the wonderful scenery
of a New Zealand holiday. The colors seemed appropriate too.
It's amazing how many blocks will fit into a handbag for
whiling away the time on long journeys!"*

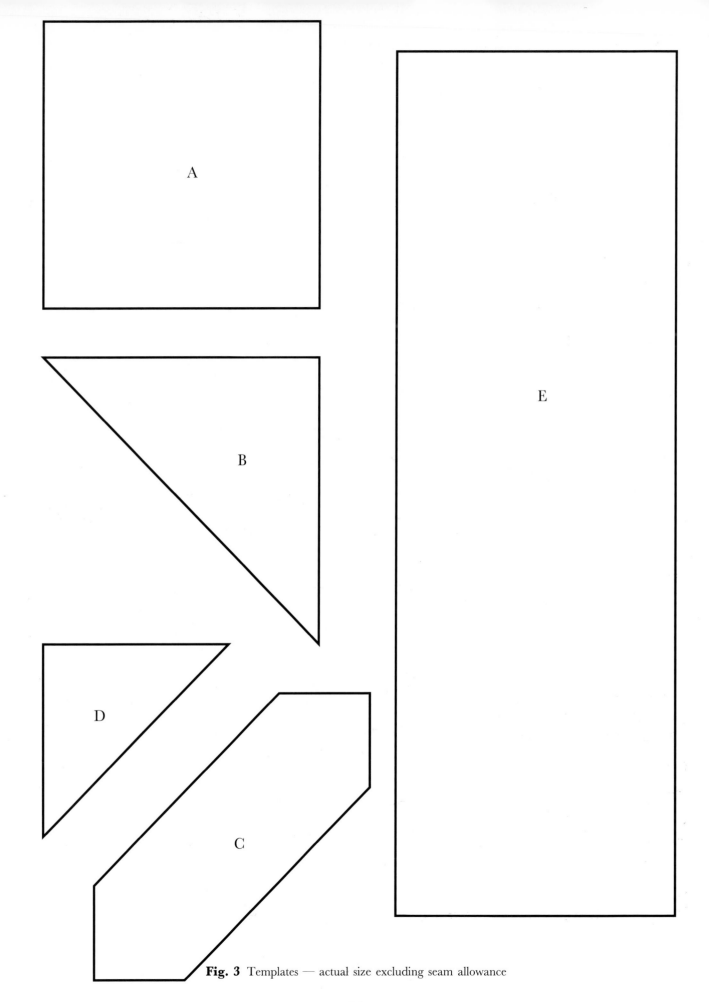

Fig. 3 Templates — actual size excluding seam allowance

on a mat with a small rotary cutter with the seam guide set ¼ inch from the blade.

4 Arrange the cut pieces on a flat surface, or pin them in position on a piece of plastic foam. Adjustments can be made at this stage. Do not assemble the leaf, and then join it to the background. Instead, assemble each of the nine squares first, as shown in Fig. 4. Place the first two triangles together, right sides facing. The pencil markings will be on the outside and must be exactly on top of each other, as they indicate the sewing lines.

Fig. 4

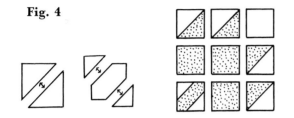

5 Align the starting points of the sewing lines by pushing a pin through both layers of fabric until the head is on the surface of the top fabric. Repeat this to mark the finishing point (Fig. 5a). Reposition the pins at right angles to the seam. Add more pins along the seamline, matching the marked lines (Fig. 5b).

Starting with a double stitch, sew along the penciled line with small running stitches, about the same length as machine stitches, loading several stitches on to the needle at a time. Begin each run of stitches with a backstitch to secure the work firmly. Finish the seam exactly at the end of the marked line with several backstitches (Fig. 5c).

Do not sew into the seam allowances. These are left free so that, once the block is complete, the seams may be pressed to one side. Occasionally machined seams can be pressed open, and I have indicated where this is possible in this book, however hand-stitched seams are never pressed open, because the hand-sewn stitches are not strong enough.

Fig. 5a **Fig. 5b**

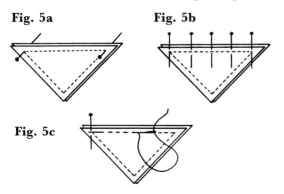

Fig. 5c

6 After all nine squares are assembled, sew together the horizontal rows of three squares, pinning and matching the seams as before (Fig. 6).

Fig. 6

7 Join the top two rows by placing them with right sides together, matching seams. Push a pin exactly through the seams and corners on each piece. Reposition the pins at right angles to the seams and add more along the seamlines, matching the marked lines (Fig. 7a). As before, sew together without sewing into the seam allowances; instead, sew up to each seam and make a backstitch. Pass the needle through the seam allowances to the other side. Backstitch again and continue sewing (Fig. 7b). Join the third row in the same way.

Fig. 7a **Fig. 7b**

8 Attach a border strip to the side of the block, using the same method. Join the remaining square and border strip together. Finally, sew these along the bottom edge to complete the block. Measure the block. It should be 12½ inches square. If it needs trimming, trim away on the two border sides *only* so you do not trim off the corners of the maple leaf (Fig. 8).

Fig. 8

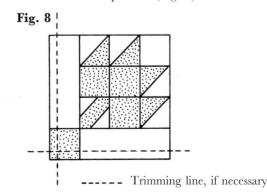

------ Trimming line, if necessary

9 When you are ready, add the sashing strips. See page 110 for instructions.

TRIP AROUND THE WORLD

This design of squares is a traditional pattern frequently found in Amish quilts. The Amish are a religious sect, who live in Pennsylvania, Ohio, and Indiana. They left Alsace, on the borders of France and Germany, to avoid persecution in the 18th century and founded their own farming communities in the New World. They live a simple life set apart from the surrounding world. They do not use the telephone or electricity or automobiles. The horse and buggy is their means of transportation. They are

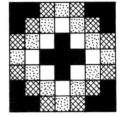

known as excellent farmers, and they till their fields with horse-drawn equipment. They follow a strict code in the way they decorate their houses and in their clothing. Everything is plain. They make all their clothes, using black, white, gray, browns, greens, blues, and mauves. The women's dresses are simple and are worn with a white bonnet and a black or white cape and apron. No ruffles or patterned fabrics are used in their clothing, nor in the quilts for which they are famous. The simple quilt designs use a mixture of clear, plain colors and have a strength and elegance. Amish quilts, have been likened to modern abstract art, and some are now collector's items, commanding very high prices.

The design Trip Around the World is based on simple squares using several colors. The central square represents the world, and each surrounding row is a new color, making a diamond design around the single central square (below). There must be an

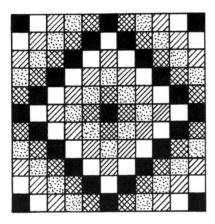

odd number of squares in each row — 9, 11, or 15 — so there is one square in the center of the block for the focus (the world). For the 12-inch block in the sampler quilt, I have used seven squares in each row so the piecing is not too tedious, making a total of 49 squares.

COLOR CHOICES

If you wish, you can use seven colors, changing for each circuit of squares. This can look very intricate, so you may wish to limit the fabrics to four or five. Three different arrangements of squares are given as examples of variations on this design, to give you some ideas (above right). Most books suggest that when planning the colors for a design like this, you should draw out the block on squared paper and color it in to see the different effects. That is fine, but I find it very difficult to relate the shaded pencil col-

ors to actual fabric. Ideally, you should just cut lots of fabric squares and play with them, but that inevitably leads to waste. It also takes a strong person to 20 cut squares of one fabric in favor of another because the original idea did not work as well as had been hoped. I favor a compromise: from each fabric, cut a strip ½ inch wide and 10 to 12 inches long. From these, cut off ½-inch squares. Now play with these small pieces until you find the design you like best. There is little waste using these narrow strips, and you will get a good idea of what the completed block will look like. Either glue the chosen arrangement onto cardboard or paper, or draw a plan of it on graph paper to keep as a reference. Using a felt board is ideal, because the fabric squares can be placed on it and they will stay in position without pinning (see Basic Equipment, p.10).

CONSTRUCTION

1 From your chosen fabrics, cut strips $2\frac{1}{4}$ inches wide. The length of each strip will vary according to how many $2\frac{1}{4}$-inch squares are needed for your design. Place each strip horizontally on the cutting mat, lining the top long edge with a horizontal marking line on the mat. Cut pieces from each strip to make $2\frac{1}{4}$-inch squares (Fig. 1).

Fig. 1

2 Arrange the squares in your chosen design and check that it looks as good as it seemed when you made it with the tiny squares. Stitching an exact ¼-inch seam at all times, machine together the squares from the top row of the design. Position the squares by matching them edge to edge, so there is no need to pin them together. If you use a smaller stitch (about two-thirds the normal size), there is no need to secure the ends by reversing the stitching. Since the design is symmetrical, Row 1 will be the same as Row 7, Row 2 the same as Row 6, and Row 3 the same as Row 5. Row 4 is the center row, and unique (Fig. 2).

Fig. 2

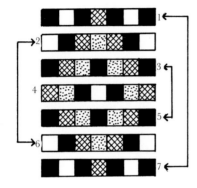

3 Consider streamlining your stitching and saving time and thread by sewing each pair of identical rows at the same time. Stitch together the first pair of squares in Row 1, stopping at the last stitch on the fabric. Take the identical pair of squares from Row 7 and place them with right sides together, matching the edges. Without lifting the pressure foot, slip this pair under the front of the foot and continue sewing (Fig. 3a). A short line of machined stitches will separate each pair of squares. Remove the squares from the machine and cut the threads to separate them. Open out the joined squares from Row 1 and place the third squares in position. Stitch down this seam and continue stitching the identical seam for row seven (Fig. 3a). Remove the pieces from the machine and

cut the threads to separate them. Continue to do this for each square that you add, stitching Row 1 first, and then Row 7. Do the same for Rows 2 and 6, and for Rows 3 and 5. This technique is called stringing, or chaining.

4 Press from the front, ironing the seams of row one in one direction and those in row two the opposite way. Press each row with seams alternately pressed to the right and left. Pin together Rows 1 and 2, matching the seams. This is made easier by the pressed seams, which lock into each other (Fig. 4a). Pin diagonally across the seam allowances to keep them flat while stitching (Fig. 4b).

Fig. 4a **Fig. 4b**

5 If the squares do not all match each other, and a little "easing" has to be done, stitch with the shorter edge on top, because this will stretch. Stitch Rows 1 and 2 together. Continue to pin and stitch each row until the block is completed.

6 Press from the front with the seams to one side, as before. If the seams are too bulky, press these final long seams open from the back.

7 Measure the completed block. It should be slightly more than 12½ inches square and will need to be centered and trimmed down on all four sides to an exact 12½-inch square. See page 109 for instructions on trimming the blocks.

8 When you are ready add the final sashing strips. See page 110 for instructions.

Fig. 3a **Fig. 3b**

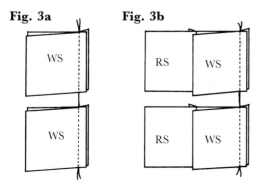

FINISHED QUILT BY CHRIS MUNDY

"The quilt includes some of my favorite things: shades of blue, decoy ducks, and, of course, patchwork and quilting. It won a silver cup as first prize in the handicraft section at the local flower show. Flushed with success, I have now embarked on another sampler quilt."

◆◆

AMERICAN PIECED PATCHWORK

CARD TRICK

This block uses only two templates, which is fewer than the Maple Leaf. But the pieces are smaller, so there is more work involved. When I made my own sampler quilt, I made the finished size of the Card Trick block exactly 12 inches, but I altered the size to a 9-inch block with an added surrounding border for the students, in case the completed blocks finished up a little bigger than planned. Trimming the block down to size would have cut off all those beautiful points around the outside edges and ruined

40

the effect. This was just a contingency plan, however, when I saw it I liked the smaller scale of the 9-inch block and wished I had made mine that size (as shown below).

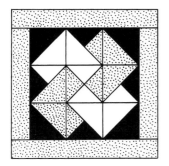

The templates here are for a 9-inch block, but if you prefer the larger version, it is very easy to draft your own templates. The block is based on nine squares, three rows of three squares, which is known as a Nine Patch. To make a 12-inch block (12$\frac{1}{2}$-inch when the sashing is added), each square needs to measure 4 x 4 inches. Draw a 4-inch square on graph paper or template plastic, keeping the lines as accurate as possible. Divide the square with a diagonal line (shown below). One of the resulting triangles is used as the larger template A. Draw another diagonal line from one corner, stopping at the center point so the second large triangle is now divided into two. Either of these two smaller triangles is template B. If working on graph paper, cut roughly around the square, glue it onto cardboard,

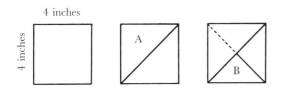

and then cut the two triangular templates A and B from the cardboard. See page 15 for instructions on making templates.

COLOR CHOICES

The Card Trick block is given its name because it looks like a handful of playing cards spread out in a fan shape. There are four "cards" made from two fabrics placed alternately, although four different fabrics can be used. Another fabric is needed for the background. As with the Maple Leaf, this background is not just a large square onto which the cards are stitched. Instead, every piece is cut to shape and joined with its neighbor to make the block. The

"card" fabrics need to balance each other in their density of color. In other words, you do not want one color that is much stronger than the others. Arrange the "card" fabrics in a cross shape on a piece of the background fabric. Stand back and half-close your eyes. If one fabric seems to dominate, change it. It is easier to achieve a balance if you use just two fabrics for the cards, as in the example on the left. The background can be dark, as shown here, or much lighter. You may, of course, use one fabric throughout the sampler quilt for all the backgrounds of the blocks. Remember that with the 9-inch block, an edging border of at least a 1$\frac{1}{2}$-inch finished width has to be added to increase it to the required 12-inch block, so the fabric for this also has to be considered. Any extra borders around blocks like this should not be the same fabric as the divider strips, so if you have not made a decision on the divider fabric, you may need to before you can progress.

CONSTRUCTION

1 Make cardboard templates by tracing triangles A and B from Fig. 1, cutting them out and gluing them on to cardboard, or use template plastic. If you want to make the larger block, draft your own templates as explained earlier (see page 15 for instructions on making templates).

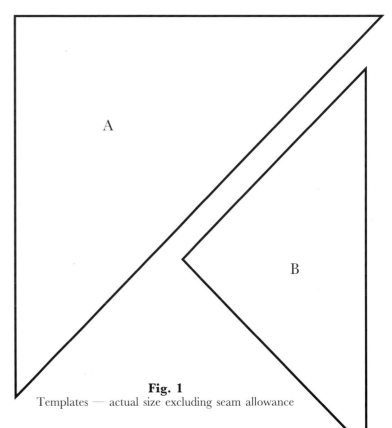

Fig. 1
Templates — actual size excluding seam allowance

2 On the wrong side of each fabric, draw accurately around the templates, using a sharp marking pencil. This marks the sewing line. Leave at least ½ inch between each drawn outline so the seam allowance of ¼ inch can be added to each shape when cutting out.

If you are using two fabrics for the "cards," you will need four of triangle A and four of triangle B from each fabric. (If using four fabrics, you need two of each triangle from each fabric.) You also need four of each triangle from the background fabric. Save space by arranging the shapes on the fabric, as shown in Fig. 2. Cut out each shape to include the ¼-inch seam allowance, by using a ¼-inch ruler known as a quilter's quarter or a seam wheel, (see Basic Equipment, p.10). I like to cut on a mat with a small rotary cutter, with the seam guide set ¼ inch from the blade.

Fig. 2

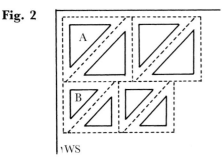

3 Arrange the cut pieces on a flat surface or pin them in position on a styrofoam tile or board. Final adjustments to the design can be made at this stage. Do not try to assemble the "cards" and then join them to the background pieces. Instead, assemble each of the nine squares in the following way (Fig. 3).

Fig. 3

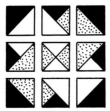

4 Place the first two triangles together with right sides facing. The pencil markings will be on the outside and must be exactly on top of each other because they indicate the sewing lines. Align the starting points of the lines by pushing a pin through both layers of fabric until the head is on the surface of the top fabric. Repeat to mark the finishing point (Fig. 4a). Reposition the pins at right angles to the seam. Add more pins along the seam

Fig. 4a **Fig. 4b**

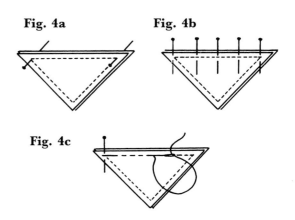

Fig. 4c

line, (Fig. 4b). Starting with a double stitch, sew along the penciled line with small running stitches, about the same length as machine stitches, loading several stitches onto the needle at a time. Begin each run of stitches with a backstitch to secure the work firmly. Finish the seam with several backstitches exactly at the end of the marked line (Fig 4c).

Do not sew into the seam allowances. These are left free, so that the seams can be pressed to one side when the block is complete. They are pressed open, because the hand-sewn stitches are not strong enough. There is no set rule for which way each seam is finally pressed; just press them to avoid too much bulk building up on the back.

5 The squares made from three pieces need to be sewn in two stages (Fig 5). First, join together the two smaller triangles. Next, sew the halves together to make the square, pinning and matching the seams as before.

Fig. 5

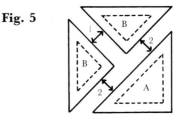

FINISHED QUILT BY SANDRA ROBSON

"My first completed quilt, made in Lynne's class. In my enthusiasm, I bought far too many fabrics and found I was always behind everyone as I agonized over what to use for each square. Since I'm not an experienced quilter, I felt a real sense of achievement when it was eventually completed. And of course, I have plenty of fabric left over for another quilt!"

6 When sewing this second seam, do not sew over the seam allowances in the middle. Instead, sew up to the seam and make a backstitch. Pass the needle through the seam allowances to the other side. Backstitch again and continue sewing (Fig. 6).

Fig. 6

7 For the central square, sew the triangles into pairs, and then join the two halves (Fig. 7).

Fig. 7

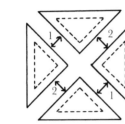

8 Once the nine squares are assembled, sew the horizontal rows of three squares together, pinning and matching the seams as before (Fig. 8).

Fig. 8

9 Join the top two rows by placing them with right sides together, matching seams. Push a pin exactly through the seams and corners on each piece. Reposition these pins at right angles to the seams and add more along the seam line, matching the marked lines (Fig. 9). Stitch together without sewing over the seam allowances as before. Join the third row to the first two in the same way.

Fig. 9

10 If you have chosen to make a larger block, it is now complete, ready for the final sashing

strips to be added. If you are making the smaller block, it will now need a border. Cut four strips from your chosen fabric, two measuring $2^{1}/_{4}$ x $9^{1}/_{2}$ inches and two measuring $2^{1}/_{4}$ x 13 inches. Using a sharp marking pencil, draw a line on the wrong side of each fabric strip $^{1}/_{4}$ inch away from one long edge. Mark the line as shown in Fig. 10.

Fig. 10

11 With right sides together, pin the shorter strips to opposite sides of the block, matching the marked lines. Marks A and B should match the drawn corners of the block. Use pins as before (Fig. 11). Because the block has been pressed, all the seam allowances are pressed in the chosen directions. These border strips can be stitched on through all the seam allowances if you prefer. Stitch from one end of the strip to the other, not just from A to B. Stitch these strips onto the block by hand or by machine. A machine foot lets you see the penciled line as you stitch — a straight stitch foot is ideal since you need to sew exactly along the drawn line.

Fig. 11

12 Press the two strips outward. With right sides together, pin the longer strips to the other two sides of the block, matching the marking lines. Marks C and D should be matched with the corners of the block (Fig. 12). Stitch along the drawn lines from one end of the strip to the other, not just from C to D. Press the strips outward. Measure the block. It should be a little more than $12^{1}/_{2}$ inches square. Center it on the cutting mat and trim to $12^{1}/_{2}$-inch square. See page 109 for trimming the blocks.

Fig. 12

13 When you are ready, add the sashing strips to make a double mount to the block. See page 110 for instructions.

MACHINED STRIP PATCHWORK

STRIP RAIL

Like Rail Fence, this design uses long strips of fabric, which are stitched into a band and then cut. Two sets of strips are constructed, one in reverse order to the other. These are then cut diagionally and rejoined in pairs to give the arrowhead design seen overleaf. Diagonal cutting and stitching creates a strongly diagonal feeling to the block, so it makes a good choice for a corner of your sampler quilt. Very exciting quilt designs can be made from the repeated block, especially if it is placed "on point" –

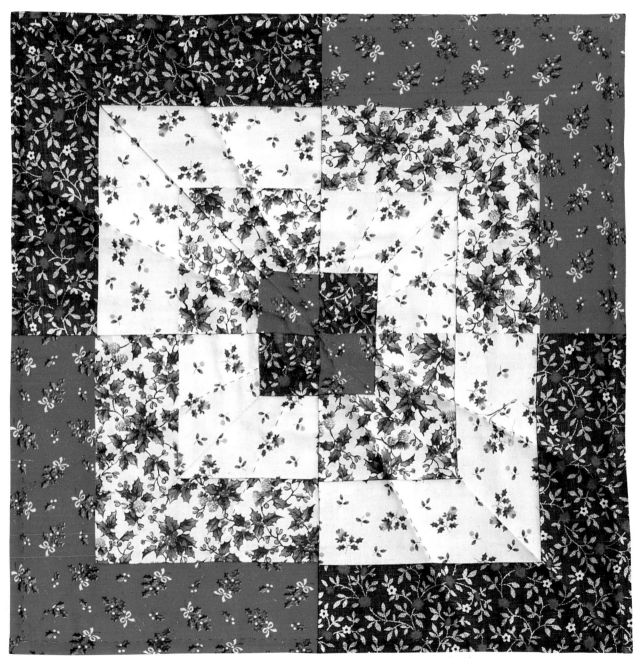

with the corners of the block at the top, bottom, and sides, and extra fabric added to make a square (shown below).

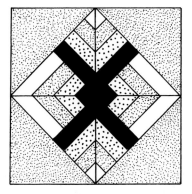

COLOR CHOICES

Four fabrics are used in this block, and they could be full of contrasts or could graduate in color from light to dark. The strongest fabrics are most effective when used on the outside rather than on the inside of the band of four. Take your chosen fabrics and fold them into narrow strips. Place them in order on a flat surface so that you can judge the effect. Rearrange them until you are satisfied.

CONSTRUCTION

1 From each fabric, cut two sets of strips, each measuring 2⅛ inches wide and 15 inches long (Fig. 1). See pages 18 and 19 for cutting strips.

Fig. 1

2 Set the stitch length on your sewing machine to about two-thirds the size of the usual dressmaking stitch to prevent the seams from coming undone when the strips are cut across. As usual, the seams need to be a scant ¼ inch. Use a strip of masking tape to help you accurately stitch the seams (see page 16 for setting up the machine). Stitch the four strips together, alternating the direction in which you sew them to keep the band straight and not slightly rippled (Fig. 2).

Fig. 2

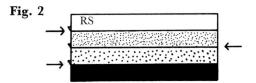

3 Press one band of strips from the *front* with the seams pressed toward the top of the band. Press the second band from the *front* with the seams pressed down toward the bottom of the band (Fig. 3). See page 15 for general advice on pressing.

Fig. 3

Band 1　　　　　　Band 2
Seams pressed up　Seams pressed down

4 Take band one and place it horizontally on the cutting mat, right side up, lining up the top edge with one of the horizontal markings on the mat. If the band is slightly rippled, do not worry; just pat it as flat as you can and continue. Four different fabrics cannot be expected to lie completely flat when joined. If they do, take all the credit; if they do not, blame the fabric!

Take Band 2 and place it, right side down, on top of Band 1, matching colors and seams carefully. The seam allowances go in opposite directions, which helps to line up the seams of the two bands (Fig. 4).

Fig. 4

5 Measure the width of the bands. If you have stitched a scant ¼-inch seam, the bands should measure 7 inches. Using the rotary ruler and cutter, trim one end of the layered bands to straighten them, and then cut off two sections, each 7 inches long, to make two layered squares (Fig. 5). If your bands do not measure 7 inches, even if they are only ⅛ inch off, take the measurement you have and cut the squares to

Fig. 5

FINISHED QUILT BY MARY TELFORD

*"I chose to make a small sampler quilt using Christmas
fabrics to hang on the wall each December. I was
particularly pleased with the Christmas tree border,
which I sorted out without any help from teacher."*

match it. If the two bands are not identical in width, restitch one of them so that they match each other. Work from the final width measurement of both bands to cut your squares. You will finish up with completely accurate squares, even if they are slightly long or slightly short. You can make any adjustments to that later, if necessary.

6 Keeping the two layers matching exactly, cut each square diagonally in one direction (Fig. 6). Each double layer of triangles is now ready to sew.

Fig. 6

7 Pin the diagonal edges together on all four pairs of triangles, matching the seams. Handle the pieces carefully because the cut edges are on the bias (the diagonal grain of the fabric) and will be very stretchy. This stretchiness can be a help though if you have to do a little easing to make the seams match. Machine-stitch along each diagonal seam. Press from the front of the work, pressing the seam allowances to one side. The resulting squares show two different color arrangements (Fig. 7).

Fig. 7

8 Arrange the four squares until you find a design you like. Two alternatives are shown in Fig. 8. Many more are possible, so keep moving the squares around until you find your favorite.

Fig. 8

9 Pin and machine-stitch the top two squares together with a ¼-inch seam. If you place the pins at right angles to the seams, you will be able

to stitch right up to each pin before you need to remove it (Fig. 9). If the two edges do not match because one is shorter than the other, pin and stitch with the shorter edge on top, because this edge will stretch slightly as you stitch and should ease the problem. Press the seams to one side from the front of the joined squares.

Fig. 9

Stitching line

WS

10 Pin and machine-stitch the second pair of squares. Press the seams in the opposite direction to the first half (Fig. 10).

Fig. 10

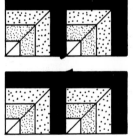

11 Join the two halves by stitching across with a ¼-inch seam, being careful to match the center seams. Pressing the center seams of each half in opposite directions will help you to match them accurately, because they lock into each other as you sew. Pinning diagonally helps keep both sets of seam allowances flat while stitching (Fig. 11). The final long seam can be pressed to one side, or if this makes it too bulky, press the seam open.

Fig. 11

12 The finished block should measure slightly more than 12½ inches square. If this is the case, center it on a cutting mat and trim it down to an exact 12½-inch square. See page 109 for instructions on trimming the blocks. Add the sashing strips, following the instructions that are given on page 110.

CURVED SEAM PATCHWORK

DRUNKARD'S PATH

This design originated in England, where it was known as Robbing Peter to Pay Paul. It traveled to America with the early settlers, who gradually developed a whole series of designs based on 16 squares, each of which is divided into 2 parts; a quarter-circle and the rest of the square. As the block patterns evolved, they were given a variety of names, such as Wanderer in the Wilderness, Solomon's Puzzle, Old Maid's Puzzle, and the best-known, Drunkard's Path.

The arrangement of the 16 squares, 4 in each of four rows, changes the block design so much that it is quite possible to include several Drunkard's Path blocks in a sampler quilt without anyone realizing that they are the same basic design. Fig. 2 shows six different arrangements, each using just two fabrics. This block is another that is constructed by American piecing, with the new problem of sewing the curved seam that joins shapes A and B to make a square (above). There are 16 of these seams in the block, so by the time you have finished, you should have become quite familiar with it. This traditional curved seam block and its many variations is a really great favorite of mine.

COLOR CHOICES

The designs below use only two fabrics, although you might like to use more, as shown above right. As you have now made quite a number of blocks, it is a good idea to lay them all out while you choose the fabric for this design. If there is one fabric that seems

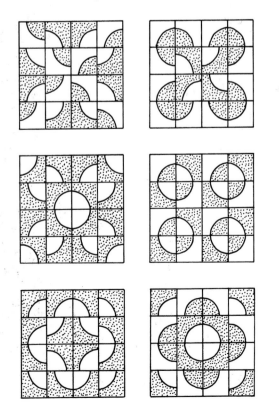

to jar, you must decide whether it was a mistake or whether you just need to use more of it in future blocks. Assemble your fabrics according to which arrangement of Drunkard's Path you have chosen, and decide which fabric is to go where in the design. You may find it easier to make a rough sketch or tracing of the block and color it in so that you know how many of each shape you need to cut out from each color of fabric.

CONSTRUCTION

1 Make cardboard templates by tracing templates A and B from Fig. 1 and cutting them out. These are combined to make a 3-inch square; 16 squares will make the block. Glue the traced shapes onto cardboard, or use template plastic. See page 15 for instructions on making templates. Use your colored drawing of the block to ascertain how many of each template shape you need in each fabric. For example, you need eight of template A and eight of template B from each of the two fabrics for the top left-hand block that is shown in the two-color variations examples at left.

Fig. 1 Templates – actual size excluding seam allowance

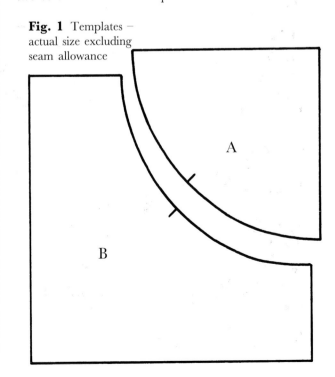

2 On the wrong side of each fabric, draw accurately around the templates, using a sharp marking pencil. This marks the sewing line. Mark the center point on each curve in the seam allowance (Fig. 2a). Leave at least ¹/₂ inch between each drawn outline so that a seam allowance of ¹/₄ inch can be added to each shape when cutting out.

Fig. 2a

Save space by arranging the shapes on the fabric as shown in Fig. 2b. Cut out each shape to include the ¹/₄-inch seam allowance. Do this by using a quilter's quarter, a seam wheel, or a small rotary cutter with a seam guide attachment. See Basic Equipment, pages 10–14). Arrange the cut pieces on a flat surface, or pin them in position on a styrofoam tile or bulletin board. You may find that you rearrange the pieces to make a completely new design. Always keep an open and flexible attitude as you work, and be prepared to change your mind if you come up with a better alternative.

Fig. 2b

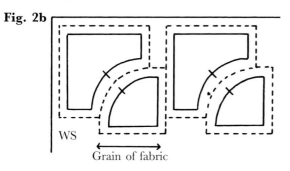

Grain of fabric

3 Take the two shapes A and B, which make up 1 of the 16 squares in the design. Using a small pair of scissors with sharp points, clip the curved seam allllowance on shape B, snipping at roughly ¹/₄-inch intervals, going nearly, but not quite, to the drawn line (Fig. 3).

Fig. 3

4 Joining shape A to shape B seems easy enough when the pieces are arranged in the block, but they do not seem to match at all when you place them right sides together, ready for pinning. The only way you can make them fit each other is by curving the pieces in your hand as you pin, like setting-in a sleeve in dressmaking.

Match the center marks on each piece by pushing a pin through both layers of fabric until the head is on the surface of the top fabric. Reposition the pin at right angles to the seam. I find it easier to sew if the pins are arranged with the points outward, and that way I don't prick my fingers (Fig. 4).

Fig. 4

5 Swing one corner of shape A around to match the corner of shape B, lining up the straight outer edges of both pieces. Align the corners of the sewing lines by pushing through a pin (Fig. 5).

Fig. 5

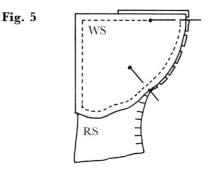

6 Swing the other corner of shape A around, and match and pin the drawn corners, aligning the two straight edges. The resulting shape cannot be held flat — it takes on a deep curve, as in Fig. 6.

Fig. 6

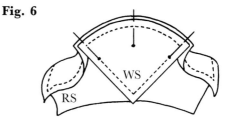

7 More pins are needed to secure one drawn line exactly on top of the other, so match and pin

the two pieces at intervals no greater than ½ inch, and closer if you need to. This makes a porcupine of a seam, bristling with pins, but it is the only way to keep the lines matching exactly (Fig. 7).

Fig. 7

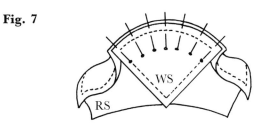

8 Sew along the penciled line with small running stitches, removing the pins as you work (see Maple Leaf, pages 31–35, for more detailed instructions). Do not sew into the seam allowances at either end of the curve (Fig. 8).

Fig. 8

9 You may find it easier to pin the curve with shape B on the top, so that the seam curves away from you. Alternatively, you may find it simpler to ease in the fullness by curving it over your hand while you pin and sew (Fig. 13). Try both ways to see which you prefer.

Fig. 9

10 Press the completed square from the front with the curved seam toward the larger shape B. The clipped edges spread and reduce the bulk of the seam so that it lies flat (Fig. 10a).

Assemble each of the 16 squares in this way, then arrange them into your chosen design. Join the squares into horizontal rows, pinning and matching the seams in the usual way. Join the rows together to complete the block. This is the only time I break the rule of not sewing across the seam allowances

when stitching across the curved seam, because it has already been pressed to one side (Fig. 10a). I sew from one marked corner of the square to the other, sewing right across the pressed curved seam allowances (Fig. 10b).

Fig. 10a **Fig. 10b**

To assemble the squares by machine, pin the two squares together, matching the drawn lines as for hand-piecing. Machine-stitch carefully along the drawn line, using a straight stitch foot so you can see where you are stitching. It is usual when machine-stitching the marked lines to sew beyond the drawn lines into the seam allowances, right across the fabric from edge to edge.

Join each row of four squares. Press from the front, ironing the seams of Row 1 in one direction, those in Row 2 the opposite way, and so on (see also page 36). When you join the rows together, match and pin the drawn lines carefully. Machine-stitch along the drawn line right across the fabric, stitching through all the seam allowances. Do not attempt to machine the curved seam itself on this 3-inch square, because you are likely to trap tiny pleats in the seam as you sew.

11 Press the completed block from the front and measure it. It should be 12½ inches square. If it is not, make adjustments to bring it to the exact size by trimming the square or adding a narrow border. See page 109 for instructions on trimming and bordering blocks.

12 Add the sashing strips, following the instructions on page 110.

FINISHED QUILT BY DOT SIDGWICK

"My quilt was built around the colors in the flowery border. Originally I wanted to use only pale greens and pinks, but it looked rather dull when I started to add green borders. I then changed to black, and the whole quilt seemed to sharpen up, making the very light green and deep pink look much more vibrant."

SPIDER'S WEB

This kaleidoscopic design used to be painstakingly hand-pieced, using templates for all the little strips. With rotary cutters and quick piecing techniques, it has become another one of those clever "join the strips, cut it up again" processes. It looks wonderful when all eight sections have been joined to form the final design and the eight points all meet in the center. Many patchwork designs have six or eight corners meeting, and they do not always work out as well as the quilter hopes. The trick is to get it

right at each stage of construction. That way any mistakes are corrected as you go along, and you don't finish up with a jumble of points and angles at the end, with no idea how to correct them.

COLOR CHOICES

Four fabrics are used in a sequence of strips, so look at the blocks you have already completed to see which fabrics could be reintroduced. You may already have a block that uses four fabrics that you could use again. The fabrics are joined to form a long band, which is then cut and turned in alternate directions, so the top and bottom colors come together to form the center, and the two middle colors alternate with each other in the design (shown below). Wait until after the web is made to cut out the corner triangles, because then it will be much easier to choose the fabric that looks best.

CONSTRUCTION

1 Make templates A and B from Fig. 1 on page 56 (see page 15 for instructions on making templates). Mark the three dotted lines and the three dots on template A. Push a large pin through each dot on template A to make a hole. The holes need to be big enough to take the point of a pencil to let you mark fabric through them.

2 Cut a strip, measuring 2 x 30 inches, from each of your four chosen fabrics. Machine-stitch the strips together with the usual small stitch and a ¼- inch seam allowance. Alternate the direction in which you sew the strips, as explained in Rail Fence block (page 28). Press the band from the front with the seams all in one direction (Fig. 2).

Fig. 2

3 Place the fabric band on a cutting mat with the wrong side up. Place template A on the

band. It should fit exactly from top to bottom, with the stitched seams matching the dotted lines on the template (Fig. 3). If it does not, you should restitch the seams to get a good fit. It is important that the template fits properly top to bottom.

Fig. 3

4 Using a sharp pencil, draw down both sides of the template and mark the dots. Move the template along the band, turning it 180° to fit against the first drawn shape. Draw around the template again. Continue this way until eight shapes have been marked on the band (Fig. 4).

Fig. 4

5 If two shapes do not fit against each other accurately, leave a small space between them if necessary — the band is long enough to allow you to do this (Fig. 5). Mark the dots on each shape.

Fig. 5 Gap

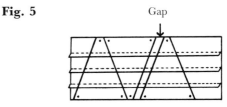

6 Use a rotary cutter and ruler to cut the drawn lines. Now arrange the eight triangular shapes to make a spider's web. Join the triangles in pairs, matching the seams carefully and stitching right through the marked dots on both pieces (Fig. 6).

Fig. 6

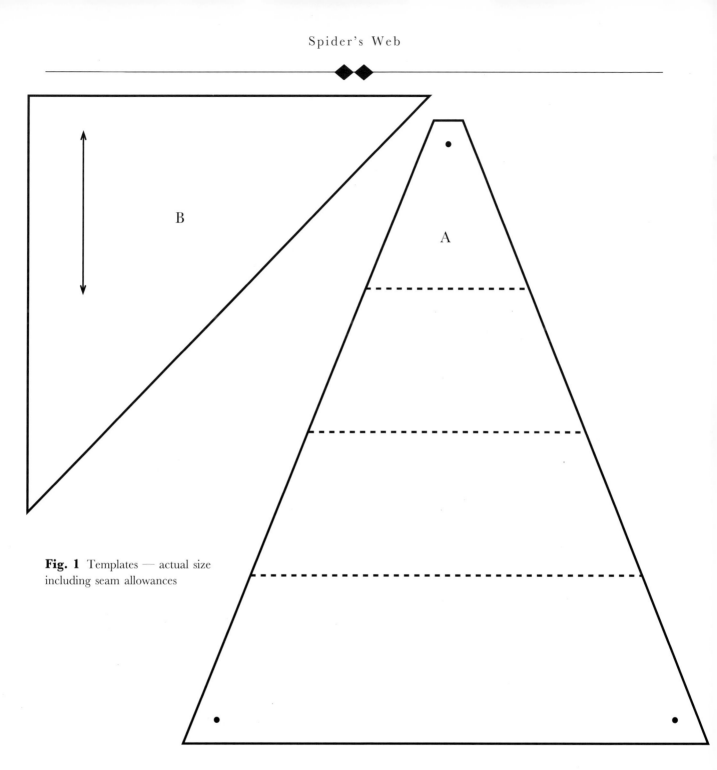

Fig. 1 Templates — actual size
including seam allowances

B

A

7 Make sure that each pair is exactly the same as
the others (Fig. 7a) and not stitched together in
the reverse order (Fig. 7b); otherwise, they will not
fit together to make the design. Press the seams
from the front to one side.

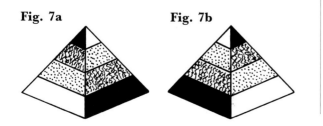

Fig. 7a　　　　**Fig. 7b**

FINISHED QUILT BY ANN LARKIN

*"The selection of rich brown fabrics used in this quilt
was chosen deliberately to complement the closets and
cupboards surrounding the bed. Golds, beiges, and
greens were added, and the quilt was finished with a
Drunkard's Path border."*

8 Now pin two pieces together, matching dots carefully, and stitch through them as accurately as possible. Do not set your machine-stitch length too small, in case you need to unpick the stitches at some stage. Repeat this process with the other two pieces. Now comes quality-control time. Open out each half and inspect them from the front. You are aiming to have the two inner fabrics meeting in an arrowhead exactly ¼ inch away from the top edges of the fabrics (Fig. 8a).

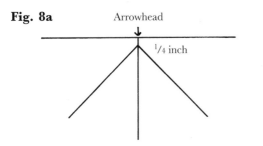

Fig. 8a Arrowhead ¼ inch

If you have successfully matched the arrowheads, but it is less than ¼ inch from the top edges, resew the center seam (the last one to have been sewn), stitching just inside the original stitches. There is no need to unpick these stitches, because they are now in the seam allowance. However, if the arrowheads are *not* matching, but look like Fig. 8b, unpick the center seam, match the dots more carefully, and stitch again. If you take time to get the two halves of the web right at this stage, they will match more accurately in the final long seam. When you are happy with the arrowheads, press from the front, pressing the seams to one side.

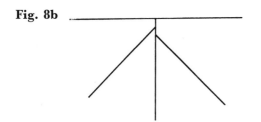

Fig. 8b

9 Pin the two halves together, matching the seams along the edges and taking care to position the tips of the two arrowheads in the center exactly on top of each other. Check by peeling the top half back with the pin. When the arrowheads match, hold them in position firmly and pin on both sides of the center seam. I use extra-long, extra-fine pins so that I can machine-stitch over them (Fig. 9). Stitch the seam.

Now check from the front. If you have lost the tips of the arrowheads, your seam allowance was too wide. Finger-press the seam open and check on

how the center looks — this can make quite a difference to the balance of the central eight points. If you are unhappy with the result, unpick 2 inches or so on each side of the center and try again. Do the best you can and remember that only you will notice if it is not perfect. Finally, press the long seam open from the back of the work.

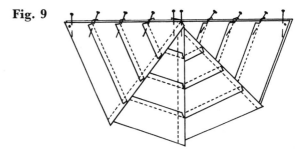

Fig. 9

10 The large triangles from template B form the four corners of the block. They can be placed adjacent to the sides or edges that use fabric one, or adjacent to the sides using fabric four (Fig. 10), so choose the fabric that works best for these corners. Draw around the template on the wrong side of the chosen fabric four times and cut out exactly on the line. No extra seam allowance is needed.

Fig. 10

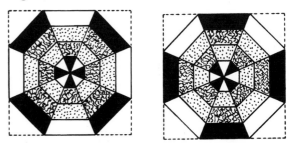

11 With right sides together, pin and stitch each corner to the block, matching the long edge of shape B with the outer edge of the block (Fig. 11). Press the corners with the seams outward. Trim the block to an exact 12½-inch square. See page 109 for instructions on trimming the blocks.

Fig. 11

GRANDMOTHER'S FAN

This traditional block has always been pieced by hand, but nearly all of it can easily be machine-pieced if you prefer. It features the curving lines used in Drunkard's Path, but on a larger scale to give a fan shape. The fan is divided into 6 sections, although in old quilts it can often be seen with up to 10 divisions. Compared with piecing the Drunkard's Path curves, this one is really quick and easy. There are only two curves to be pieced, and one of them is so large that it hardly seems like a curve at all.

The center of Grandmother's Fan is not in the middle of the block but in the corner, which makes it an ideal design to use in a corner of the sampler quilt, where it gives weight and encourages the eye to move in to the rest of the quilt. This simple block design has been repeated and combined to make the beautiful blue and white quilt in the project on page 139.

COLOR CHOICES

The fan has six sections, or blades, which can be made from six different fabrics or, as shown (above right), from three fabrics repeated in sequence. A striking design can also be made with just two contrasting fabrics used alternately in the sections. The background is a large, empty area of fabric, so if you choose a plain fabric, you may need to break it up visually with quilting. The central quarter-circle is like the eye of a flower and should be strong enough to give the fan a focus without dominating everything else. If you are not sure which center or background fabrics will look best, cut and piece together the fan before making a decision.

CONSTRUCTION

1 Make templates A and B from Fig. 1 (see page 15 for instructions on making templates).

2 The background shape is too large for a template to be shown here, so make it in the following way. On a large piece of graph paper, draw a 12-inch square. Open a drawing compass to a distance of 10 inches. (I use an extra long pencil in the compasses). Insert the point of the compass in a corner of the drawn square and draw a quarter-circle, as shown in Fig. 2a on page 62. The shaded section of the square will be your template. If you cannot make your compass reach

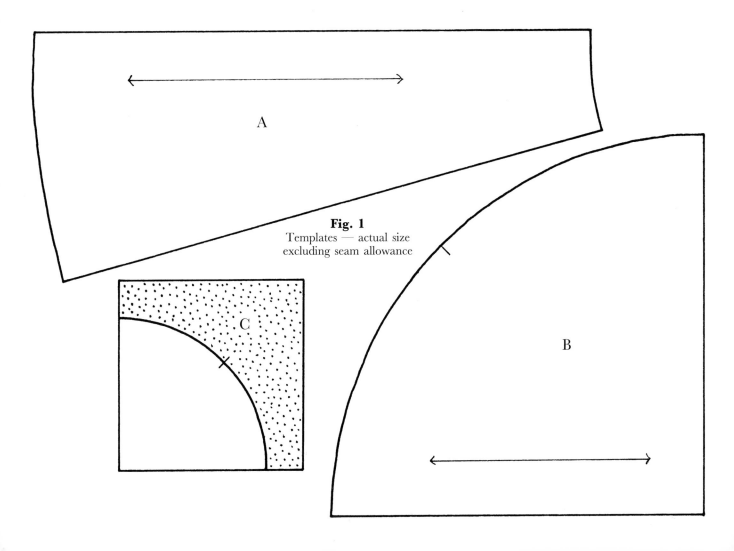

A

Fig. 1
Templates — actual size
excluding seam allowance

C

B

FINISHED QUILT BY KATE KEARNEY

*"My principal feeling about this quilt is that if I could
do it, then anyone could. It was very difficult to find
enough fabrics in the colors I wanted. On reflection, this
restriction has made the quilt more harmonious."*

Fig. 2a **Fig. 2b**

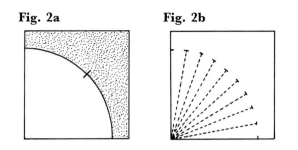

to 10 inches, use a ruler and mark 10 inches at roughly ½-inch intervals. Join these marks by eye to make the curve (Fig. 2b). Mark the center of the curve by placing a ruler diagonally across two corners of the square and marking the point where the ruler crosses the curve. Glue the template onto cardboard, as usual.

3 On the wrong side of your chosen fabrics, draw accurately around the fan template A, using a sharp marking pencil. This marks the sewing line. Leave at least ½ inch between each drawn outline so that a seam allowance of ¼ inch can be added to each shape when cutting out (Fig. 3). You need six shape A pieces. You also need one shape B and one shape C. Cut out each shape to include the ¼-inch seam allowance, using a quilter's quarter, a seam wheel, or small rotary cutter with a seam guide attachment (see Basic Equipment, page 10).

Fig. 3

WS

Grain of fabric

Arrange the sections of the fan on a flat surface, or pin them in position on a styrofoam tile or a bulletin board. Move them around to verify that you like the sequence of fabrics.

4 Take the first two sections of shape A and place them with right sides together, matching the drawn lines with pins (Fig. 4), as in the Maple Leaf block, page 31.

Fig. 4

5 Stitch along the drawn lines, either by hand or machine. If by hand, sew along the lines, but not into the seam allowances at each end. If by machine, stitch along the lines from one end of the fabric to the other, including the seam allowances (Fig. 5). Join all six pieces of the fan together in this way. Press the seams from the front of the work to one side.

Fig. 5

Hand stitches finish

Hand stitches start

Machine-stitch across seam allowance

6 Clip the seam allowance of the fan along the smaller curved edge (Fig. 6a). Pin and sew the fan to the center piece B in the same way as described for Drunkard's Path (pages 51–52). I am quite happy sewing this by hand, but do try it by machine if you want to. Press the seam toward the fan, pressing from the front as usual. Clip the seam allowance of the curved edge of the large background piece. Pin the longer curve of the fan to the clipped edge of the background, matching corners and centers carefully (Fig. 6b), as described in Drunkard's Path, page 49. Press the seam toward the background fabric.

Fig. 6a **Fig. 6b**

7 Measure the completed block. It should be 12½ inches square. If it needs trimming, trim away from the two sides of the background fabric *only*, leaving the fan its full size (see page 109 for instructions on trimming the blocks).

8 Add the sashing strips (see page 110 for instructions).

LOG CABIN

Log Cabin quilts have always been part of the American quilt heritage, but they have also been known in Europe for several hundred years. The design appears in Dutch, Swedish, and British quilts of the 19th century and earlier. It is likely that settlers took it to America, where it has become one of the most popular of the traditional quilt patterns.

The design is made of rectangular strips of light and dark fabrics arranged around a central square. Traditionally, the strips represented the wooden logs

that made up the pioneer's log cabin. The central square was either red, to represent the fire in the hearth, or yellow, for the welcoming light in the window. Light and dark fabrics were cut into strips with templates and then pieced together around the centers to make squares that showed strongly contrasting areas of light and dark (shown above).

This is still the way the design is worked today, but modern cutting and stitching techniques have revolutionized the speed and accuracy with which a quilt can be assembled. In the sampler quilt, four identical squares of Log Cabin are made at the same time in a mass-production method. These are then joined together to make the final block.

COLOR CHOICES

Choosing fabric for Log Cabin is always torturous. You need two sets of fabric distinctly different from each other: a dark set contrasting with a light set, a set of plain shades against patterned, or even a complete change of color, like red fabrics against black. Within these sets, the fabrics should be similar so that they blend together without one standing out against the others too much. Lay your fabrics out on a flat surface, overlapping so that you get an idea what ³/4-inch strips will look like when stitched together. Arrange them in the two sets and avoid using a fabric that does not obviously belong in either set. For example, if you are using dark green fabrics with light cream fabrics, do not include a medium green-and-cream print, which could be part of either set. That would lose the element of contrast that gives the block its distinctive appearance. If you have a limited number of fabrics to choose from, you can restrict them to two fabrics in each set and use those alternately, as in the example below. The central square does not have to be the traditional red or

yellow, but can be anything you like. In the Log Cabin project for a baby's crib quilt on page 128, I have used yellow fabrics for one set and blues for the other, with blue centers. You may prefer a strong concentration of color for each center, or a color that does not match either set of strips but gently complements them. Study some of the Log Cabin blocks in the sampler quilts shown in this book and choose one of the effects you like best.

CONSTRUCTION

1 Cut strips 1¼ inches wide from each fabric and arrange them at the side of the sewing machine in the order in which they will be used. A total length of about 10 feet of strips for each set is needed. Cut a short strip, measuring about 7 inches long and 1¼ inches wide, from the center fabric. Cut pieces from this strip to give four 1¼-inch squares (Fig. 1).

Fig. 1

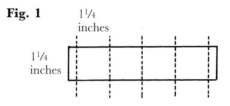

2 Tape a small square of masking tape onto the back of one of these central squares, avoiding the ¼-inch seam allowance. Label the tape with numbers 1, 2, 3, and 4, as shown in Fig. 2. The numbers give a guide to where each strip will be stitched.

Fig. 2

3 Choose the fabric you wish to use first and place it right side *up* on the machine in the correct position for a ¼-inch seam to be sewn. Lower the pressure foot and wind the needle down into the fabric. Now the pressure foot can be lifted and the central squares added without the first strip slipping out of position. Place the first square right side *down* on the strip, with side one on the masking tape as the edge to be stitched. Using a short stitch and a ¼-inch seam, sew the central square onto the strip. Sew a few stitches more and place a second square right side *down* on the strip.

Sew this square in position, then add the third and fourth squares in the same way (Fig. 3).

Fig. 3

4 Remove the strip from the machine and carefully trim it to match the central squares exactly, using either sharp scissors or a rotary cutter (Fig. 4).

Fig. 4

5 Finger-press the seams away from the squares by holding the central square between your forefinger and thumb, and pushing the strip away from the center with your thumbs, pressing the seam firmly (Fig. 5).

Fig. 5

Center
RS

6 In building up the Log Cabin strips around the center piece, each fabric is always used twice, making an L-shape. So put the same fabric strip on the sewing machine again, right side *up*, and wind the needle down into the fabric. Take the original block with its piece of masking tape and place it right side *down* on the strip, with Side 2 at the edge to be sewn (Fig. 6a). Sew down this edge and place the second block on the strip in the same way. The first block is your model, and the next three blocks

must follow the same arrangement when they are positioned on the strip. Sew down, and add the third and fourth blocks to match (Fig. 6b).

Fig. 6a **Fig. 6b**

7 Trim the strip to match the edges of the four blocks exactly (Fig. 7a). Finger-press the seams away from the center square (Fig. 7b).

Fig. 7a

Fig. 7b

8 Having sewn on two strips from the first fabric, take a strip of fabric from the contrasting set and place it on the machine, right side *up*, with the needle wound down into it. If you were using dark fabrics, now change to light, or change from plain to patterned. Position the original block with Side 3 on the tape at the sewing edge (Fig. 8).

Fig. 8

9 Sew down this edge and add the remaining three blocks to match the first (Fig. 9a). Trim the strips to match each block and finger-press the seams away from the center (Fig. 9b).

Fig. 9a **Fig. 9b**

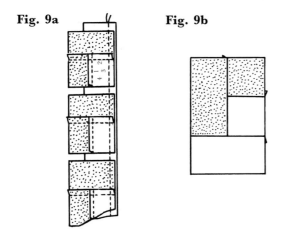

10 Using a strip of the same fabric (remember, always use each fabric *twice* to make an L-shape), follow the same procedure, sewing the strip onto Side 4. You now have a complete series of strips surrounding the central square (Fig. 10a).

Now that you have completed this much, there is a quick way to see immediately which side is the next to be stitched. Look at the block and find the edge that has two seams along it. This is the side that is to be stitched next (Fig. 10b).

Fig. 10a **Fig. 10b**

11 Continue building up the design, referring to the masking tape square. Sides 1 and 2 always have the same set of fabrics against them, and sides three and four always have the contrasting set of fabrics. Remember to use each fabric *twice* to make the L-shape. The sequence of fabrics is: two sides from first fabric from set one; two sides from first fabric from set two; two sides from second fabric from set one; two sides from second fabric from set two. When three series of strips have been sewn, check against the examples on page 64 to make certain that you have attached the correct number of strips. Press each square from the front.

Arrange the four squares in the design you like

best. Pin and machine-stitch the top two squares together with a ¼-inch seam, as usual. If the two edges do not match exactly, and one is shorter than the other, pin and stitch with the shorter edge on top because this edge will stretch slightly as you work and that should solve the problem. Press the seam from the front to one side. Pin and stitch the second pair of squares, pressing the center seams in the direction opposite to the first half (Fig. 11).

Join the two halves, matching the center seams carefully. The final long seam can be pressed to one side, or if this makes it too bulky, press the seam allowances open.

Fig. 11

12 Measure the completed block. It should be about 11 inches square. Choose a fabric to use as an extra frame around the block before the sashing strips are added. Cut strips 1½ inches wide for this frame and attach them (see page 109 for instructions on trimming and adding frames).

Trim the block to an exact 12½-inch square. Add the sashing strips (see page 110 for instructions).

FINISHED QUILT BY JANE HODGES

"My sampler quilt was my first attempt at patchwork. The choice of colors is a reflection of my upbringing in the Southern Hemisphere, and the quilt became affectionately known as 'have you seen that blue and yellow thing around the corner?'"

COURTHOUSE STEPS

This is a variation of Log Cabin (pages 64–66) and can be used for another block in the sampler quilt because it looks very different.

CONSTRUCTION

1 Proceed exactly as for Log Cabin, cutting similar strips and centers and labelling the latter with masking tape. The fabrics are used to create a symmetrical design in each block (Fig. 1).

2 Add the first fabric twice (Fig. 2), but at *opposite* sides of the central square. Sides 1 and 3 marked on the masking tape.

3 The first contrasting fabric is then sewn onto Sides 2 and 4 (Fig. 3). Continue to add strips.

The first set of fabrics goes on Sides 1 and 3, and the contrasting set goes on Sides 2 and 4, until three series have been attached.

4 Join the squares together. Add a border and sashing strips, as for the Log Cabin.

Fig. 1

Fig. 2

Fig. 3

FINISHED QUILT BY HELEN BURRETT

"Just six fabrics were used to produce this sampler quilt. Decisions were quickly reached when choosing fabrics for each block, but it was also necessary to take care that neither green nor pink became the dominant color."

PIECED PATCHWORK

DRESDEN PLATE

There are many patchwork blocks based on the circular plate design, and Dresden Plate is the most popular and best-known of these. The number of sections in the plate varies from 8 to 20, while the outer edges may be all curved, all pointed, or a mix-

ture of the two. No number or layout is obligatory, so these can be varied. In the example given here the Dresden Plate has 12 sections, 4 with pointed edges to give a stronger accent at the top, bottom, and two sides (shown on page 71). The sections are

joined to make the plate, which is then appliquéd onto a background. The outer edges are turned over and basted before being stitched to the background. Finally, the central circle is appliquéd in position. This block is as much about appliqué as about piecing.

COLOR CHOICES

This is another block, like Grandmother's Fan and Baby Blocks, that has a design set on a background. When choosing the fabrics, arrange them on the background fabric to get an idea of how they look. You may vary your backgrounds or keep them all one color, but you need to pin up or lay out all the completed blocks to check how the selection and balance of colors is developing. If it is not possible to

pin them onto a vertical surface, lay them on the floor and view them from as great a distance as possible — stand on a chair or even a stepladder. Note the fabrics you need to use more of, and what is needed to keep a good balance.

For the plate sections, choose a selection of three fabrics that are equal in value. Try to avoid one that is much stronger than the others, or use it for the pointed-edged sections to make a cross. You can leave the decision about the central circle until later if you are not sure what to use at this stage.

CONSTRUCTION

1 Make templates A, B, and C from Fig. 1 (see page 15 for making templates).

2 On the wrong side of your chosen fabrics, draw accurately around template A and template B using a sharp marking pencil. You need eight A shapes and four B shapes. Mark the lines X in the seam allowances on each piece (Fig. 2a). Leave at least ½ inch between each drawn outline so a seam allowance of ¼ inch can be added to each shape when cutting out. Note that you can save space by arranging the shapes as in Fig. 2b.

Fig. 1 Templates — actual size excluding seam allowance

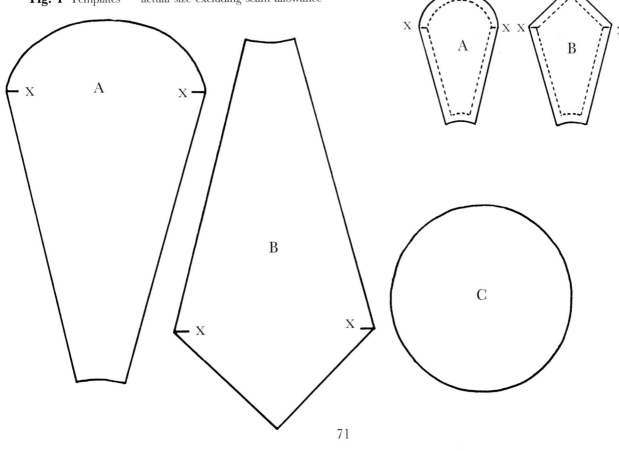

Fig. 2a

71

Fig. 2b

WS

3 Cut out each shape to include the ¼-inch seam allowance, using a quilter's quarter, seam wheel, or small rotary cutter with a seam guide attachment (see Basic Equipment, pages 10–14).

Arrange the sections on the background fabric to make sure that you are happy with the sequence of fabrics before stitching them together. Take two adjacent sections and place them with right sides together, matching the drawn lines with pins from the corner to the lines marked X (Fig. 3), as in Maple Leaf block.

Fig. 3

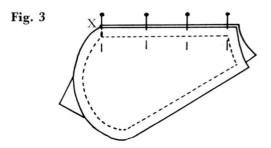

4 Stitch along the drawn lines, either by hand or machine, beginning and finishing at the corner of the design and at X (Fig. 4).

Fig. 4

5 Join all 12 sections together in this way to make a complete circle (Fig. 5). Press the seams from the front of the work to one side.

Fig. 5

6 Turn the plate to the wrong side and carefully clip the seam allowance of the curved outer edge, snipping at roughly ¼-inch intervals, going nearly but not quite to the drawn line. The seam allowances along the outer edge of the plate need to be turned to the back of the work and basted.

The turning lines are most easily marked by the traditional technique called needle-marking. Lay the plate right side down on a pad of folded fabric (a folded flannelette sheet is ideal) or an ironing board. Position template A on one of the curved sections, exactly on the drawn outline. Using a large blunt tapestry needle, trace around the curved edge of the template, holding the needle at an angle and pressing firmly. You should find that the needle has pressed a crease along the curved line (Fig. 6). Repeat this process on all eight curved edges, then use template B to needle-mark the pointed edges of the remaining four sections.

Fig. 6

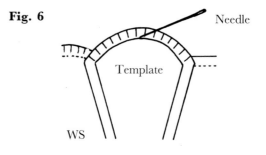

Needle

Template

WS

7 Turn the plate over to its front. Following the creased lines, turn under the outer edges to the back of the work, basting them down with small running stitches as you work (Fig. 7). Do not press this basted edge. It will be easier to appliqué the plate onto the background in a really smooth curve if the edge is unpressed, so any little irregularities can be adjusted as it is stitched.

Fig. 7

8 Cut a 13-inch square of fabric for the background. This allows for any pulling in of the background when the plate is appliquéd onto it. The fabric can be trimmed to exactly 12½ inches later on.

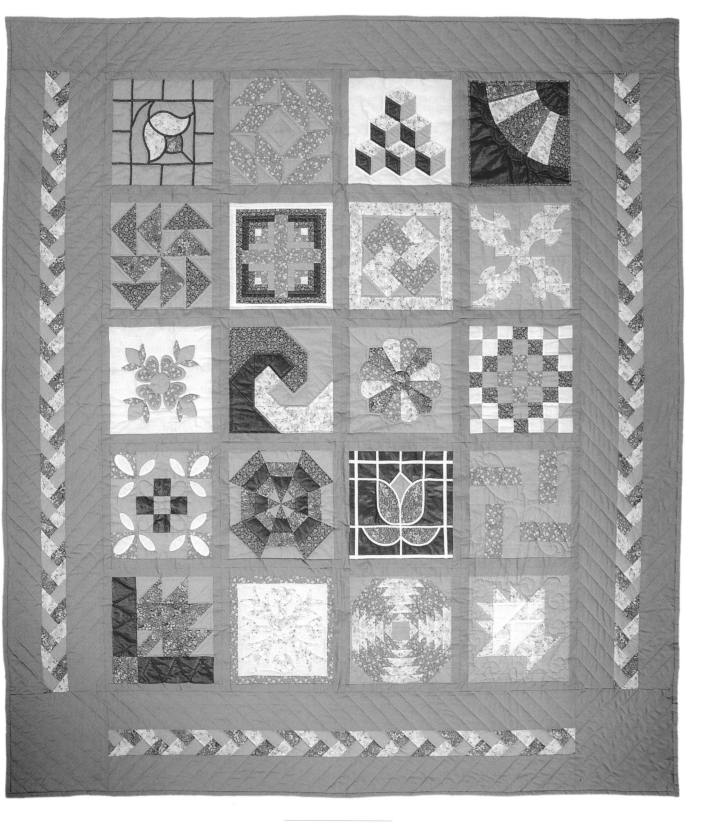

FINISHED QUILT BY CHRIS WASE

*"The blocks for my quilt were made during evening classes
and the rest during occasional weekend classes.
The border was chosen to complement the quilt and because
it would be quick. In fact, it led to more and more quilting,
which took longer than the rest of the quilt!"*

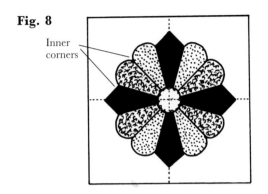

Fig. 8

Inner corners

Fold the background square of fabric into quarters and press lightly to mark the center. Unfold it and position on the plate, centering the creased lines within the hole in the plate (Fig. 8).

9 Pin or baste the plate onto the background, and using thread to match the fabrics of the plate and not the background, sew it in position, using small, even slip stitches (Fig. 9). Sew a double stitch at each inner corner to secure it. Press from the front.

Fig. 9

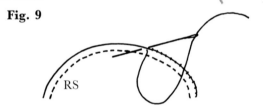

RS

10 On the wrong side of your chosen fabric, draw around circle template C and cut it out with a ¼-inch seam allowance added. Make a line of small basting stitches close to the outer edge of the fabric circle (Fig. 10a). Place the cardboard template on the wrong side of the fabric and pull the basting stitches so that the edges of the fabric are gathered tightly over the cardboard (Fig. 10b). Secure with a double stitch and press lightly from the front. Remove the cardboard circle by bending it slightly. Pin the fabric onto the center of the plate and stitch in place.

Alternatively, you might like to try freezer paper to make the circle in this design (see Basic

Fig. 10a **Fig. 10b**

WS Cardboard circle

Equipment, page 12). On the freezer paper, draw around template C and cut it out exactly. Iron the circle, shiny side down, onto the wrong side of the fabric. Cut around it with a ¼-inch seam allowance. Clip the curve nearly, but not quite, to the freezer paper (Fig. 10c). Carefully peel off the circle, replacing it in exactly the same position but with the shiny side facing up (Fig. 10d). With the tip of an iron, push the seam allowance over the freezer paper, sticking it down as you work. Be careful not to press in any tiny pleats on the outer edge, but keep the curve smooth (Fig. 10e). If there are areas you are not happy with, just peel the fabric back and re-press in the correct position. Place the circle of fabric in the center of the plate and press. This will secure it on the background while you stitch it in place.

Fig. 10c **Fig. 10d**

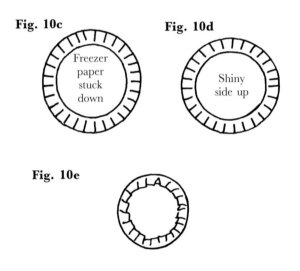

Freezer paper stuck down Shiny side up

Fig. 10e

11 If you use freezer paper, cut a slit in the background fabric after the block has been completed, to remove the paper. If the center has been appliquéd in the normal way, it is up to you whether you cut the background away, although it does allow the block to lie flatter and will be easier to quilt (see Baby Blocks, page 22, for instructions on cutting away the background).

12 Trim the block to an exact 12½-inch square (see page 109 for instructions on trimming the blocks).

13 Add the framing divider strips (see page 110 for instructions).

TRIANGLES

Patchwork designs worked by the pioneers depended greatly on the simple square, for it provided a way of making a quilt from scraps quickly and with little wasted fabric. Large squares were often combined with groups of four smaller squares in a checkerboard arrangement to create more-elaborate designs and as a way of using up scraps.

An exciting progression from these squares was to divide the square diagonally into two right-angle triangles. These triangles were combined with squares

and other triangles to create a huge number of block patterns as well as decorative borders and edgings (shown above). The usual method of making these designs was to make a template, cut out the shapes, then piece them together by hand or machine, following the drawn sewing lines in the American piecing technique. However, there is a quicker and easier way of turning the triangles into squares by using rotary equipment and a sewing machine. You still have the boring job of joining the squares and matching the corners, but the preliminary cutting and stitching is simplified.

This technique is based on a drawn grid of squares, the size of which depends on the final size needed. When planning a machined design that uses 3-inch squares, finished size, you must cut 3½-inch squares to allow for the ¼-inch seam allowance on all sides (see below).

3 inches 3½ inches

For a finished square measuring 3 inches and made up of two triangles, the starting measurement has to allow for the diagonal seam across the square and must be 3⅞ inches square (see below).

3 inches 3⅞ inches

COLOR CHOICES

Six block designs are shown above right. Each one uses just two fabrics. Because the designs are so varied, it is quite possible to make more than one block for the sampler quilt without any similarity between them.

CONSTRUCTION

1 From each of the two chosen fabrics, cut a piece measuring about 16½ x 9 inches. Place them with right sides together and press. This will help keep the two layers in place. Place the two layers of fabric on a cutting mat. On the top fabric you need to draw a grid of eight squares — two rows of four — with each square measuring 3⅞ inches square (Fig. 1). To do this accurately, it is better to use the measurements on the ruler rather than those on the cutting mat.

Fig. 1

FINISHED QUILT BY LINDY WARD

"I love the colors in old, faded quilts, so I selected my materials to give that soft, muted effect now, rather than waiting years for it to happen naturally."

2 Find the line or marks on the ruler that are 3⅞ inches from one edge. Mark this distance by placing a small piece of tape at each end of the ruler on the 3⅞-inch line (Fig. 2).

Fig. 2

3⅞ inches

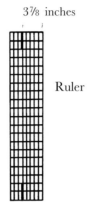

Ruler

3 Place the ruler vertically about ¼ inch from the left-hand edge of the fabrics (Fig. 3a). Using a marking pencil, draw a line from top to bottom of the fabric along the ruler's edge.

Fig. 3a

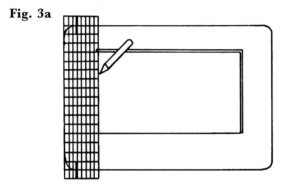

Move the ruler across the fabric to the right until the marked 3⅞-inch line is exactly on top of the drawn line (Fig. 3b). Draw a line along the ruler's edge.

Fig. 3b

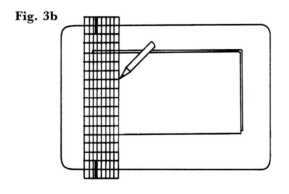

Move the ruler across the fabric to the right until the new drawn line lies exactly under the

3⅞-inch line on the ruler. Draw a line along the ruler's edge. Repeat this procedure until five vertical lines have been drawn on the fabric at 3⅞-inch intervals. Left-handed quilters should begin marking from the right-hand side and move the ruler across the fabric to the left.

Turn the ruler horizontally and draw a line on the fabric about ¼ inch from the bottom edges (Fig. 3c). In the same way as before, move the ruler up over the fabric until the 3⅞-inch line is exactly on top of the drawn line (Fig. 3d). Draw a line along the ruler's edge. Repeat this once again to complete the grid of two rows of four squares.

Fig. 3c

Fig. 3d

4 Draw diagonal lines across each square in one direction only (Fig. 4).

Fig. 4

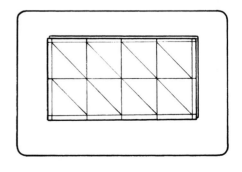

5 Pin the two fabrics together with 8 to 10 pins to hold the layers while stitching. Machine a line of stitching on *each side* of the drawn diagonal lines at a distance of exactly ¹/₄ inch, using a slightly smaller stitch (Fig. 5).

Fig. 5

If you have a strip of masking tape stuck onto your machine plate as a stitching guide, you will not be able to see it through the layers of fabric, so another way of stitching accurately must be found:

a Use a special ¹/₄-inch foot on the machine (see Basic Equipment, page 13).

b If your machine has the facility, move the machine needle until the distance between it and the side of your machine foot is exactly ¹/₄ inch.

c Using a different color of marking pencil to prevent confusion, draw in a line ¹/₄ inch away from the diagonal line on both sides.

6 After the pairs of lines have been stitched, remove the fabrics from the machine and place them on the cutting mat. With a ruler and a cutter, cut along all the drawn vertical lines. Without moving the fabric, cut along the drawn horizontal lines. Finally, cut along the drawn diagonal lines (Fig. 6). You will find that a miracle has happened, and that when you pick up each triangle of fabric, it has been stitched to another. You will have a pieced square made of two triangles of two different fabrics.

7 Some of the triangles will have a line of

Fig. 6

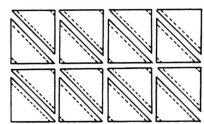

stitches across one corner (Fig. 7). Loosen these gently by pulling the fabrics apart. They will easily come undone and the threads can be removed.

Press each square from the front with the seams toward the darker fabric.

Fig. 7

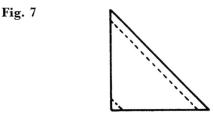

8 Arrange the 16 squares in your chosen design. If they do not all fit together perfectly, remember that you can swap the squares around, because they are all identical. Sew together the top four squares to make a row. If you have a design where two triangles meet in a point, check to see that, once they are joined, the two triangles meet in an arrowhead ¹/₄ inch from the top edges of the fabric (Fig. 8), see Spider's Web (page 58). From the front, press all seams on Row 1 in one direction.

Fig. 8

9 Join together the four squares in Row 2. From the front, press the seams in the direction opposite to Row 1. Join Rows 1 and 2, matching seams carefully. Repeat with Rows 3 and 4 until the block is completed.

10 Press the completed block from the front and measure. It should be exactly 12¹/₂ inches square. If it is not, trim or add a small border (see page 109 for instructions on trimming the blocks and adding borders).

11 Add the sashing strips, following the instructions on page 110.

HAND APPLIQUÉ

ROSE OF SHARON

Appliqué is a technique often used in quilt-making. Many of the traditional appliqué designs, which include simplified flowers, leaves, and wreaths, are used together with piecing and quilting to create beautiful quilts.

The appliqué block for the sampler quilt is the Rose of Sharon design, which I chose for its good looks and because it combines all the possibly tricky elements of appliqué: sharp points, deep V-shapes, curves, and overlapping pieces. By the time you have

finished stitching it, you should be ready for any appliqué design that appeals to you in the future.

COLOR CHOICES

This design gives you a chance to use up all the small pieces of fabric you may have, for none of the appliqué pieces are very big. You will need a 13-inch square of background fabric, which will be trimmed down to a 12½-inch square when the appliqué has been completed. Cut out and arrange one section of the design on the background square (Fig. 1, page 84) before you begin sewing, to verify that you like the arrangement of fabrics.

CONSTRUCTION

Before beginning any appliqué design, you must do some planning. First, the appliqué shapes should always be cut so that the straight grain of all the fabrics matches the straight grain of the background fabric when they are sewn in position. The straight grain is marked on the templates here with a double-headed arrow. Second, the appliqué shapes must be attached in the right order, so the top shapes are added last. Where two shapes meet, the seam allowance of the bottom background piece is left unturned. The second piece is then placed overlapping this raw edge. In Fig. 1 on page 84, the dotted lines indicate where the seam allowances are left unturned and overlapped by another shape. Short arrows indicate edges where the seam allowances are turned under and basted.

1 Cut a 13-inch square of fabric for the background. Fold it diagonally into quarters to find the center point, then finger-press. Trace the design layout Fig. 1, on page 84, onto paper. Place the fabric square over the design layout, positioning the center of the fabric over the central cross on circle E and a diagonal fold over the broken positioning line. Draw *very* lightly with a marking pencil, about ⅛ inch inside the lines of the design to give an indication where the appliqué pieces will be positioned. Do not draw exact outlines in case these show around the edges of the appliquéd shapes after stitching. If the fabric is not fine enough to trace through, use a light box (see Basic Equipment, page 14). Turn the fabric and place another diagonal fold over the positioning line on the layout. Draw the guidelines for each shape, as before. Repeat this with the other two diagonal foldlines, until the complete appliqué design has been marked on the fabric.

2 Make templates A, B, D, and E from Fig. 2 on page 84 in the usual way (see page 15 for instructions on making templates). Template C is for the inner flower and is optional. If the fabric for the outer flower D is very detailed, you may feel that you do not need the extra layer, in which case omit template C.

The outlines of the shapes can be transferred to the fabrics in two ways:

a Hold the cardboard template in position on the *front* of the appliqué fabric and draw around it lightly with a sharp marking pencil.

b Or draw around the template on the *wrong* side of the appliqué fabric. Place the fabric on a pad of folded fabric, wrong side up. Hold the cardboard template in position on the drawn outline and run the point of a large blunt-ended needle very firmly around the edge of the template. This is the needle-marking technique first used in Dresden Plate.

Both these techniques work well, so choose whichever appeals to you most. You may find that your fabric does not crease well enough for needle-marking or that a marking pencil does not show up clearly. Try both methods and use the more efficient one.

For the design, you will need eight of shape A, four of shape B, four of shape C, four of shape D, and one of shape E.

3 Once the outlines have been transferred to the appliqué fabric, cut them out, adding a ¼-inch seam allowance. With sharp scissors, clip any curved edges at right angles to the pencil line, nearly but not quite to the line itself. Outer points should be left unclipped for ½ inch on each side of the point, while V-shaped edges need to be clipped cleanly to the pencil line (Fig. 3).

Fig. 3

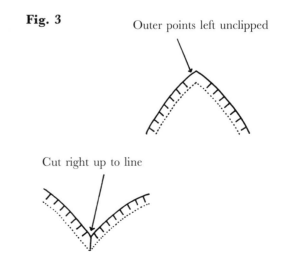

Outer points left unclipped

Cut right up to line

4 Begin with shape A; Fig. 4a shows the edges
that are to be clipped and turned under. Clip
to the line at the points marked X, so that the
narrow stem shape can be turned under. The two
unturned edges will be overlapped by the B shapes.
Turn the appropriate seam allowances to the
back after clipping, following the pencil line or
needle-marked fold exactly, and baste with small
running stitches, as in Dresden Plate. Do not press
the basted appliqué pieces because it will be
simpler to ease out any irregularities in the edges as
you stitch if they are unpressed.

Fig. 4a

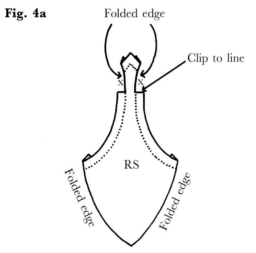

Clip and baste under all edges of shapes B. The
sharp corners can be folded over neatly in three
stages (Fig. 4b).

Fig. 4b

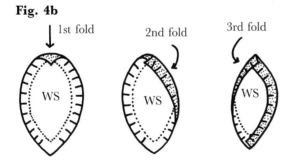

Clip and baste under shapes C (if used) and D
on the outer curves only (Fig. 4c). Shape E can be

Fig. 4c

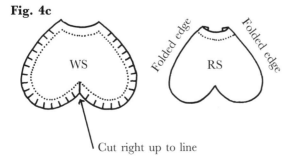

Cut right up to line

made by gathering the fabric circle around a
cardboard template, or by using freezer paper.
Follow the instructions given on page 74.

5 Arrange the basted shapes in position on the
background, beginning with A, then B, C, D,
and finally E. Make sure that each shape overlaps
the previous one by ¼ inch. Pin or baste each
piece in place (Fig. 5).

Fig. 5

6 Stitch each shape onto the background with
small, even slip stitches, beginning with A and
working toward the center (Fig. 6a). Match the
sewing threads to the appliqué, not the background.
In the V-shaped areas of any shape, which have
been clipped right up to the line, reinforce with two
or three stitches in the inner corner (Fig. 6b).

Fig. 6a **Fig. 6b**

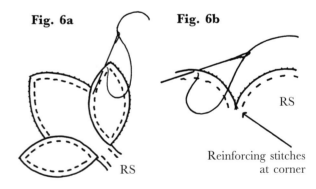

Reinforcing stitches
at corner

7 Once the appliqué has been completed,
remove the basting stitches. If freezer paper has
been used for the central circle cut a slit in the
background fabric to remove the paper. If you
wish, the layers can be reduced by cutting away
the background fabric behind the appliqué.

8 Trim the background fabric to an exact
12½-inch square.

9 Add the framing sashing as usual, following the
instructions on page 110.

FINISHED QUILT BY JENNY SPENCER

"My first quilt, called Golf Widow — now I have my own obsession! I wanted the effect of an old, faded quilt, so chose soft, muted colors. When I learned Seminole Patchwork, I couldn't stop; hence the borders."

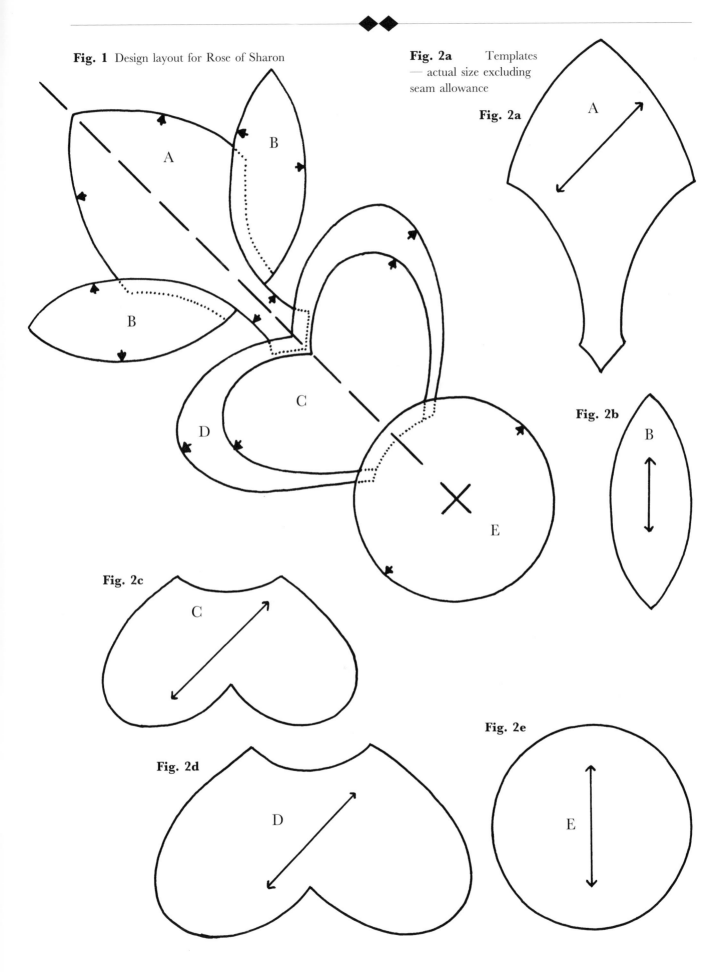

Fig. 1 Design layout for Rose of Sharon

Fig. 2a Templates
— actual size excluding
seam allowance

Fig. 2a

A

Fig. 2b

B

Fig. 2c

C

Fig. 2d

D

Fig. 2e

E

WILD-GOOSE CHASE

A BLOCK BASED ON FLYING GEESE

Flying Geese is a favorite pattern that appears in many quilts as blocks and borders, as the examples given overleaf (top left) show. The block for the sampler is called Dutchman's Puzzle, but it is also known as Wild-goose Chase, which I prefer because it conjures up the desperate chase for the perfect fabric for the quilt! Traditionally this design was laboriously pieced using templates and American piecing.

The quick method of sewing half-square triangles

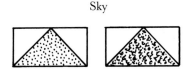

CONSTRUCTION

The design is made from eight Flying Geese, the finished size of each unit is 6 x 3 inches. The large squares are cut 1¼ inches larger than the finished size: 6 inches + 1¼ inches = 7¼ inches square. The small squares are cut ⅞ inch larger than the finished size: 3 inches + ⅞ inch = 3⅞ inches square.

1 Cut a 7¼-inch square from each of the two fabrics you are using for the geese. Draw the diagonals on the *right side* of each square with a sharp marking pencil (Fig. 1).

Fig. 1

(see page 76) is based on the principle that if you want to finish up with a square of a certain size, you must start with a square that is ⅞ inch larger (see below). This includes the ¼-inch seam allowance around the edges, plus the diagonal seam that joins the two triangles.

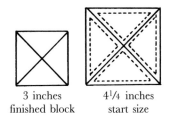

3 inches
finished block

3⅞ inches
start size

There is a similar formula for cutting a square divided into four triangles. The final size required needs to have an extra 1¼ inches added to it at the beginning. This extra includes the ¼-inch seam allowance around the edges, plus the two diagonal seams (see below).

2 Cut eight 3⅞-inch squares from the sky fabric by cutting a strip 3⅞ inches wide and cutting off 3⅞-inch lengths (Fig. 2).

Fig. 2

3⅞ inches 3⅞ inches 3⅞ inches 3⅞ inches

3⅞ inches

3 Draw one diagonal on the *wrong side* of each of these (Fig. 3).

Fig. 3

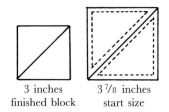

3 inches
finished block

4¼ inches
start size

COLOR CHOICES

The block uses two main colors for the large triangles, known in the pattern as geese, and one background shade for the smaller triangles, which represent the sky (see below). When you get to this block, you may be running short of some fabrics, so it is best to check against the sizes given below to make sure you have enough for your chosen shades.

Sky

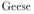

Geese

FINISHED QUILT BY PAM CROGER

"My first sampler quilt. The great thing was the camaraderie within the group. I learned to use fabrics with much more confidence and more boldness."

◆◆

4 With right sides together, pin two of the smaller squares onto one of the larger squares, lining up the drawn diagonal lines. The two corners of the smaller squares will overlap in the center (Fig. 4a).

Fig. 4a

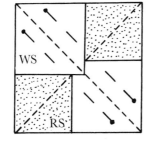

Trim these corners off, following the drawn line on the large square so that the two smaller squares meet but do not overlap (Fig. 4b).

Fig. 4b

5 On the smaller squares, machine-stitch a seam on each side of the drawn diagonal lines, exactly ¼ inch from the line (Fig. 5). This is the same technique used in Triangles (pages 75–79).

Fig. 5

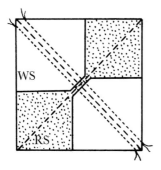

6 Cut along the drawn diagonal line between the two stitched lines (Fig. 6).

Fig. 6

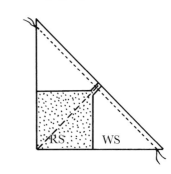

7 Take one section and finger-press the small triangular pieces away from the main triangle (Fig. 7).

Fig. 7

8 With right sides together, pin a small square onto the main triangle, matching the drawn diagonals (Fig. 8a).

Fig. 8a

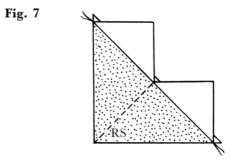

Machine-stitch a seam on each side of the diagonal line on the small square, exactly ¼ inch from the line (Fig. 8b).

Fig. 8b

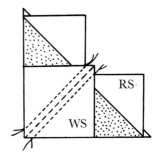

Cut along the drawn line between the two stitched lines (Fig. 8c).

Fig. 8c

9 Repeat steps 1–8 with the other section and one small square. Press each piece from the front, with the seams lying toward the smaller triangles. You will now have made four identical Flying Geese (Fig. 9a).

Repeat the entire process, using the second large square of fabric and the remaining four smaller squares. This will give you four Flying Geese in the second color combination (Fig. 9b).

Fig. 9a　　　　**Fig. 9b**

10 Arrange the eight Flying Geese in the design shown on the top left of page 88, or any other arrangement that looks good. Join the Flying Geese into pairs, pinning them as shown in Fig. 10a, so that when you stitch, you sew through the crossed seams in the center (Fig. 10b). If you stitch right through this cross of stitches, you will not cut off the point of the large triangle. After all, who wants Flying Geese with bent beaks?

Fig. 10a

Fig. 10b

11 Press seams to one side from the front of the work (Fig. 11).

Fig. 11

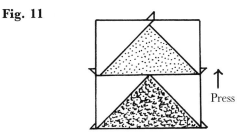

12 Arrange the four sections in the design. Join the top two together so the two seams meet in an arrowhead ¼ inch from the edge (Fig. 12).

Fig. 12

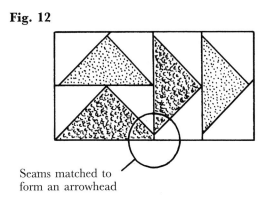

Seams matched to form an arrowhead

Press the seam to one side. Join the bottom pair, pressing the seam in the opposite direction. Sew the two halves together, matching the center seams carefully. Either press this long seam to one side or press it open, so the seam lies flat.

13 Measure the completed block. It should be 12½ inches square. If the block is too big, try taking in the seams a little rather than trimming down the outside edges; losing the sharp points can ruin the design. If the block is too small, add a narrow border to bring it up to size (see page 109 for instructions on trimming and adding borders).

14 Add the sashing strips (see page 110 for instructions).

TULIP BLOCK

Stained glass has been used to enhance the windows of churches and houses for hundreds of years. The depth of color from light pouring through tinted glass outlined by black leading gives a stunning effect. Stained-glass patchwork, which is a variation of hand appliqué, aims to create the same effect with fabric. The colored sections are basted in position on the background, then the edges are covered by narrow strips of black fabric to give the impression of stained glass.

COLOR CHOICES

If you were planning a wall hanging of a stained-glass design, your chosen fabrics would probably imitate the brilliance and jewellike quality of true stained glass. However, these strong colors may not be appropriate for the sampler quilt, so just use colors that complement the blocks you have already made. The edging around each area of color can be of any fabric you wish. It does not even have to be a plain color; striped or patterned fabrics can look wonderful. The background needs to be a 13-inch square, while the bias strips (strips cut diagonally across the fabric) for the "leading" can be cut from a piece measuring 14 inches square.

CONSTRUCTION

1 Draw a 13-inch square on a large sheet of tracing paper. I do this by laying the paper on a cutting mat, using the mat markings to find the four corners of the square. I mark these with dots, then join up the dots with a long ruler to make the square. Mark the center vertical line with a dotted line (Fig. 1) using the same technique. Mark the center point O on this line.

Fig. 1

2 Trace the design in Fig. 2 on page 92 onto one half of the tracing paper, matching the center lines and point O.

3 Continue drawing the lines of the design to meet the edges of the paper square (Fig. 3).

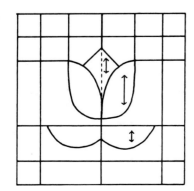

Fig. 3

From point O, measure along the center dotted line $5\frac{1}{4}$ inches above and $5\frac{1}{4}$ inches below. Mark both these points. From each point, draw a horizontal line across the design to the edge of the paper square. Turn the paper over and trace the other half of the design, matching the center lines and both halves of the design exactly (Fig. 3). Include the arrows that show the direction of the straight grain of the fabric.

4 Cut a 13-inch square of fabric for the background. Fold it in half vertically and crease it lightly to mark the center line. Place the fabric square over the design layout, matching the creased line with the central dotted line on the tracing. Trace the design onto the fabric with a sharp marking pencil. Use a light box, if necessary (see Basic Equipment, page 14).

Cut shapes A, B, and C (Fig. 4) from the tracing paper. Use these as patterns. Pin them onto the right side of the fabrics, matching the arrows on the tracings with the straight grain of the fabric (the direction of the woven threads). Cut each shape exactly. No extra seam allowance is needed. Use a single layer of fabric for shape A, and a double layer (right sides together) for shapes B and C to give one center tulip petal, two side petals, and two leaves.

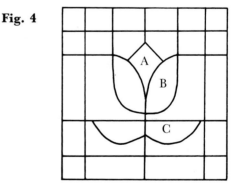

Fig. 4

5 Pin each piece in position on the background square so that the raw edge of each shape abuts its neighbor. Baste in place (Fig. 5).

Fig. 5

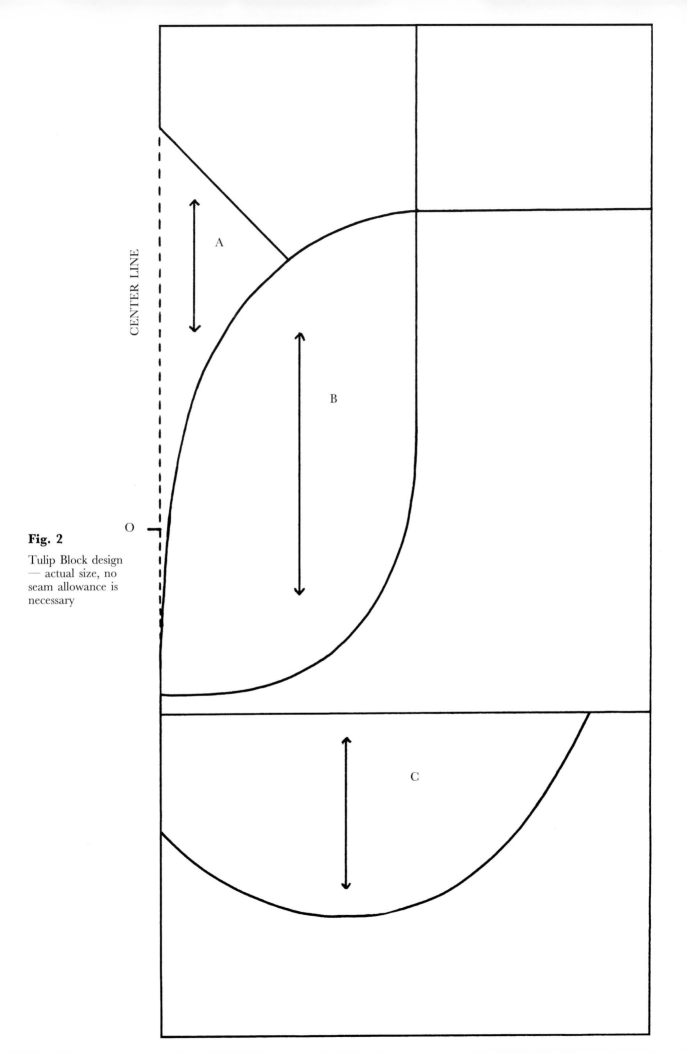

CENTER LINE

A

B

O

Fig. 2
Tulip Block design
— actual size, no
seam allowance is
necessary

C

6 The leading strips must be cut on the bias of the fabric because they need to stretch slightly to curve around the shapes without puckering; 1-inch-wide bias strips are needed for this design.

To cut the strips, a single layer of fabric is squared up on a cutting mat with one corner on top of the 45° line on the mat. Cut along the line with a rotary ruler and cutter (Fig. 6a). Turn the fabric so that the cut edge is on the left and move the ruler over it until the cut edge lines up with the required width on the ruler. Cut along the right side of the ruler. Repeat this across the fabric (Fig. 6b). Left-handers should cut their strips from the right, not the left.

Fig. 6a **Fig. 6b**

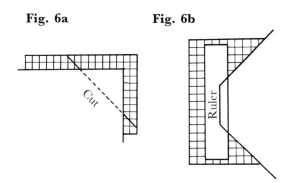

7 There are two gadgets that will help quilters make folded bias strips: a bias-maker and bias bars (see Basic Equipment, page 12). They work differently; so it's a good idea to try both if you can, then choose and use the one that appeals to you.

With a bias-maker, use the $^1/_2$-inch version and follow the manufacturer's instructions for pulling the strip of bias fabric through the gadget. Press the bias strip with a steam iron when it appears in its folded form from the narrower end of the bias-maker (Fig. 7a). This will make a length of bias that looks exactly like commercial bias binding and is about $^1/_2$ inch wide, which is a little too wide for this design.

Fig. 7a

To narrow the folded strip, refold one side across the back (Fig. 7b) and press with a steam iron.

Fig. 7b

Original fold

8 With bias bars, use a $^1/_4$-inch-width bar. With wrong sides facing, fold the 1-inch-wide bias strip in half. Using a slightly smaller stitch, machine-stitch a $^1/_4$-inch seam down the length of the strip to make a tube. Make a sample length first to make sure the bias bar will fit snugly into the tube (Fig. 8a). Trim the seams to $^1/_8$ inch (Fig. 8b). Slide the bias bar into the tube, twisting the fabric so that both seam and allowance lie across one flat side of the bar and cannot be seen from the other side (Fig. 8c). With the bar in place, press the seam to one side. Slide the tube off the bar, pressing firmly.

Fig. 8a **Fig. 8b** **Fig. 8c**

The sequence for adding the strips has been planned so that as many bias ends as needed are concealed beneath other strips. The order of stitching is shown in Fig. 9.

9 Take a length of pressed bias tubing slightly longer than line 1 in Fig. 9, using the full-scale design (Fig. 2) for measurement. Pin the strip so that it covers and is centered on the line.

Fig. 9

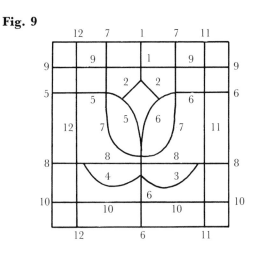

10 Trim the ends exactly to match the end of the drawn line (Fig. 10). Matching the sewing thread to the strip, not the background, sew both sides of the strip onto the background with small, even slip stitches.

Fig. 10

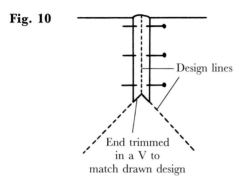

Design lines

End trimmed in a V to match drawn design

11 Cut a length of pressed bias tubing slightly longer than the V-shaped Seam 2 in Fig. 9. Fold it into a mitered corner about halfway along, and pin in position with the corner covering the end of Strip 1 and the drawn guideline halfway beneath it (Fig. 11). Trim the ends of the strip to match the ends of the drawn lines. Sew the strip in place on the background with slip stitches.

Fig. 11

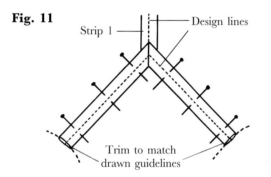

Strip 1

Design lines

Trim to match drawn guidelines

12 Cut a length of pressed bias tubing slightly longer than Seam 3 in Fig. 9. This is a curved line, so it must be treated slightly differently. The strip must be positioned half on the basted leaf C and half on the background (Fig. 12a).

Fig. 12a

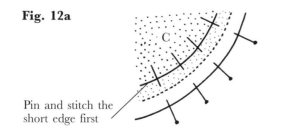

C

Pin and stitch the short edge first

Pin and sew the shorter inside edge of the curve first. The longer outside edge can then be stretched slightly when sewing to fit the curve (Fig. 12b). If you attach the longer edge first, the shorter edge will end up with little pleats in it. Trim the ends of the strip to match the drawn guidelines.

Fig. 12b

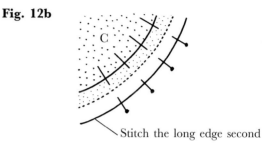

C

Stitch the long edge second

13 Continue to pin and stitch each length of pressed bias tubing in turn, following the sequence shown in Fig. 9.

14 Remove basting and press. Trim the background fabric to an exact 12½-inch square.

15 Add the sashing strips as usual, following the instructions on page 110.

FINISHED QUILT BY COLLIE PARKER

"My enthusiasm for quilting was engendered by the American tradition, especially those quilts which displayed bold color contrasts and clear designs. In planning my first sampler quilt, I tried to choose colors that would say 'America' to me."

CROCUS DESIGN

American missionaries introduced patchwork techniques to Hawaii in the 1820s. Since then, the native Hawaiians have developed their own colorful interpretations of hand-appliqué quilts. Quilt-size pieces of paper are folded into eighths and then cut to create patterns that represent the flowers, fruit, and leaves of the Hawaiian Islands. This paper is then unfolded, and the pattern is used to cut out the huge fabric appliqué motif, which is basted in place on the contrasting quilt background.

Colors are clear and vibrant, like red, green, or blue on white, and only plain fabrics are used. The appliqué edges are stroked under with the point of a needle and stitched onto the background in one process. Quilting lines follow the outline of the appliquéd design and are repeated to the edge of the quilt, just like contour lines on a map (see below).

This appliqué technique (known as needle-turning), using a design based on folded paper shapes, can be scaled down and adapted for a block in the sampler quilt. Rather than copy the exotic tropical plants of Hawaii, I felt it was more appropriate to use a design taken from the garden. In this case, I chose a crocus, with its characteristic long, pointed leaves. Many of my students have insisted that the flower is more like a tulip than a crocus, but since there is already a tulip in the stained-glass block, I am calling this a crocus.

COLOR CHOICES

A 13-inch-square piece of fabric is needed for the background. The appliqué design is cut from a folded 11-inch square of fabric. Just because traditional Hawaiian quilts feature strong, plain colors, don't feel that you must do the same. A visitor to one of my classes was horrified when she saw the soft colors and patterned fabrics being used with abandon as backgrounds or appliqué. As always, use the technique shown, but choose fabrics that suit the balance of your collection of blocks.

CONSTRUCTION

1 With right sides together, fold the smaller fabric square (the appliqué fabric) in half (Fig. 1a). Fold it in half again (Fig. 1b). Finally, fold it diagonally (Fig. 1c). Verify that the center of the

square is positioned as shown. If it is not, you may end up with several pieces of fabric instead of one whole one. Press the folded fabric firmly to give sharp folds.

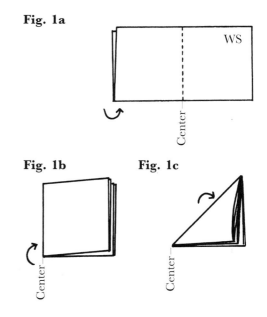

Fig. 1a

Fig. 1b **Fig. 1c**

2 Make a template of the appliqué design in Fig. 2 on page 98 by tracing it onto cardboard, or use template plastic (see page 15 for instructions).

3 Place template on the folded triangle of fabric, matching the centers. Make certain the bias and straight edges of the fabric match the bias and straight markings on the template (Fig. 3). Draw around the template with a sharp marking pencil.

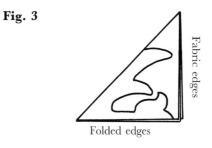

Fig. 3

Secure the layers of folded fabric with two or three pins. Using very sharp scissors, cut out the drawn outline through all eight layers, holding the fabric firmly so that none of the layers slip.

Fold the background square into eighths, in the same way as before. Press lightly with an iron so the folds make guidelines for positioning the appliqué.

Fig. 2 Template — actual size
seam allowance included

BIAS

CENTER

STRAIGHT

4 Unfold the background fabric and lay it on a
flat surface. Place the folded appliqué onto the
background with the centers matching (Fig. 4a).
Unfold the appliqué design section by section
(Figs. 4b and 4c) until the whole design is revealed
(Fig. 4d). Be sure that the foldlines on the appliqué
design are lying exactly on the guideline folds in
the background fabric.

Fig. 4a

Fig. 4b

Fig. 4c

Fig. 4d

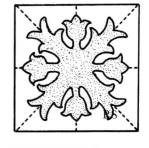

FINISHED QUILT BY YVETTE LONG

*"The colors of the blocks are based on Spring,
Summer, Autumn, and Winter. This was my first
piece of patchwork, and I think Lynne nearly died
when I told her what I wanted to do! The quilt was
used on the cover of the catalog of the Great British
Quilt Festival in 1993."*

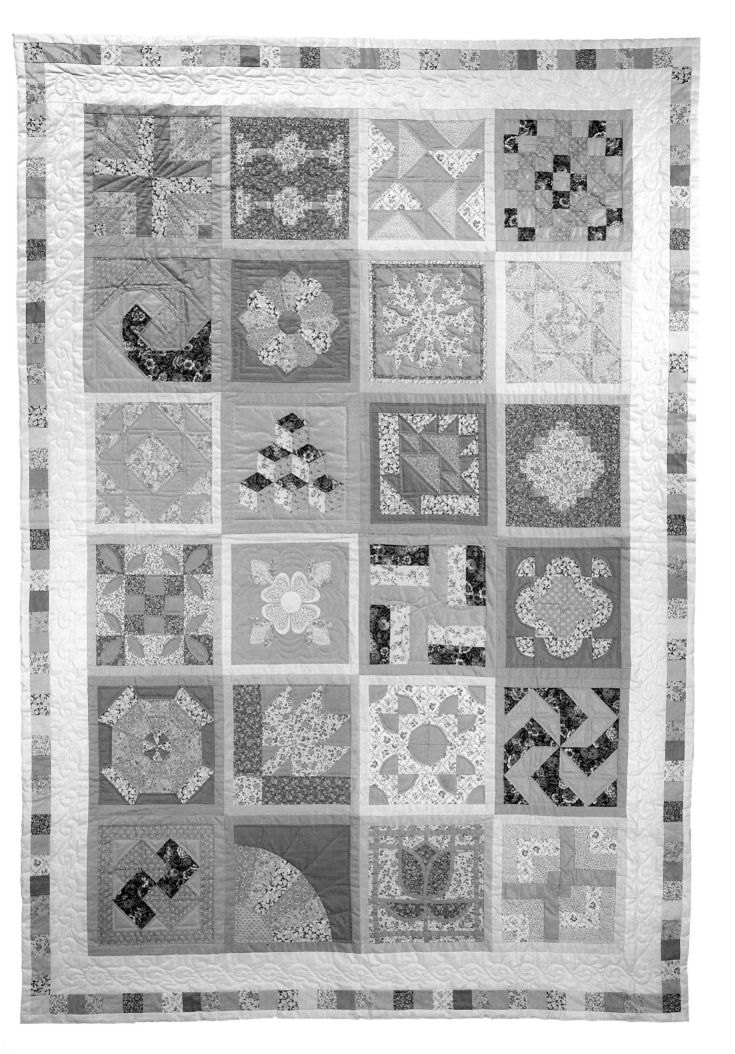

5 Pin the appliqué to the background in several places, then baste in place, using ¼-inch-long stitches and keeping them about ¼ inch from the edge of the design so that the appliqué is held firmly in place (Fig. 5).

Fig. 5

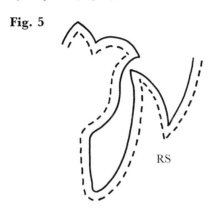

6 Using thread to match the top fabric, turn under and sew the raw edge just ahead of the needle. The turning should be about ⅛ inch, and it is made by stroking the fabric under with the point of the needle (Fig. 6). Use small, closely spaced slip stitches to sew the folded edge in place.

Fig. 6

7 When sewing an outside point of the design, work to within ⅛ inch of the point and make a firm stitch (Fig. 7a). Using the point of the needle, stroke down the raw edges of fabric away from the last stitch and tuck under the usual ⅛ inch (Fig. 7b). Sew the turned edge and continue.

Fig. 7a

Fig. 7b

8 Do not clip any inner curves. With the needle point, sweep the seam allowance under in a scooping movement. Repeat the movement from side to side until the point becomes rounded and all the seam allowance has been stroked under. Sew the curve with slip stitches that are very closely spaced (Fig. 8).

Fig. 8

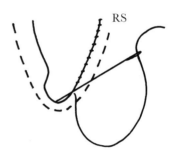

9 Continue turning under and sewing the edge of the appliqué design until it is completely sewn down. Remove the basting stitches and press.
 Turn the block to the reverse side and carefully cut away the background fabric behind the appliqué, leaving a seam allowance of ¼ inch beyond the stitching line (Fig. 9). See page 26 for instructions on removing bulky layers of fabric.

Fig. 9

10 Trim the background fabric to an exact 12½-inch square.

11 Add the sashing strips as usual, following the instructions on page 110.

HONEYBEE

This block and the following design, Grape Basket, have been included to make up the number of blocks needed to complete the quilt. Neither has new techniques to be mastered, so I have kept the instructions fairly basic, to help you get used to working on your own. This particular pieced patchwork design can be worked by hand or machine. And it incorporates some hand-appliqué, which calls for skills which you should have acquired by now.

COLOR CHOICES

Three or more fabrics are used in Honeybee, so it is a good design for using up odd remnants. The curved appliqué shapes are supposed to represent bees. The center Nine Patch could be a flower perhaps or even the hive. Just choose the fabrics to suit your quilt, as always, by getting out the blocks you have already completed and studying them to see what is needed for balance. This gets easier and easier, because there are now more completed blocks to relate colors to. At this stage, you probably have very little fabric left to choose from, which simplifies the selection process quite a bit.

CONSTRUCTION

1 This block is usually made by using templates and drawing around them. The piecing can then be done by hand or machine. If you wish to use this method, make the templates shown in Fig. 1a and proceed as usual for drawing around, cutting, etc.

Fig. 1a

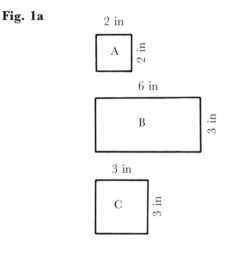

Alternatively, since all the shapes, except the appliquéd bees, are squares or rectangles, it makes sense to calculate the sizes of the shapes to *include* the seam allowances, cut with rotary equipment, and then stitch together with machined ¼-inch seams. This is template-free machined patchwork, like the early Trip Around the World block. To do this, you need to look at the *final* measurements of each shape shown in Fig. 1a. To each measurement, add on ½ inch to allow for the ¼-inch seam allowance on both sides of the shape. Shape A is 2½ inches square, shape B is 6½ x 3½ inches, and shape C is 3½ inches square (Fig. 1b).

Fig. 1b

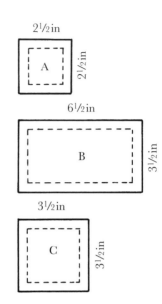

2 Following the method of construction you prefer most, cut out nine of shape A — five in one fabric, four in another. Cut four of shape B and four of shape C. Assemble the central Nine Patch square by stitching three rows of three squares each. From the front, press the seams toward the darker fabric (Fig. 2a). Join the rows together to make the Nine Patch square (Fig. 2b).

Fig. 2a **Fig. 2b**

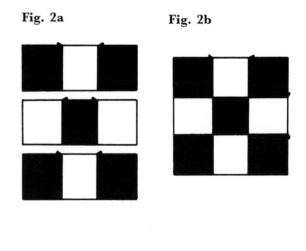

FINISHED QUILT BY ANN JONES

"I really loved making the quilt for my son and his wife. The colors were chosen to pick up the colors in their curtain material, some of which I incorporated into the design."

3 Join the two side pieces or B shapes onto the central Nine Patch square (Fig. 3).

Fig. 3

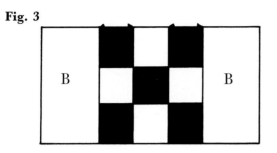

4 Stitch together the top row of shapes C, B, and C. From the front, press the seams toward shapes C (Fig. 4). Repeat this to make the bottom row.

Fig. 4

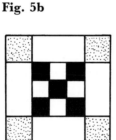

5 Join the three rows together, locking the seams so they match exactly (Figs. 5a and 5b).

Fig. 5a **Fig. 5b**

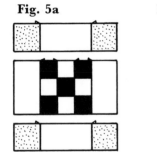

6 Shapes D and E in Fig. 6 represent the bee's body and wing. The appliqué can be done using freezer paper, or by needle-marking the outlines as in the Rose of Sharon. Four bee body shapes and eight bee wing shapes are needed. If you are needle-marking, make templates of shapes D and E. Needle-mark on the backs of the chosen fabrics and cut out with a ¼-inch seam allowance. Baste under the seam allowances, following the needle-marked creases.

If you are using freezer paper, trace four bee body shapes and eight bee wing shapes onto the smooth side of the freezer paper. Cut out the shapes and iron them, shiny side down, onto the wrong side of the fabrics. Cut out with a ¼-inch

Fig. 6 Templates — actual size excluding seam allowance

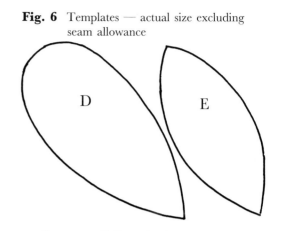

seam allowance. Follow the instructions on page 74. If the folded fabric at the pointed sections of the shapes does not tuck flat and shows from the front of the appliqué, either tuck it under while stitching the appliqué on to the background or secure it with a dab of glue from a glue stick. Water-soluble glue will not harm your fabric.

7 Arrange the four bee body shapes and eight wings on the pieced block (Fig. 7), and pin or baste in place. Sew each one onto the background with small slip stitches, using thread to match the appliqué, not the background.

Fig. 7

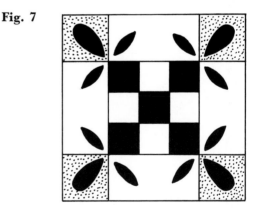

8 Once the appliqué has been completed, the backing fabric can be cut away. If it has been traditionally stitched, this is a matter of choice, but if freezer paper has been used, cut a slit in the back layer so that the paper can be removed.

9 Press the completed block from the front and measure it. It should be 12½ inches square. If it is not, trim or add a border (see page 109 for trimming the blocks and adding borders).

10 Add the framing divider strips, following the instructions on page 110.

GRAPE BASKET

This is the second of the optional bonus blocks for the sampler quilt. Again, there is nothing new in the techniques used to make it, so the instructions are pretty basic. Many basket blocks can be found in traditional American patchwork. Some are set as straight baskets, often with appliquéd flowers; others, like the Grape Basket, are set on the diagonal, which adds interest to the sampler quilt. This is a small block, 10 inches square, so it needs a frame to enlarge it to the required 12½-inch square when it

is completed. The pieces are small but not difficult to piece, and the resulting block will give richness to the quilt. The simplest way to construct Grape Basket is with templates and American piecing by hand or machine.

COLOR CHOICES

The basket is set on a background fabric and uses two or more fabrics, as you prefer. Use the diagram below as a guide for planning your design; make a tracing and shade it in with colored pencils if this helps. Remember that an extra border, 1 inch wide, must be added to the design before the final sashing.

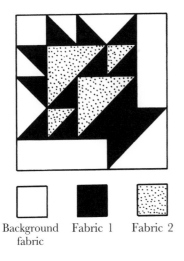

Background fabric Fabric 1 Fabric 2

CONSTRUCTION

1 Make templates of the five shapes in Fig. 1 on page 108.

2 On the wrong side of the appropriate fabrics, draw around the templates with a sharp marking pencil. Following diagram above, mark on the background fabric: two of shape A, one of shape B, two of shape C, two of shape D, and one of shape E.

On Fabric 1, mark 12 of shape C and 1 of shape E. On Fabric 2, mark 2 of shape C and 2 of shape E. Cut out each shape, adding a ¼-inch seam allowance on all sides.

3 This design is not an obvious Four Patch or Nine Patch, so the hardest part is figuring out a sequence for piecing. The main central block can then be divided into two halves and each half into sections, as shown in Figs. 3a and 3b. Assemble these sections to make the two halves of the main design.

Fig. 3a **Fig. 3b**

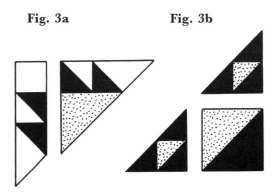

4 Now join the two halves to make a square (Fig. 4).

Fig. 4

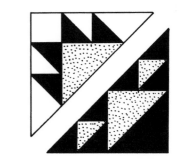

5 Assemble the two long sections ready to join to the main design square (Fig. 5).

Fig. 5

FINISHED QUILT BY CHRIS LAUDRUM

"This was my first quilt, called Tickled Pink, and made for my daughter Claire. The border is heavily quilted and edged with folded triangles of fabric, which took far longer than I had planned, but was well worth it."

Fig. 1
Templates —
actual size
excluding seam
allowance

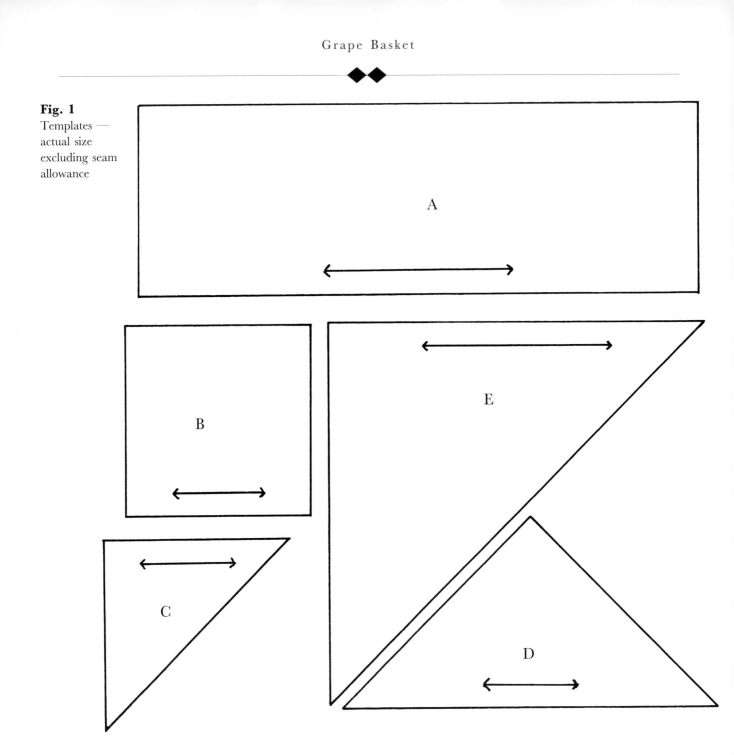

6 Next attach the side sections to the square as shown (Fig 6). Finally add Triangle D to complete the block.

Fig. 6

7 The block now needs its extra border. Cut four strips from your chosen fabric, two measuring $1^3/4$ x $10^1/2$ inches and two measuring $1^3/4$ inches x 13 inches. Follow the instructions given in Card Trick (page 44) for adding an extra border.

8 Measure the block; it should be a little larger than $12^1/2$ inches square. Trim it to exactly $12^1/2$ inches square. See page 109 for instructions on trimming the blocks.

9 Add the sashing strips, following the instructions on page 110.

FINISHING THE BLOCKS

When you have completed all your blocks,
don't think you can relax, because
there is still plenty more work to be done to finish
the blocks before they can be joined together.

TRIMMING THE BLOCKS

Each block should measure *exactly* 12½ inches square. If the block is too large, it should be trimmed down to the correct size, but do not trim off part of the design and lose corners and points. If necessary, try taking in some of the seams within the design to bring it down to size. Blocks like Baby Blocks and Dresden Plate can be safely trimmed because only the background squares will be cut into.

To trim down the block, take the completed block and place it on a cutting mat with the design centered on a vertical line on the mat (Fig. 1). From the cen-

Fig. 1 Center

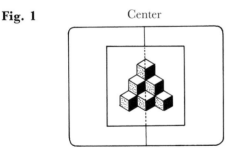

tral line, measure 6¼ inches to the right, using the markings on the mat as your guide. Measure to the left if you are left-handed. Place the ruler vertically on this measurement and trim the fabric (Fig. 2).

Fig. 2 6¼ inches

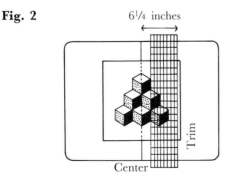

Trim

Center

Turn the cutting mat 180°, or walk around the table, measure 6¼ inches from the center, and trim the opposite side of the fabric square in the same way.

Reposition the fabric on the mat so that the trimmed edges are lying horizontally. Center the design on a vertical line on the mat (Fig. 3). Trim the left and right edges in the same way as before. Use the marked grid on the cutting mat to establish that your fabric square is now exactly 12½ inches.

Fig. 3

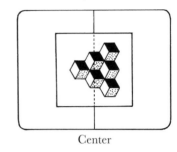

Center

If the block has ended up a bit smaller than 12½ inches square, add a narrow extra border to it. First measure the completed block. If necessary, try to reduce the size to 12 inches square or less, or else the extra border will be too tiny to deal with. Some blocks can be trimmed down as described above, but others may need seams within the design taken in to reduce them.

When the block is trimmed, measure the fabric square. From the fabric chosen for the narrow borders, cut two 1-inch-wide strips to match this measurement. Pin and stitch these to each side of the block, easing in any fullness if necessary. Press the seams outward, away from the block, ironing from the front of the work (Fig. 4).

Fig. 4

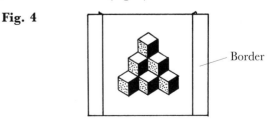

Border

Measure across the center of the block from side to side (Fig. 5). Cut two 1-inch-wide strips of the fabric for the narrow border to match this

Fig. 5

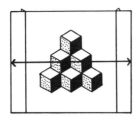

measurement. Pin and stitch these to the top and bottom edges of the block, easing in any fullness if necessary. Press the seams outward, away from the block, ironing from the front of the work (Fig. 6).

Fig. 6

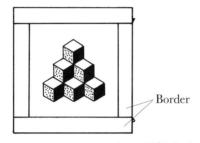

Border

The block will now measure more than 12½ inches square. Follow the instructions for centering and trimming given earlier. It may seem wasteful to add a strip and then cut some off, but a final trim to size makes a really accurate square.

ADDING THE SASHING STRIPS

Once the required 12½-inch square is achieved, the sashing strips can be added. These are cut 1½ inches wide. Do not take a long strip and just stitch it on, trimming the end after stitching. The edges of the block may stretch as you stitch, and then will no longer measure a true 12½ inches square when you finish. Cut the sashing strips to size and make the block fit them exactly. First cut two strips 12½ inches long and 1½ inches wide, and pin and stitch these to the *sides* of the block. Press the seams outward, away from the block, as in Fig. 4, ironing from the front of the work.

Next cut two pieces 14½ inches long and 1½ inches wide. Pin and stitch these to the *top* and *bottom* edges of the block, making the block fit the cut strips exactly and easing in any fullness if necessary. Press the seams outward, away from the block, as in Fig. 6, ironing from the front of the work.

The final framed block should now measure 14½ inches square. If the divider strips are cut to these measurements each time, and the blocks have been trimmed or added to so that they measure exactly 12½ inches square, then every block will match the others and there will be no unpleasant surprises when you start to join them together.

QUILTING

Patchwork quilts are often enhanced by decorative patterns of running stitches, known as quilting. These are used to hold the front and back of a quilt together and to keep in place any extra padding that has been sandwiched in between. The stitches are made through all the layers to give an attractive design on both sides of the quilt.

Quilting the sampler is done block by block before joining the blocks together, a technique called lap quilting or quilt as you go. This way, the blocks are portable and you can quilt them individually when they are completed, instead of waiting until the whole quilt top is pieced together and you have to tackle a bed-size project. You may like to quilt each block after it has been completed before moving on to the next, or you may prefer to wait until several have been made before you launch a concerted attack on them.

Before tackling any blocks, it is a good idea to sew a practice piece first, made up from two unpieced squares of fabric any size you like, with batting between. The Pauper's Block, shown on page 111, is an ideal design to quilt for the practice piece because the stitching is continuous from the center outward, without awkward changes in direction. It also gives you a chance to find out whether you really enjoy hand-quilting and to find out how much time you are prepared to devote to it. You need to know this when you start quilting your blocks, because each block needs to be quilted about the same amount as all the others to keep the final sizing consistent. If you quilt the first block very densely, then you have to do the same to all the others.

WHERE TO QUILT?

Quilting on a piece of patchwork often simply echoes the lines of the patchwork. This may be as close to the seam line itself as possible, called "quilting in the ditch", or more often about ¼ inch away from the seam lines, called "outline quilting" (Fig. 7).

Fig. 7

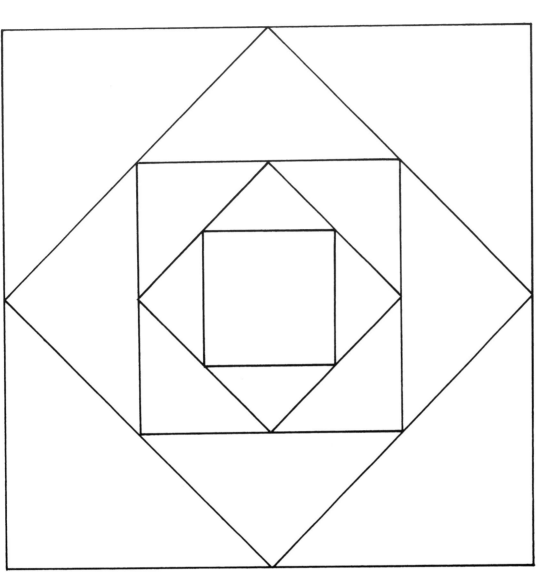

Pauper's Block
quilting pattern
and design

Quilting in the ditch can be effective around appliqué shapes or the leading in stained glass patchwork, but otherwise does not add much to the appearance of a block because it sinks into the seam and cannot be seen. Quilting in the ditch is not advisable if seams are pressed open, only if they are pressed to one side. Large areas, such as the background to Grandmother's Fan, can be broken up by quilting lines running across them. When I made my sampler quilt, shown on page 2, I limited the quilting to outlining the patchwork sections, sometimes with extra quilting lines running parallel. Students have since put me to shame by using the most imaginative designs of lines and curves to enhance their blocks. Study the blocks shown in the many excellent quilt photographs throughout this book for inspiration.

For curves, put glasses, plates, and saucers on the block and draw around the edges; the larger the plate, the gentler the curve will be. If you feel this approach is beyond you, stick to outline quilting. After all, that's the traditional way to quilt. And plastic stencil in the form of quilting patterns are readily available. You just place them on the fabric and draw around them. There is a wide range of plastic-stencil chain and cable designs available in a variety of sizes. You — like many other quilters — may find these designs particularly useful for borders.

MARKING THE DESIGN

It is best to mark the quilting design on the fabric before the extra layers of batting and backing fabric are added. Outline quilting lines, which are 1/4 inch away from the seam lines, can be sewn by eye or by using masking tape. Place the tape lightly on the surface of the top fabric with one edge against the seam line. Quilt close to the other edge and remove the tape immediately after the stitching has been completed

Fig. 8

Tape

(Fig. 8). More-complex designs can be drawn out and traced through onto the quilt top, using a light box if necessary, or by drawing directly onto the block. It is important to use a marking pencil that fades or wears off the fabric and does not leave a permanent line (see Basic Equipment, page 10).

BASTING THE LAYERS

For each block, cut a 15½-inch square of the batting and backing fabric, so that both are ½ inch larger on all sides than the completed block. Place the backing fabric right side down on a flat surface. You may like to anchor it at the corners with masking tape. Lay the batting on top, patting it into place. Place the block centrally on the batting (Fig. 9a). Using a long, fine needle and light-colored basting thread, baste the block with running stitches that are ¾ to 1 inch long. Work from the center of the block outward across the quilt in a grid of vertical and horizontal lines.

Rather than beginning each basting line in the center with a knot, cut enough thread to use right

across the block. Begin in the center, leaving about half the thread as a long end at the start. Baste to the edge, finish with a double stitch, and remove the needle (Fig. 9b). Rethread the other end and baste in the opposite direction (Fig. 9c). The basting should be just tight enough to hold the layers together without denting the surface. Continue to baste the horizontal and vertical lines, about 3 to 4 inches apart, to form a grid (Fig. 9d).

USING A FRAME

In the past, small projects were quilted with a quilting hoop. I would recommend one of the newer plastic frames, because they make a convenient shape to fit around the blocks. A basted block should never be stretched tightly in the frame. Adjust the side clips by turning them slightly in toward the block that so the fabric has some give to it, which will make quilting easier. Using a frame really does make the work much smoother and flatter, and it is essential for quilting large pieces. If you can use a frame for quilting the sampler blocks, it will prepare you for any large projects you might undertake in the future. However, if you are more comfortable working without a frame with the block in your lap, it is perfectly possible to quilt such a small area very successfully that way, provided the block is completely basted.

STARTING TO QUILT

If you have ever looked closely at the prize-winning quilts at quilt shows, you may think that all quilting stitches have to be tiny, even, and exquisite. Some are, of course, but many quilts have far larger stitches and are still very effective. What matters is sewing stitches of the same size, which will come as you establish a rhythm. Begin with the Pauper's Block quilting pattern on page 109. As you sew, you will find the stitches become more even and you can control the size more easily. Check the back to make sure that the stitches are being made on that side as well, but don't expect them to be exactly the same size. They are usually smaller, and as long as you are catching in enough of the back fabric to hold it securely in place, that will be fine. With your practice piece, do not waste time unpicking poor stitches or you will never establish a good rhythm. Just keep going until you feel you are ready to tackle one of the blocks.

To begin, cut a length of quilting thread about 18 inches long. This can provide a contrast to your fabric if you would wish, or choose a color that blends

Fig. 9a **Fig. 9b**

Fig. 9c **Fig. 9d**

Starting position: The knot is ready to be popped through into the batting, out of sight.

Quilting without a frame: The needle is pushed down vertically into the fabric and swung upward again to make the stitch.

with the colors of the block so that any errors are less obvious. Start quilting in the center of the block and work outward. All starting and finishing work is done from the top of the quilt, so make a knot at one end of the thread and push the needle into the top fabric and batting (not the backing) 1 inch away from the starting point, preferably farther along the line on which you are going to quilt. Bring the needle back up to the surface in position to make the first stitch. Pull gently to pop the knot through the top fabric into the batting.

THE QUILTING STITCH

Always begin with a backstitch followed by a space, so that you appear to be making a running stitch. When you first quilt, it may be easier to make one stitch at a time, but with practice, you may be able to sew two, three, or more stitches at a time. If you are quilting without a frame, it is possible to hold the fabric between the thumb and forefinger of one hand while quilting with the other to maneuver the layers. To make the running quilting stitch a reasonable size on both the back and front, the needle must be pushed into the work as vertically as possible and then swung upward. This is why it is best to use betweens needles, since they are short, strong, and will not bend too easily.

I like to use the top of a thimble to swing the needle up and down. Maintain the tension of your stitches by pulling the thread to tighten the stitches just enough to draw the top fabric down, but not so much that it puckers. When quilting without a frame, always work from the center outward. It may be easier to use several threads at the same time while doing this. If you turn and quilt back toward

the middle, you may finish up with a bulge or a twist in the fabric in the center.

If you are quilting with a frame, you need a different approach, because the fabric cannot be gathered and held between your thumb and finger while quilting. Place your free hand under the quilt with the top of your middle finger in the area where

The underneath finger supports the vertical needle. The thumb of the top hand presses the quilt layers down.

the needle should come through the quilt back. Rest the top of the needle against the flat end of the thimble and push the needle vertically through the layers until the tip is just (and only just) touching the underneath finger. Press down the layers ahead of the needle with the thumb of your sewing hand.

Push the tip of the needle upward with the underneath finger. At the same time, use the thimble to swing the needle head over and forward to help bring the needle tip to the surface. All this is easier to do than to describe!

To make the next stitch, swing the head of the needle upward until it is almost vertical, and push down with the thimble until the needle tip touches the underneath finger.

Again, use a combination of the underneath finger and the thumb in front of the needle to help force the needle up to the surface of the work while you swing the needle head down onto the quilt top with the thimble. This rocking action can be repeated to place several stitches on the needle.

Pull the needle through the layers, giving a slight tug on the thread to pull the stitches snugly onto the quilt top. Continue to work this way until the quilting has been completed.

The top of the needle is swung down to bring the point to the surface.

The top of the needle is swung upward to make the next stitch.

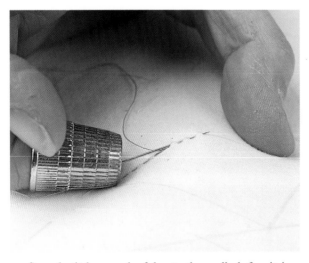

Several stitches can be fed onto the needle before it is pulled through.

Finish with a knot, or by winding the thread twice around the needle and running the needle into the batting for at least 1 inch.

FINISHING

Finish by either making a knot in the thread close to the surface of the fabric, or by winding the thread twice around the needle, inserting the needle into the batting, then running the needle at least 1 inch away from the stitching. Pull gently to pop the knot beneath the surface of the top fabric. Cut off the

thread close to the quilt top and let the free end disappear into the batting.

I use the same technique if I want to move from one part of the design to emerge at another. Finish with a knot, run the thread through the batting, and emerge at the new stitching line. Remember to always begin with a backstitch before continuing to quilt.

JOINING THE BLOCKS

Joining the blocks together is not a difficult task, but it can be tedious. At least by this stage, all the quilting is completed, and the quilt starts taking shape like magic as each new row is added. The following method will ensure that the joining seams on the back of the quilt reflect those on the front, so the back looks as neat and balanced as possible.

CONSTRUCTION

1 Arrange the completed blocks in your chosen design. Take your time over this and, if possible, get a second or third opinion, preferably from a fellow quilter. There may, of course, be a block that just does not fit in, and you may have to be brave, discard it, and make another. Sometimes, though, the block you have felt uneasy about since the beginning fits in the final arrangement. Only at this stage, when all the blocks are laid out and the overall balance established, can you make these decisions.

2 Take the blocks that will make up the top row of the quilt (Fig. 10) and place the first two of them right sides down.

Fig. 10

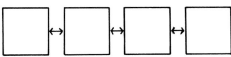

3 Pull the backing fabric and batting back from the vertical sides to be joined on each block front and pin them out of the way (Fig. 11).

Fig. 11

4 With right sides facing, match and pin the two edges of the block fronts together. Machine-stitch them together with a ¼-inch seam allowance. Finger-press the seam open and press it lightly with the point of an iron from the *front* of the work (Fig 12). If you try to press it on the back, there is a very real danger that the iron will touch the batting and melt it.

Fig. 12

5 Lay the joined blocks, right side down, on a flat surface. Unpin the batting, but leave the backing fabric pinned back out of the way. Let the two edges of batting overlap each other, and cut through both layers along the center so that the final cut edges abut. It does not matter exactly where this cut is made because it will be hidden by the fabric. If you are nervous about accidentally cutting the front of the blocks, you can slide an ordinary 12-inch ruler between the batting and the block front before you cut. That way your scissors cannot touch with the block beneath (Fig. 13).

Fig. 13

Ruler

6 Keep the ruler between the layers while you stitch the two abutting edges of batting together. I use a large herringbone stitch because it helps to keep the edges flat (Fig. 14).

Fig. 14

◆◆

7 Remove the ruler and turn the joined blocks over so that they are now right sides up. Push a line of pins through the joining seam and batting from the front. The pins should be pushed right through, so that their points stand upright when the quilt blocks are turned over. Avoid using glass-headed pins because the heads roll and prevent the pins from remaining upright (Fig. 15a).

Fig. 15a

8 Turn the blocks over with the backing fabric facing up (Fig. 15b). Fold each piece of fabric so that the folded edge abuts the line of pins. Finger-press the fold and trim any excess fabric to the ¼-inch seam allowance (Fig. 15c).

Fig. 15b **Fig. 15c**

9 Remove the pins. Unfold the backing fabric of Block 1 and smooth it flat on the batting (Fig. 16a). Unfold the backing fabric of Block 2 and *refold* it so that the seam allowance is turned *under*.

Fig. 16a

Block 1

Foldline

Block 2

Fig. 16b

Block 1

Foldline

Block 2

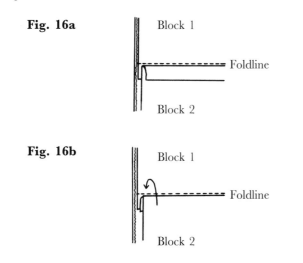

Match the fold of Block 2 to the creased line of Block 1 (Fig. 16b). Pin together, and once more place ruler under the seam, this time to make sure you avoid sewing into the batting.

10 Sew along the overlapping seam with a slip stitch or blind hemstitch. You can remove the ruler to sew most of this seam, but keep it in place for the 2 inches nearest the edge (Fig 17). It does not matter if the stitches penetrate the batting along this seam in the middle areas, but the end 2 inches have to be kept in separate layers so that they can be joined to the next row of blocks.

Repeat this process to join all the blocks in the top row. Make certain that the backing fabric is not pulled too tight, and that the front sashing strips are well matched and lying flat. At this stage, there is time to adjust the back seams if they are pulling too tightly.

Fig. 17

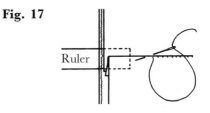

Ruler

11 Join the blocks in each horizontal row in the same way (Fig. 18). Then join the rows in exactly the same way, matching seams and borders carefully (Fig. 19). The quilt is now ready for its outer borders and final binding.

Fig. 18 **Fig. 19**

MAKING UP

When work on the individual blocks has been completed, and the quilt top has been joined together, you need to start thinking about the borders before moving on to binding the quilt edges.

BORDERS

When the quilt top has been joined together, you need to start thinking about the border. Put it in position on an appropriate-size bed to see how wide the borders need to be. If the quilt is just going to cover the top of the bed, like a comforter, it may not need any extra borders.

When I started making my own sampler quilt, I wanted it for a single bed. With 20 blocks, the width was fine, but I needed more length. Rather than make more blocks, I added a pieced border at the top and bottom of the quilt before adding the final 4-inch-wide strip of patterned fabric on all sides (see page 2). If I had added the pieced border to the sides in addition to the top and bottom, it would have fitted a double bed.

Study all the photographs in this book. They are of genuine handmade products: quilts made in my sampler class, many by complete beginners. Some of them have complex and imaginative borders; others, just a simple double border of complementary fabrics, which sets the quilt off beautifully. The choice of what kind of border you make is entirely yours.

Because of your earlier color selection you may be severely restricted in your choice of fabrics by this time. Pieced borders using all the left-over remnants may be the answer, or you could use totally new fabrics. It does not matter if a fabric has not been used in the quilt, as long as it looks as though it belongs.

Plain borders cry out to be quilted, although wide patterned borders, especially if they form the drop down each side of the bed, can look good without quilting. If you have really had enough by this time, then add simple borders and keep any quilting to a minimum.

At this stage, it is easiest to make the borders and join them to the front of the quilt only, and not to the batting and backing. Ignore the back until all the extra pieces except the final binding have been added to the quilt top.

STRIP BORDERS

A simple framing border of one or more strips of fabric is very effective (Fig. 1). If there is not enough fabric to cut strips for the length of the quilt, you can get away with a few seams, provided they look planned. The inner border can have a joining seam in the center, even if the fabric is a plain one. That

Fig. 1

Block

Sashing

Border strips

way, the seam will look obvious, but the center placing of the seam line will still look balanced (Fig. 2a). Try to avoid making a joining seam in the same position in the next border, because it will look clumsy and unprofessional. If possible, use a patterned fabric and make two seams at equal distances from the center. Then if they are noticed at all, the seams will look planned and balanced (Fig. 2b).

If you do not have any suitable fabric left for the outer border, you may have to go out and buy

Fig. 2a **Fig. 2b**

something special. It may seem an extravagance, but any fabric left over will always be useful for a future project. I have been telling myself that for years.

CONSTRUCTION

1 Lay the quilt top on a flat surface and carefully measure the length of the quilt down its *center*, not along the edge (Fig. 3). If you always do this, and cut the borders to match the center measurements, there is no danger of the quilt edges spreading with wavy borders.

2 Measuring the length of the quilt exactly, cut two strips of the chosen width to match this measurement for the sides. Pin back the batting and backing fabric out of the way, and pin and machine-stitch each side strip to the quilt top, easing in any fullness in the quilt. This is easiest to do if you put the quilt on a flat surface and match the centers and both ends first, before pinning the rest. Press the seams outward, away from the quilt top (Fig. 4).

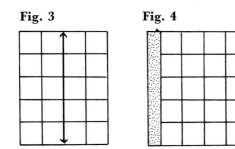

Fig. 3 **Fig. 4**

3 Measure the width of the quilt from side to side across the center (Fig. 5). Cut two strips of border fabric of the necessary width to match this measurement. Pin and machine-stitch these to the top and bottom of the quilt, matching the centers and both ends, and avoiding the batting and backing as before. Press the seams outward away from the quilt top (Fig. 6).

Fig. 5 **Fig. 6**

4 If another border is planned, measure the quilt across its center and cut strips to match. Attach the border strips in the same way as before, sides first, then the top and bottom strips (Fig. 7).

5 You may prefer to make the borders with squares in the corners (Fig. 8). These could be made in the same fabric as the rest of the border, or in a contrasting fabric. Squares placed like this appear in Honeybee (see page 103) and are known as cornerstones. They are much easier to make than you would think.

Fig. 7 **Fig. 8**

First measure the quilt across the center in *both* directions and cut strips of the required width to match these measurements. Machine-stitch the side strips only onto the quilt, as usual. Press the seams outward, away from the quilt top.

Cut four squares of fabric for the corners, measuring the same as the cut width of the border strips (Fig. 9a). Machine-stitch one of these to each

Fig. 9a

FINISHED QUILT BY HAZEL HURST

"Scraps of green fabric were the basis of this quilt with one floral print added to most of the blocks. The border is made up of machine-pieced units, which were a problem because of an error with my math. This was solved by adding an extra unit, then the corners fitted perfectly."

end of both the top and bottom border strips (Fig. 9b). Press seams toward the long strip.

Fig. 9b

Pin these border strips to the quilt top, matching the seams carefully. Because the seam allowances are lying in opposite directions, they will lock together (Fig. 9c). If a second border with cornerstones is planned, remeasure the quilt after the first border is added and repeat the process (Fig. 10).

Fig. 9c

Fig. 10

PIECED BORDERS

Pieced borders are usually the direct result of finding little left to work with other than a large assortment of scraps. They may mean more work, but they can greatly enrich your quilt. This could be the point in your quilt-making career when you learn the meaning of the word *random*. It is unlikely that there will be enough of all the fabrics to create a pattern and repeat it slavishly. You will probably have to juggle with the cut pieces until you reach an attractive arrangement. Because you have already done this 20 times when choosing the fabrics for each block throughout the book, this will not be as difficult as it was when you first started.

At this stage, the outer edge of your quilt will have only one width of strip around it. With a detailed pieced border, you may find that a second width

needs to be added to the quilt before the border is stitched in place. If this is the case, cut and join the strips to the quilt top, following the instructions for strip borders given earlier.

Both squares and rectangles can be used to make a pieced border. Figs. 11a and 11b show suggested designs for using cut squares; 2½-inch cut squares are a comfortable size and should fit mathematically around the quilt. If not, position a seam at the center of the quilt and trim the two ends to make matching rectangles (Fig. 12). Fig. 13 shows a design

Fig. 11a

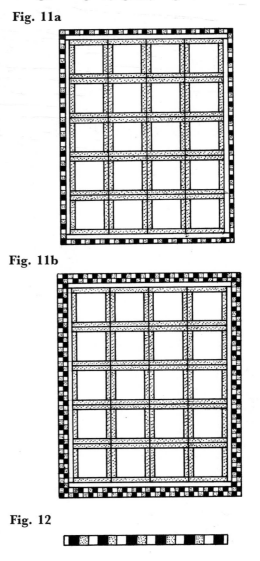

Fig. 11b

Fig. 12

using 2½-inch-wide rectangles — any length you like — around the quilt.

The quick-machine technique for Flying Geese makes a spectacular border, and it is worth the effort (Fig. 14a). Measurements need to be adjusted so that the geese fit the quilt blocks, which should have a finished size of 14 inches square. The size of a Flying

Fig. 13

Fig. 14a

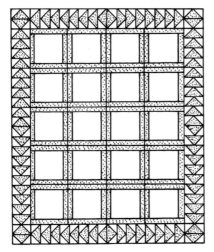

Geese border block is 7 x 3½ inches; four geese should fit each quilt block (Fig. 14b). Adapt the measurements for these Flying Geese so that they consist of a large square that is cut 8¼ inches and small squares that are cut 4⅜ inches. See page 85 for the instructions on Flying Geese.

Fig. 14b

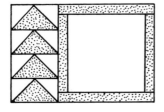

Once you have decided on the border design, take measurements from the quilt and follow the instructions for joining the pieced strips to the quilt top given earlier. If the design can be used to make the four corners of the border, as in Figs. 11a and 11b,

it will make a stunning frame to the quilt. Otherwise, incorporate cornerstones (Fig. 13).

You may want to add another frame beyond the pieced border. Lay the quilt top on a flat surface and measure it again. Work from these measurements when cutting the new strips. If you keep a tight control on the length of each border strip as you add it, you will finish with a beautifully flat quilt without a hint of a wave or ripple.

BACKING THE BORDERS

Once all the borders have been completed and joined to the quilt top, turn the whole thing over. An extra strip of batting, which extends at least ½ inch beyond the quilt, must be added to the original batting on all sides. Join the batting with herringbone stitches along the abutting edges in the same way as when joining the blocks (see page 115). Strips of the backing fabric can then be machine-stitched to the back of the quilt to make it the same size as the batting. Join the side pieces first, and then join the top and bottom strips. Be careful not to catch any of the batting in the stitching. Press the seams outward.

Any quilting in the border areas should be done at this stage, basting the layers together thoroughly before quilting. Although the quilt is cumbersome now, at least the extra quilting is all around the edges, so it should not be too difficult to get at. When all the quilting is done (or none, if that was your choice), trim all the layers to match the front of the quilt before the final binding.

BINDING

There are many ways to finish the raw edges of a quilt, and not every quilt needs the same treatment. However, I do suggest that the sampler quilt be finished with the pressed binding described here, because it is easy to apply and always looks good. This binding is made from strips of fabric cut along the straight grain of the fabric, not the bias; bias is necessary only if the edge to be bound is curved.

COLOR CHOICES

Only about ½ inch of binding shows on the final edges of the completed quilt, but it is surprising how important it is to use the right fabric. It can match the border fabric, or be another fabric altogether. As always, seek some opinions. This is the last color decision you will have to make about this quilt, and it may not be easy. You may also have very little fabric left to choose from. If that is the case, consider

cutting 2-inch-wide strips of all the scraps you have left, then cut them up into pieces, each 2 to 4 inches in length (Fig. 15a). Join the pieces together to make a multifabric strip, which is then used to bind the quilt (Fig. 15b).

Fig. 15a

Fig. 15b

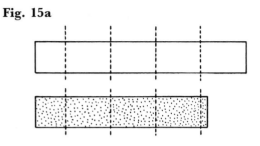

CONSTRUCTION

1 When all the borders have been added and the quilting completed, trim any excess batting and backing fabric even with the edges of the quilt top.

2 Cut four strips of fabric, each 2 inches wide, for the binding. Two strips, for the sides, should equal the length of the quilt from top to bottom. Two strips, for the top and bottom edges, should equal the width of the quilt from side to side, plus 1½ inches.

3 With wrong sides together, fold each strip in half lengthwise and press (Fig. 16a). Open out each pressed strip and bring in the raw edges to the center crease (Fig. 16b). Press the edges. Finally, fold in half again and press (Fig. 16c).

Fig. 16a **Fig. 16b**

Fig. 16c

4 Take one of the binding strips for the side edges. Open it out and, with right sides together, pin it to one long side of the quilt front with the raw edge of the binding extending slightly above the raw edge of the quilt (Fig. 17a). This will help accommodate the thickness of all the layers when the binding is folded over the quilt edge.

5 Machine-stitch along the top crease line through all the layers (Fig. 17b). This is easier to do if a walking foot is used (see Basic Equipment, page 12), because it helps prevent the layers from creeping and shifting as you stitch.

Fig. 17a

Fig. 17b

6 Fold the binding over to the back of the quilt so that the center crease in the binding matches the raw edges of the quilt. Slip stitch the remaining folded edge in place along the machine-stitched line on the reverse side of the quilt (Figs. 17c and 17d). Trim the ends of the binding to match the quilt exactly.

Fig. 17c **Fig. 17d**

Quilt front Quilt back

7 Bind the opposite side of the quilt in exactly the same way. Pin and machine-stitch the binding to the top and bottom of the quilt in the same way, leaving about ³/4 inch of binding extending beyond the quilt at each end (Fig. 18a). Trim this extra length back to about ¹/2 inch and fold in over the quilt edge (Fig.18b). Turn the binding over to the quilt back and slip stitch it in place (Fig.18c). Make sure these corners are really square before you start to stitch them.

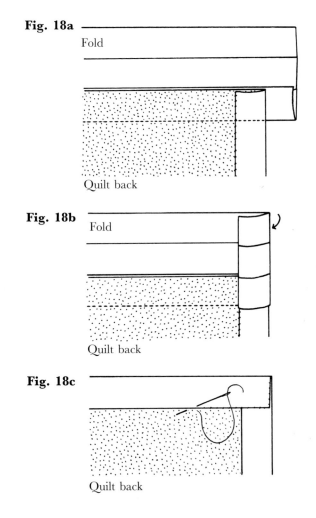

Fig. 18a
Fold

Quilt back

Fig. 18b
Fold

Quilt back

Fig. 18c

Quilt back

THE FINISHING TOUCH

When the quilt is complete, make sure that you put your name and the date on it. This is important for future quilt documentation. Remember that your quilt is a potential heirloom and should be labeled so that its origins are not lost in the sands of time. On the back of the quilt, or on a separate piece of fabric, write your name and the date with a marking pencil. Embroider it in place, using backstitch or chain stitch, or if your sewing machine will stitch letters, use that. Alternatively, use one of the special marking pens now available. You can even type your label. The fabric used for writing or typing on can be strengthened by ironing it to a piece of freezer paper. Once the writing has been done, remove the freezer paper and stitch the label in place on the back of the quilt. If your design allows, you might consider quilting or embroidering your name and details on the front of the quilt to make a feature within the overall design.

TAKING CARE OF YOUR QUILT

Do not be too apprehensive about washing your quilt. A well-made quilt will wash and wear wonderfully. If, in time, it shows signs of age, that is all part of the charm.

If you have used colorfast fabrics (see page 9), and if your washing machine is large enough to hold the quilt comfortably, put it in and use a low-temperature setting and a mild laundry detergent. A short spin will remove some of the excess water, which of course makes the quilt so heavy.

If you choose to wash the quilt by hand, use the bathtub and agitate the quilt gently with your hands. Do not let it soak in the water for any length of time as this can encourage color migration and fading. Rinse several times in the bathtub until the water runs clear. Press out as much water as you can while the quilt is still in the bathtub. Press towels against the quilt to absorb as much of the excess water as you can before removing it.

If possible, dry the quilt flat, using a layer of towels or sheets underneath it. A shady, flat area outside, or an inside floor, is ideal, although you may have to patrol outside to fend off cats and birds. Always keep the quilt out of direct sunlight, because it can fade the colors.

If the quilt needs to be pressed at all, use a cool iron without steam and press just the unquilted sections where creases may show. A hot iron can cause synthetic batting to bond to the fabric, so approach the job with caution, testing for the right heat level for your particular quilt.

Be aware of the fading action of sunlight streaming through a bedroom window onto the quilt. Even in temperate climates, the sun fades fabrics easily and can ruin a quilt, especially if only a section has been exposed to the sun and it has faded in patches.

PROJECTS

The sampler quilt blocks can be used to make other useful keepsakes. These five projects have been developed from some of the blocks, using both hand and machine techniques. They graduate in scale from a cushion to a baby's crib quilt, a lap quilt, a quillow (a small quilt that has its own pocket and folds into a small pillow), and finally a single-bed quilt. I hope they provide you with some ideas of how a block can be expanded into a larger piece, and that they inspire you to develop your own ideas. Follow them exactly if you like, or adapt them. They are there to give you confidence to create your own designs and interpretations of the techniques given in this book.

PROJECT 1

GOLDEN QUILTED CUSHION

This design was a present for a golden wedding anniversary, hence the color and the design of interlocking hearts. Raw silk was used for the pillow, with a coordinating shade for the framing border. Do not be frightened of using silk — it is a joy to quilt and its light-reflecting quality makes even a simple quilting design look wonderful.

FABRIC REQUIREMENTS

Two 20-inch squares of silk for the cushion front and back
Border fabric, four strips, each measuring 19^1/$_2$ x 3 inches
Batting, 2-ounce piece, 19^1/$_2$ inches square
Cotton fabric, 19^1/$_2$ inches square, for lining the cushion front
Cushion form, 20 inches square
Final size of cushion: 18^1/$_2$ inches square

CONSTRUCTION

1 Take a piece of tracing paper 12 inches square. Fold it into quarters. Open it out and place it over the design shown in Fig. 2 on page 126, with point O at the center and the two dotted lines matching the folds in the tracing paper (Fig. 1a). Trace the design onto one quarter of the paper.

Move the tracing paper around 90° and place point O at the center with the two dotted lines

Fig. 1a

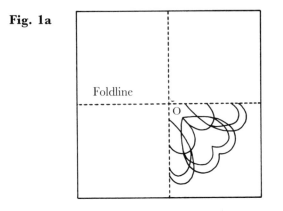

Foldline

O

matching the folds of the adjacent quarter of the tracing paper (Fig. 1b). Trace this section of the design onto the paper. Repeat for the other two quarters of tracing paper to complete the design.

Fig. 1b

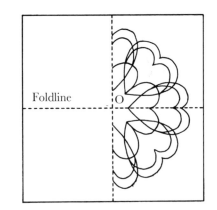

Foldline

O

2 From the main cushion fabric, cut a 13^1/$_2$-inch square for the front. Fold it into four and crease lightly to find the center.

3 Trace the design onto the cushion front, using a light box if necessary. The creased lines will help to position the design centrally on the fabric.

4 Now add the border, before the layers are assembled for quilting. The corners on the cushion front should be mitered, which is not as difficult as it seems. If you recoil in horror at the prospect, a border with cornerstones is perfectly acceptable (see page 117 for instructions on borders).

To make mitered corners, cut four strips of border fabric of the chosen width, each measuring the same length as the main square plus twice the width of the strip (this extra is for the mitered corners). For this project, the four strips should each be 3 inches wide, 13^1/$_2$ inches plus twice 3 inches long, making a total length of 19^1/$_2$ inches.

On the wrong side of the cushion front, mark 1/$_4$ inch in from each corner.

◆◆

O

Fig. 2 Quilting pattern template — actual size

6 With right sides together, fold the cushion front diagonally, so the long edges of the two border strips are aligned exactly (Fig. 4a). Using a rotary ruler, place the 45° angle line marked on the ruler on the stitching line and the edge of the ruler on the fold of the cushion fabric. Draw a line on the top strip along the ruler's edge from the stitching line to the outer edge (Fig. 4b). Pin the two strips together and machine-stitch along the drawn line. Repeat for each corner. Trim seams to ¹/₄ inch; press open. Press the cushion front and borders from the top.

5 With right sides together, match the center of one side of the cushion front to the center of one of the border strips, and pin together. Beginning and ending at the marked dots, ¹/₄ inch away from the corners of the cushion, machine-stitch together. Backstitch at the beginning and end to secure the seams (Fig. 3). Join the remaining three border strips to the cushion front in the same way.

Fig. 4a **Fig. 4b**

Fig. 3

7 Place the cushion front square on the batting and lining and baste together for quilting. (Follow the instructions for basting the layers together and hand-quilting on page 110.) I used silk thread in a slightly darker tone on the gold fabric. Extra quilting lines can be added to frame the design.

8 For the cushion back, cut two pieces, each 19^1/$_2$ x 12 inches, from the fabric used for the main cushion. Press a 1/$_4$-inch turning to the wrong side of the fabric on one long side of each piece. Fold over this edge again to make a 1/$_2$-inch turning, then machine-stitch along this edge close to the fold (Fig. 5).

Fig. 5

WS

9 Place the quilted cushion front on a flat surface, right side up. Arrange the two back pieces, right sides down, with their raw edges matching the edges of the cushion front and the folded edges overlapping across the center approximately 3 inches (Fig. 6a). Pin the front and

back together and machine-stitch all around the outer edges with a 1/$_2$-inch seam. Trim the seam allowance at corners to reduce the bulk (Fig. 6b).

Fig. 6a **Fig. 6b**

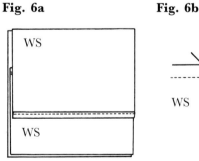

WS

WS

WS

Trim

10 Turn the cushion right side out and press the outer seam. Machine-stitch a line 3/$_8$ to 1/$_2$ inch from the edge all around the cushion. This gives an extra finish to the cushion.

PROJECT 2

LOG CABIN CRIB QUILT

For the sampler quilt, four squares of Log Cabin were made, and then joined to make the block. Here the same instructions are followed, this time using the same strip measurements to make 24 Log Cabin squares. These are then arranged in the diamond design known as Barn Raising. A wide coordinating border completes the quilt, which is then quilted.

COLOR CHOICES

I used three yellow print fabrics and three blue print fabrics, plus an extra blue fabric, for the central square and the binding. It is also possible to use just two yellow and two blue fabrics and alternate them, following the instructions on page 63.

FABRIC REQUIREMENTS

Two or three yellow, medium-weight, cotton fabrics, totaling 1 yard
Two or three blue, medium-weight, cotton fabrics, totaling 1 yard
10 inches of blue fabric for centers and binding
1 extra yard of one of the yellow prints for borders and backing
Piece of 2-ounce batting, 29 x 40 inches
Final size of quilt: 26½ x 37 inches

CONSTRUCTION

1 Make four Log Cabin squares, following the instructions given on page 63–67, but do not add any sashing.

2 Make four more squares, but change the order of the fabrics as you use them (Fig. 1).

Fig. 1

3 Continue to make Log Cabin squares, four at a time, alternating the arrangement of fabrics so that, of the final 24 squares, 12 are in the first arrangement and 12 in the second. By alternating the squares in the final layout, you will be able to avoid having two strips of the same fabric placed next to each other.

4 Check the size of each finished square by placing it on the grid on a cutting mat. The squares will probably vary in size, and at this stage it is possible to cut off narrow strips from the edges of any that are too big. If you find that you have any squares which are too small they should have their last two strips restitched with narrower seams to help increase the final size. Do not be disheartened — these squares involve so many seams that it would be a miracle if they all matched one another exactly.

5 Arrange the squares as shown in Fig. 2. Swap individual squares around so that the sizes match as nearly as possible. You will find that all the odd ones finish up around the outside edge and on the corners!

Fig. 2

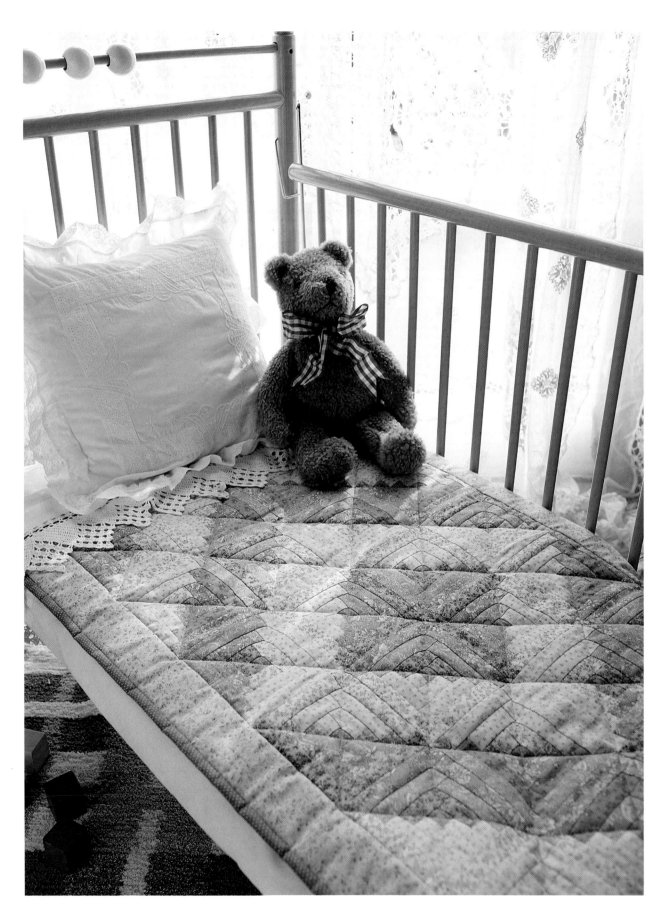

6 Machine-stitch the squares into rows (Fig. 3), pressing the joining seams of each row in alternate directions to help lock the seams (Fig. 4). Place each row back with the others to prove that the layout of the design is still correct. It is so easy to place one square the wrong way and not notice until the last stitch in the quilt has been made. The final long seam allowances can be pressed to one side, or if this seems too bulky, press open.

Fig. 3

Fig. 4

7 Measure the length of the quilt down its center, not along the edge (Fig. 5). From the border fabric, cut two 3-inch-wide strips to match this measurement. Pin and stitch these strips to each side of the quilt, easing any fullness in the quilt to fit the border strips. Press the seams outward, away from the quilt (Fig. 6).

Fig. 5 **Fig. 6**

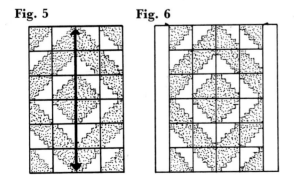

8 Measure the quilt from side to side across its center (Fig. 7). From the border fabric, cut two 3-inch-wide strips to match this measurement. Pin and stitch these strips to the top and bottom of the

quilt, easing any fullness in the quilt to fit the border strips. This way the border will retain the measurement of the quilt center and not spread at

Fig. 7

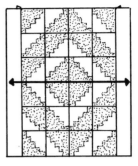

the edges. If you see a quilt with wavy edges where there is obviously too much fullness, it is because the border strips have not been cut to size before being joined to the quilt.

9 Cut the backing fabric to match the batting by laying the batting on it and cutting around the edges. If the piece for the back of the quilt is not large enough, add strips of any remnants you have left (except the binding fabric). This will give the quilt a patchwork back, which makes it even more interesting and attractive.

10 Baste the three layers together, ready for quilting. Quilting through all these seams will not be easy, so aim for even stitches and do not worry about size too much. The quilting design is shown in Fig. 8. For general instructions on quilting, see pages 110–114.

Fig. 8

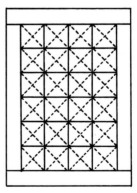

11 When the quilting has been completed, trim the batting and backing to match the front. Follow the instructions on page 121 for binding the edges of the quilt, and remember to label your quilt (see page 123).

DRUNKARD'S PATH LAP QUILT

A lap quilt is a small quilt, anything from 3½ feet to 5 feet square. Children love them, and they become their own piece of home that travels in the car, on vacation, and from room to room. They can also be used in a student's dormitory, to add some life to a drab bedspread by being placed in a diamond shape on the bed, or even draped over the back of an old sofa that can profit from a bit of beautifying.

The thing I like about a lap quilt is that, because it is going to be used so much, it just cannot be regarded as an heirloom. This gives you a wonderful sense of freedom to do just what you like — to try new techniques, to try machine quilting, or to use all those odd fabrics you have been longing to experiment with. A small quilt does not take too long to make, so the person you give it to does not feel intimidated by the responsibility of such a gift.

This lap quilt uses the Drunkard's Path design in two red and two black prints, plus a plain red for the corners and borders. Three borders have been added

I pieced the back of my lap quilt in an original design of strips and cornerstones using scraps of leftover fabric

because I wanted to use a wonderful African print dress fabric which I had in my collection. Your lap quilt may not look good with several borders. Put fabric against the basic quilt after it is assembled, and make your decision then. The section on adding borders, on pages 117–122, should help you with planning a different type of border if you prefer.

I used leftover scraps to make a pieced patchwork reverse side to the quilt (shown below left), with a red-and black-floral print fabric in the center. I had only that one scrap piece of the floral print, so this became the starting point of the pieced back. As you will be unlikely to have enough fabric left in one piece, you too could try piecing an original design for the back. Alternatively, find another piece of fabric, measuring approximately 56 inches square, for the reverse.

FABRIC REQUIREMENTS

18 inches each of two red patterned (A and B) and two patterned (C and D) black fabrics
28 inches of plain red fabric (E) for cornerstones and first border, plus binding
24 inches of fabric (F) for the second border
6½ feet of another fabric (G) for the third border and quilt back
Piece of batting, 56 inches square
Suitably-colored scraps to make a pieced reverse side, *or* a single piece of fabric, 56 inches square
Final size of quilt: 54½ inches square

CONSTRUCTION

Detailed instructions for cutting out and making up the squares, and joining them, are given on pages 49–53.

1 Make templates from the two curved shapes in Fig. 1 on page 132 (see page 15 for instructions on making templates). They will make a 4-inch square, which is 1 inch larger than the square used for Drunkard's Path in the sampler quilt block. This is good news because the quilt will grow more quickly and the curves are easier to piece.

Fig. 1

Templates — actual
size excluding seam
allowance

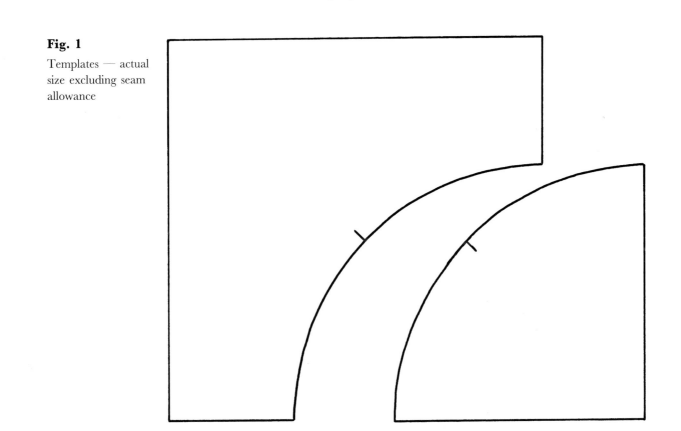

2 Study the quilt plan shown in Fig. 2 and
decide where you will use each of your chosen
fabrics. The accompanying key shows how many of
each shape you will need in each color.

Fig. 2

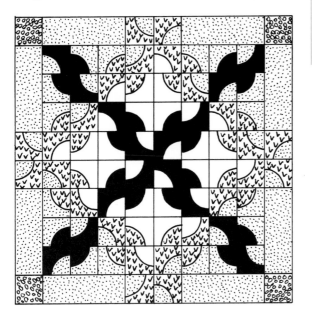

3 On the wrong side of the fabric, draw around
each template the required number of times,
marking the centers. Cut out each shape, including
the ¼-inch seam allowance. Assemble each of the
pieced squares. The fabric combinations are shown
in Fig. 3 on page 133.

4 The design is made in two parts: the main
design, or central section of pieced squares,
plus a frame that combines strips, pieced squares,
and four corner squares, or cornerstones (Fig. 4).

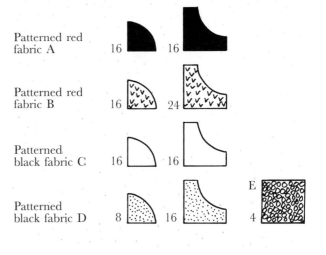

Patterned red fabric A	16		16	
Patterned red fabric B	16		24	
Patterned black fabric C	16		16	
Patterned black fabric D	8	16		E 4

Fig. 3

Cut 8

Cut 8

Cut 8

Cut 8

Cut 8

Cut 16

Cut 8

Cut 8

133

Fig. 4

The main design comprises 64 squares: eight rows of eight squares (Fig. 4). Arrange them in this design and machine-stitch together row by row. At each stage, press from the front.

5 From the second black fabric D, cut eight strips, each 4½ x 12½ inches. From the plain red Fabric E cut four 4½-inch squares. Join the strips, squares, and remaining pieced squares into two short and two long sets, as shown in Fig. 5.

Fig. 5

6 Pin and machine-stitch the two shorter lengths to opposite sides of the quilt, matching the seams of the pieced squares carefully. Press seams outward, away from the quilt. Pin and machine-stitch the two longer lengths to the top and bottom of the quilt, matching seams carefully. Press the seams outward again.

For the first border, cut four strips from the plain red fabric E, each 2 x 40½ inches, plus four squares for the cornerstones, each 2 inches square. Pin and stitch two strips to each side of the quilt and press seams outward, away from the quilt. Sew one square to each end of the remaining two strips. Press seams toward the strips (Fig. 6). Pin and

Fig. 6

stitch these to the top and bottom of the quilt, matching the seams carefully.

7 For the second border, cut four strips from the chosen Fabric F, each 2½ x 43½ inches, and four plain red fabric squares (E) for the cornerstones, each 2½ inches square. Join the cornerstones and attach the strips to the quilt, as before. Press the strips outward again.

8 For the third border, cut four strips from the black Fabric G, each 4 x 47½ inches, plus four plain red fabric squares (E) for the cornerstones, each 4 inches square. Join the cornerstones and attach the strips to the quilt in the same way as before. Press the strips outward again.

9 Either piece a quilt back to your own design or cut a piece of fabric 56 inches square, about ¾ inch larger than the quilt on all sides. Cut a matching piece of batting.

10 Plan the quilting design and if necessary draw it on with a marking pencil before basting the layers together. For instructions, see pages 110–114. I quilted this lap quilt by outlining the red shapes at a ¼-inch distance, and then just quilting in the seam line of each border strip (Fig.7).

11 When the quilting has been completed, cut and attach the binding strips (see page 121).

Fig. 7 Quilting design

PROJECT 4

FUN FOR FROGS QUILLOW

A quillow is a small quilt that folds up to fit inside its own pillow. The clever part is that the pillow is attached to the back of the quilt and looks like a matching pocket. The front of the pilllow is on the *inside* of this pocket, so an amazing conjuring trick is performed when the pillow is turned right side out and the quilt folded neatly into it.

Any design can be used for the quilt itself, which measures 3½ x 4½ feet, and for the pillow, which is 18 inches square. This quillow uses the machined Rail Fence design for the quilt, while the pillow pocket is made with pieced triangles in a simple propeller block.

FABRIC REQUIREMENTS
28 inches each of three fabrics for the quilt
and pillow block
21 inches of fabric for the border
6½ feet of fabric for the quilt back, pillow
back, and pillow block
Piece of 2-ounce batting, 44 x 56 inches
Final size of quilt:
42 x 54 inches
Final size of pillow:
18 inches square

CONSTRUCTION

1 Cut 12 strips, each 2½ inches wide, down the length of each of the three fabrics for the Rail Fence design (Fig. 1).

2 Follow the instructions given for the Rail Fence on pages 27–30 to stitch the strips into

Fig. 1

bands. Cut these bands into pieces, each measuring 6½ inches square. You will need a total of 48 squares to make the quilt.

3 Take six of the squares and arrange them in a row, as shown in Fig. 2. Machine-stitch the row together, using a ¼-inch seam allowance and a small stitch, as usual. Press the seams to one side, pressing from the front of the work. Arrange a second row of six squares, as shown in Fig. 3. Machine-stitch together and press the seams in the direction opposite to those of Row 1.

Fig. 2

Fig. 3

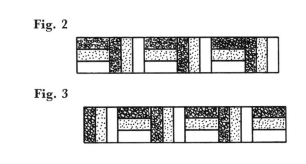

4 Arrange and stitch Row 3 as for Row 1. Press
seams in the same direction as Row 1.
Arrange and stitch Row 4 as for Row 2. Press
seams in the same direction as Row 2. Continue
until eight rows have been completed. Join the
rows together, matching the seams carefully. Press
seams to one side from the front.

5 From the border fabric, cut four strips, each
3¼ inches wide. Join them in pairs and press
the joining seams open so that they are not
noticeable. Measure the length of the quilt down
the center (Fig 4a). Trim both ends of each border
strip so that the strip matches the measurement
with the seam exactly in the center. Pin and stitch
these strips to each side of the quilt, easing in any
fullness in the quilt to fit the border strips. Press the
seams outward, away from the quilt (Fig. 4b).

Fig. 4a **Fig. 4b**

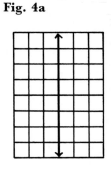

6 Measure the quilt from side to side across its
center (Fig. 4c). From the border fabric, cut
two 3¼-inch-wide strips to match this
measurement. Pin and stitch these strips to the
top and bottom of the quilt, easing in any
fullness (Fig. 4d). For more information on
borders, see pages 117–121.

Fig. 4c **Fig. 4d**

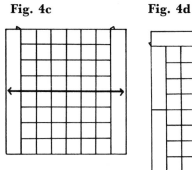

7 Layer the quilt with batting and backing
fabric, cutting both about 1 inch larger on all
sides. Baste to prepare for quilting.

8 The quilt was quilted near the seam line (see
page 110), follow Fig. 5 for guidance. This
quilting pattern helps to accentuate the stepped
effect that the layout of the fabrics creates.

Fig. 5

CONSTRUCTING THE POCKET

1 Choose two of the fabrics used in the Rail
Fence design. From each, cut two 7⅞-inch
squares. Cut each square diagonally (Fig. 6a). Join
each triangle of fabric A to a triangle of fabric B
to form four squares (Fig. 6b). Press the seams
toward the darker fabric.

Fig. 6a

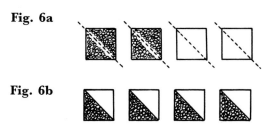

Fig. 6b

2 Arrange these in the propeller block shown in
Fig. 7. Stitch the top two squares together.
Press the seams to one side. Stitch the second two
squares together. Press the seams in the opposite
direction. Finally, stitch the two halves together,
matching the centers carefully. Press from the front.

Fig. 7

3 Measure the block. It should be 14½ inches
square. Use 1½-inch-wide strips of the
remaining Rail Fence fabric (Fig. 8a) to frame the

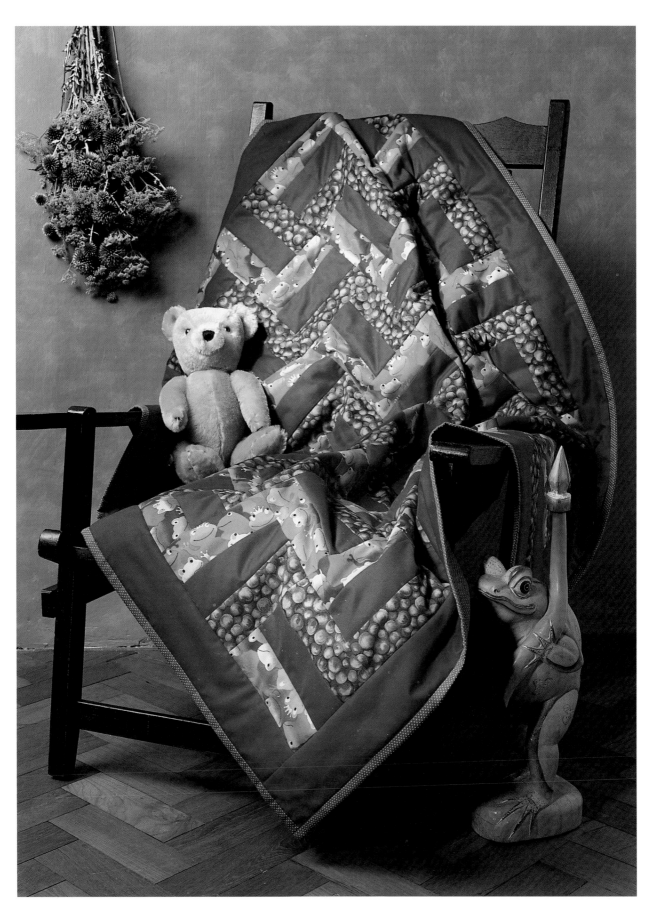

block in the same way as the sampler quilt blocks were framed with their sashing (see page 110). Repeat with 1½-inch cut strips of the backing fabric (Fig. 8b).

Fig. 8a **Fig. 8b**

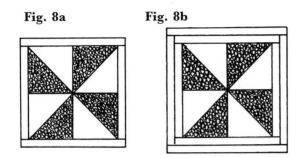

4 Cut a piece of batting and one of backing fabric, using the same fabric as the quilt back, about ½ inch larger on all sides than the pieced top.

5 Place the batting on a flat surface and position the backing fabric on it, right side *up*. Place the pieced top right side *down* on to it. Pin and stitch a ¼-inch seam around three sides of the block, leaving the fourth side open (Fig. 9).

Fig. 9

6 Trim away the extra batting and backing fabric. Turn the pocket right side out, pushing the corners out carefully without damaging the stitching. Baste the layers together and quilt the block, as shown in Fig. 10, or use your own pattern.

Fig. 10

ASSEMBLING THE QUILLOW

1 Place the quilt right side *down* on a flat surface and position the pocket centrally at the top end, with its right side *down* and the raw edges

lined up with the edges of the quilt. Baste these edges together, ready for binding (Fig. 11).

Fig. 11

2 Bind the two sides of the quilt (see pages 121–123). Next, bind the bottom and top edges, including the raw edges of both quilt and pocket.

3 Pin and carefully hand-stitch the two sides of the pillow in place on the quilt. The bottom side is left open for storing the quilt (Fig. 12). The side seams take a lot of strain, but must be hand-stitched (machine-stitching would ruin the front of the quilt). To add strength, stitch into the batting and sew each side twice. Reinforce the corners.

Fig. 12

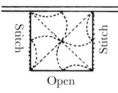

FOLDING THE QUILLOW

1 Place the quilt right side *up* on a flat surface. Fold the sides of the quilt over in line with the edges of the pocket (Fig. 13a). Pull the pocket through to its right side, enclosing the top two folded sides of the quilt (Fig. 13b).

2 Fold the quilt over so the bottom edges meet the open end of the pocket (Fig. 13c). Bring the folded edge up into the pocket so that all the quilt is inside it (Fig. 13d).

Fig. 13a **Fig. 13b** **Fig. 13c**

Fig. 13d

PROJECT 5

GRANDMOTHER'S FAN QUILT

This quilt for a single bed takes the 12-inch Grandmother's Fan block and repeats it to make a curved design that has a look similar to that of the Drunkard's Path block.

COLOR CHOICES

The fans are each made from six sections, plus a center. I used a selection of prints, stripes, and checks, and varied each fan, to give a random, scrap-quilt look to the design. A simpler effect can be obtained by limiting the number of fabrics in each fan to just two or three. The centers need to be of stronger colors than the rest of the fan, in order to give the design proper weight.

The background fabric occupies much of the quilt and can look stark if not well quilted. For that reason, I chose a white fabric with a tiny blue patterns which softens the large areas.

The first and third borders use an assortment of the fan fabrics to continue the scrap-quilt feeling. The middle border is a striped blue fabric, very similar in shade to the fabric used for the fan centers. If that fabric had not been available, I could easily have used the fan fabric instead.

FABRIC REQUIREMENTS

A total of 6½ feet of medium-weight cotton fabrics for the fan sections

16 inches of fabric for the fan centers

6½ feet of fabric for the background

51 inches extra of the fan fabrics for the two pieced borders

51 inches of fabric for the middle border, plus the binding

Backing fabric, about 90½ x 66½ inches (Cotton sheeting is ideal because it does not need to be seamed.) If 45-inch-wide-fabric is used, 5 yards.

Piece of batting, 90½ x 66½ inches

Final size of quilt: 88½ x 64½ inches

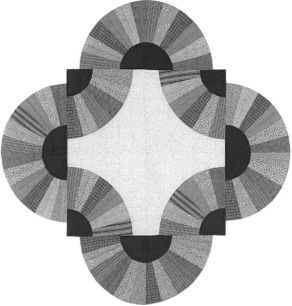

CONSTRUCTION

1 Follow the instructions given in Grandmother's Fan (page 59). Make 24 blocks and trim each one to an exact 12½-inch square. Arrange the blocks in the design shown in Fig. 1 (overleaf).

2 Machine-stitch together the four blocks in the top row of the quilt with ¼-inch seam allowance. Press the seams to one side from the front of the work. Join the four blocks in the second row. Press the seams in the direction opposite to the top row. Continue to join the blocks into rows until all six rows are complete, and the seams are pressed alternately to the right and left. If any easing has to be done to make the fans match in certain parts of the design, remember to always work with the shorter seam on top because this seam will stretch as you sew.

3 Pin and then stitch Rows 1 and 2 together, matching the seams carefully. Continue to pin and stitch each row until the quilt design is complete.

Fig. 1

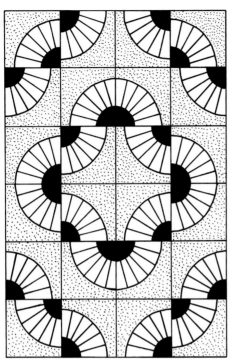

5 Press the seams to one side from the front of the work. If the seams are bulky, press the final long seams open from the back of the work.

6 For the first border, cut 124 2¹/₂-inch squares from the fabrics used in the fan sections. Do this by cutting strips 2¹/₂ inches wide, and then cutting the strips into 2¹/₂-inch squares (see Trip Around the World, pages 36–39). Join these squares into four lengths; two with 36 squares and two with 26 squares. Pin and stitch the two longer lengths to each side of the quilt, arranging them so that six squares fit against each Grandmother's Fan block (Fig. 2). Press the squares outward, away from the quilt.

Fig. 2

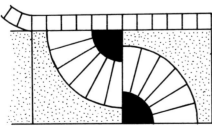

7 Pin and stitch the remaining two lengths to the top and bottom of the quilt, arranging them so that six squares fit against each block and an extra

square is left at each end, linking up with the side border squares (Fig. 3). Press the border squares outward, away from the quilt.

Fig. 3

8 The corners of the second border were mitered, but generally it is easier and more appropriate with a series of borders to add sides, and then top and bottom, just like adding dividers.

From the second border fabric, cut eight strips, each 4¹/₂ inches wide. Join them in pairs and press the joining seams open. Measure the length of the quilt down the center. Trim both ends of two of the border strips so that each stip matches this measurement with the seam exactly in the center. Pin and stitch these strips to each side of the quilt, easing in any fullness (see Borders on pages 117–121). Press the strips outward, away from the quilt.

9 Measure the quilt from side to side across the center. Trim both ends of the remaining two border strips so that each strip matches this measurement with the seam exactly in the center. Pin and stitch these strips to the top and bottom of the quilt, easing in any fullness. Press the strips outward, away from the quilt.

10 For the third border, cut 148 2¹/₂-inch squares from the fan fabrics, as before. Join them into four lengths; two with 42 squares, two with 32 squares. Ideally, each longer length will fit exactly onto one side of the quilt. If not, avoid trimming down the joined squares. Instead, try taking in or letting out the joining seams to attain the exact measurement.

11 Pin and machine-stitch the two longer border strips to the sides of the quilt. Press the borders outward, away from the quilt. Pin and machine-stitch the two shorter strips to the top and bottom of the quilt, adjusting the seams of the joined squares to match the quilt exactly. Press the borders outward, away from the quilt.

12 Plan the quilting design and, if necessary, draw it on with a marking pencil before basting the layers together. For full instructions on

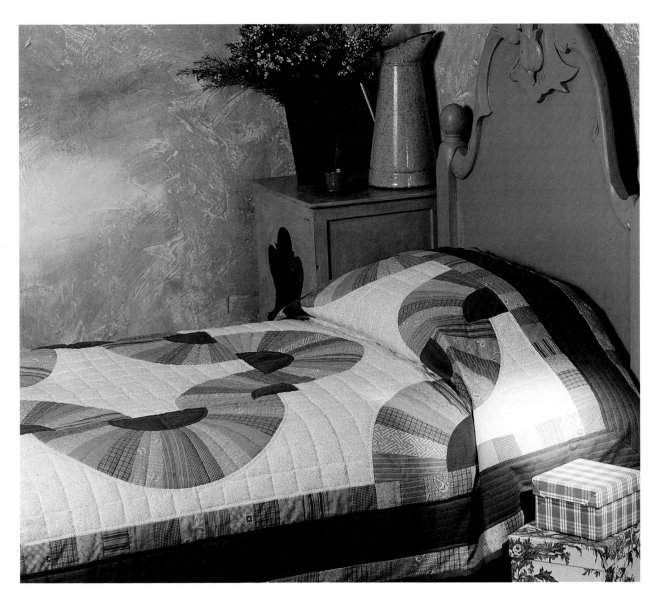

quilting, see pages 110–114. The quilting design used for the fans in this quilt is shown in Fig. 4. The background areas were outline quilted ¼ inch away from the edges and then in a 2-inch-square grid across the blocks throughout the background.

Fig. 4

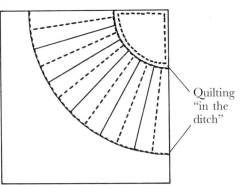

Quilting "in the ditch"

13 When all the quilting has been completed, trim the backing and batting to match the front of the quilt. Attach binding strips by following the instructions on pages 121–122. If you are using 45-inch-wide fabric as backing, you will need to remove the selvage edges and join it in three pieces with seams running from top to bottom, rather than one central one. This looks better and makes it less obvious that the fabric has had to be seamed from necessity rather than choice (Fig. 5).

Fig. 5

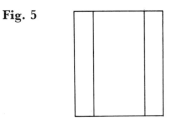

ACKNOWLEDGMENTS

My thanks to the following individuals:

To Jill Carter, whose request for a patchwork class at Coggeshall first made
me construct a Sampler Quilt Course.
To Barbara Chainey, who made the link with David & Charles to produce
a book based on the course.
To Vivienne Wells, who began the task, and to Cheryl Brown, who
continued it, to bring this book into reality.
To Shirley Prescott and Marion Edwards for their expert contributions to
the projects.
To the following for allowing their quilts to be used in this book:
Helen Burrett, Pam Croger, Marion Edwards, Sue Fitzgerald, Daphne Green,
Jane Hodges, Hazel Hurst, Ann Jones, Kate Kearney, Yvette Long,
Ann Larkin, Chris Laudrum, Collie Parker, Shirley Prescott,
Sandra Robson, Dot Sidgwick, Jenny Spencer, Shirley Stocks,
Mary Telford, Lindy Ward, and Chris Wase.

INDEX